Close

No one collective description can be applied to the wide variety of subjects in this group. Instead, when choosing a name, I opted for a small, unassuming word which, in Scottish dialect, was used to describe a landscape so inspirational that heaven seemed closer to earth in that place. For example, I grew up in MacGregor country, where it is said the most famous member of this clan, Rob Roy MacGregor, was buried in Balquhidder because he had described the glen as 'close'.

The title is also in tribute to a saying in the documentary profession that a photograph will be of no worth if the photographer isn't close enough to the subject.

Allan Pollok-Morris

Locations

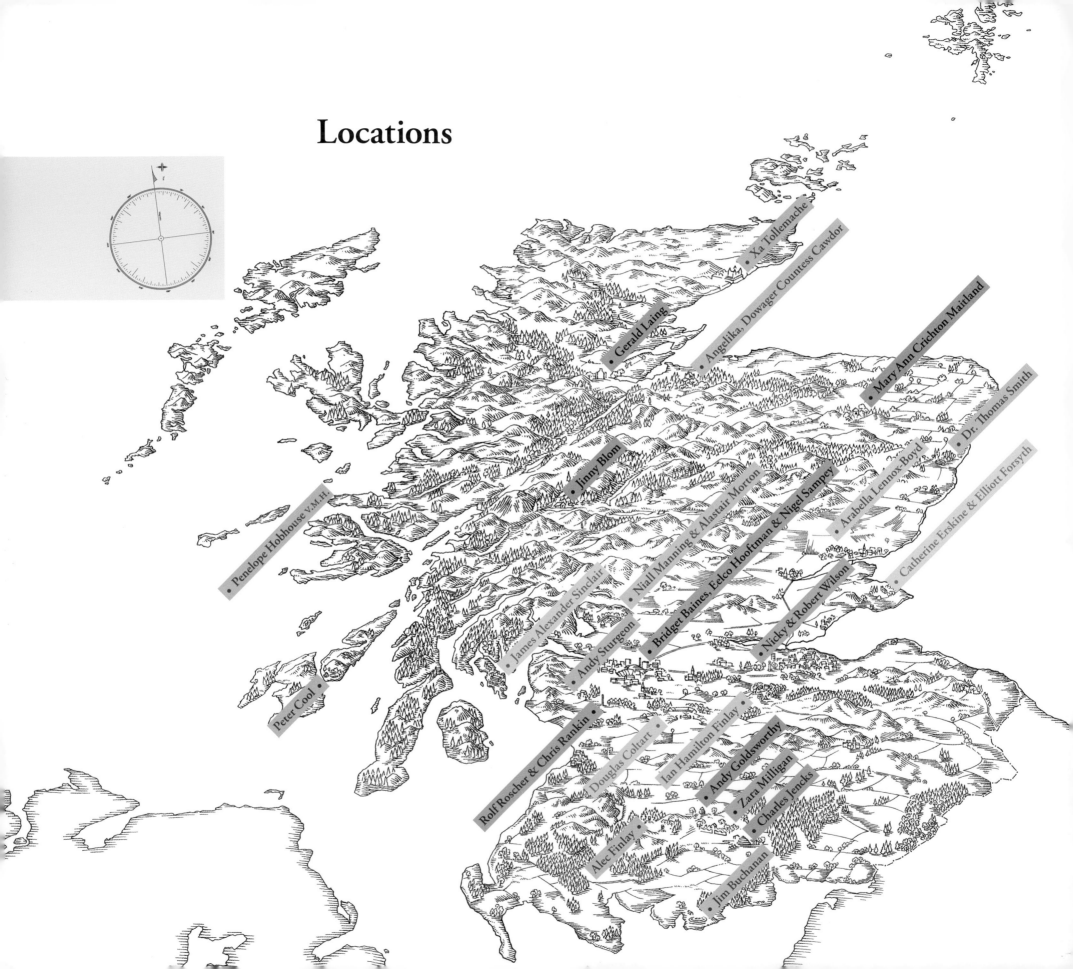

Xa Tollemache

Angelika, Dowager Countess Cawdor

Gerald Laing

Mary Ann Crichton Maitland

Dr. Thomas Smith

Jinny Blom

Arabella Lennox-Boyd

Catherine Erskine & Elliott Forsyth

Penelope Hobhouse V.M.H.

Niall Manning & Alastair Morton

Bridget Baines, Eelco Hooftman & Nigel Sampey

Nicky & Robert Wilson

James Alexander Sinclair

Andy Sturgeon

Peter Cool

Rolf Roscher & Chris Rankin

Douglas Coltart

Ian Hamilton Finlay

Andy Goldsworthy

Zara Milligan

Charles Jencks

Alec Finlay

Jim Buchanan

Contents

Foreword by
Sir Roy Strong FSA., FSRL.

This collection of photographs by Allan Pollok-Morris is a hymn to the Scottish garden, although some gardens gathered here are not the work of Scots. Nor is this introduction, although it is by someone who, like the gardeners here, recognises that horticulture North of the Border has a distinctive life of its own. Nearly all who have written record the overwhelming impact of the terrain and of a climate harsher and more unsparing of those who war against it.

Allan Pollok-Morris catches the quintessential qualities which set Scottish gardens and gardening apart. He records the sense of struggle in a land where the forces of nature always threaten to defeat those who set out to defy it and to tame and cultivate. His pictures respond fully to the massive, gaunt, if verdant landscape and to the amazing permutations of light from skies which can range from being bright and tranquil to ones which are troubled and turbulent. And they of course in turn affect the whole vision of the garden, one in which the appearance of flowers at all calls for celebration. The season is after all short and far later than in the south.

Perhaps, however, what fascinates and pleases me most from this garden gathering is that all of them embrace change with excitement, for horticulture is a mutant art. To that one can add a return to a consideration of gardening in a far more philosophical light. Time and again there is a quest for the rediscovery of meaning in the garden. What is it there for, what does it mean, how does it express the ideas and commitment of its creators. For that return to the great tradition one must be truly grateful.

Essay by
Tim Richardson

It would seem self-evident that photography is 'a visual artform'. And gardens are about looking, certainly. But they are also about hearing, smelling, touching, tasting, feeling . . . and being, being in a place at a particular time of day, in one season in certain weather conditions, at a specific moment in a garden's slow arc of development. Such variables – apparently esoteric but in reality effortlessly understood by the person 'on the ground' – contribute to our perception of the genius loci, the sense of place, which can be so strong in a garden, especially if one is ready to become attuned to it, to rise up to meet it. But can photography, like words, take us beyond what is merely visual – beyond the glossy simulacra which lie flat against the page or the wall? Are they able to absorb and re-transmit something of the space-flavour of a place, to function as a distillation of its unique expressiveness?

The images in this book, and in the exhibition which it accompanies, illustrate the way photographs can indeed take one beyond the realm of images and into the sphere of atmosphere and intuition – perhaps even into the sense of place itself (or at least some way towards it). Allan Pollok-Morris's photographs can be conceived as phials of meanings and feelings which are cracked open when we encounter them, pervading the air around us. These images record and magnify something of the particularity of manmade landscapes and gardens, endowed as they are with rich meanings and strong emotions by those who have made them and by those who now enjoy them. At the same time the wider Scottish landscape is honoured: a cloak of gilded grass, silvery granite, darksome evergreen, or a grey-white sea. This is the environment which palpably envelops and offsets the enclosed outdoor spaces, the 'gardens', in Pollok-Morris's oeuvre.

All great photographers have a way of seeing, which they are somehow able to communicate via the lens and then project onto the page. One of Pollok-Morris's distinctive traits is his ability to create a meaningful balance between the sometimes conflicting claims of human artifice in gardens and designed landscapes, imbued as they often are with recognisable emotions or themes, and the grand and implacable indifference of the natural world which surrounds them. In many of these images, the landscape and the garden seem to hold one another in an uncertain embrace, helping to create an uncanny impression of

breadth and depth. As a result the gardens are given their place. The photographs of the garden at Dunbeath, in its sublime coastal setting in Caithness, serve as a fine example of this, while a more intimate, lyrical tone is celebrated in the images of the woodland burn lighted upon by Alec Finlay as a setting for one of his artworks. It is a measure of the photographer's instinctive understanding of place that so many of his capturings of Ian Hamilton Finlay's Little Sparta are views from the edges of the garden out into the landscape. It is a sensibility born in part of a refusal to be pictorially seduced by that garden's many composed, set-piece episodes. It also honours Finlay, in this specific context, as a placemaker first and a sculptor second.

The relationship, on a landscape scale, between massiveness and solidity on the one hand, and fleeting delicacy on the other, is dramatised, too, within the domestic scale of the garden, especially where the wider landscape may not visually impinge. For example, giant yew topiaries at Cawdor Castle loom protectively (or menacingly) above the magenta, green and cream tones of the perennial borders of high summer; an herbaceous drama which must always end in the tragedy of winter, before miraculous rebirth next year. Such discrepancies of scale, colour, texture and hardiness in the world of plants contribute to the richness of our garden experience, and Pollok-Morris traces them eloquently. There is an understanding that in the best gardens hierarchies of scale, both within and without the garden, become an integral element of the aesthetic calculus formulated on the move and often instinctively by the human genius of the place. The fact that we as viewers are patently not in the garden when we encounter these images, that we may never have been to the garden, and indeed that we may well never get to visit it at all, becomes unimportant. Garden photographs do not have to act as souvenirs or tasters; they need not be conceived or construed as second-class versions of the 'real thing'. At their best, they are the thing, existing alongside the place itself. A sense of distance in fact emerges as a key to our appreciation of these photographs as works of art in and of themselves.

Pollok-Morris's compositions are also striking and memorable because of their apparent lack of composition, the way they seem to echo the spontaneity of looking when one is in a garden. So many of these images

seem to echo the serendipitous sense one can sometimes have in a garden of being blessed with a fleeting glimpse of some area or vista which lingers in the memory – as opposed to the composed and framed 'shot', concocted for a calendar, postcard or guidebook. Here is a photographer who is not interested in giving us 'highlights' or aides memoire. The photographs of Zara Milligan's garden, Dunesslin, illustrate this: away from the ostensible focus of these images, the liminal – what lies at the edge or the threshold of the scene – seems to be making incursions on both the composition and the 'composure' of the shot. It is a technique, or perhaps more nearly a sensibility, which captures something of the aesthetics of experiencing gardens outside, amid the 'chaos' of nature, the distractions of the weather and the physical act of moving through space. Gardens rarely sit still for us when we are out in them.

The subject matter of this book also reflects something of the excitement of the contemporary designed garden and landscape scene, especially in the British Isles. Scotland is home to two of the three most important new gardens made in Britain (and arguably the world) during the last quarter century, and both are illustrated in these pages: Little Sparta, in the Pentland Hills outside Edinburgh, and Charles Jencks's Garden of Cosmic Speculation in Dumfriesshire (the third was Derek Jarman's garden on the shingle of Dungeness beach, in Kent). These gardens have played a major part in shifting the emphasis of our understanding of gardens away from the chiefly herbaceous, painterly preoccupations of the Arts and Crafts movement inspired by Gertrude Jekyll and others, and towards an idea that gardens can exist as a series of sculptural or conceptual episodes which use the vocabulary and palette of materials available to the garden-maker. This is not to say that colour theory based on herbaceous border design is now irrelevant; it is simply that the horizons of many in the world of gardens have been expanded, and the photographs in this book accurately reflect that. The impact of Land Art on the garden scene is illustrated here in the activities of Andy Goldsworthy, Jim Buchanan and others, while Jupiter Artland, an astonishing new sculpture garden featuring major new works by Jencks, Goldsworthy and others, is also given generous exposure in this revised edition of Close.

The aforementioned gardens and their makers sit more or less comfortably within the hierarchy of the art world. Matters get more complicated from an art perspective when one starts dealing with places which can more easily be described as gardens, and which use plants and flowers as a primary aesthetic material. It is at that point that condescending prejudice against gardens and gardening as a bourgeois, amateurish, domestic hobby or pastime often kicks in. It is to Pollok-Morris's credit that he has never been thrown off course by the blinkered, broadcast-media-driven stereotype of garden-making as an outdoor form of DIY. Gardens reliant on planting take their place here alongside those redolent of a more familiar and 'respectable' architectural or graphic sensibility. The planting styles illustrated in images of gardens such as Cambo House and Corrour Lodge are sophisticated exercises in herbaceous colour theory, a design discipline which can be traced back at least as far as the Aesthetic movement of the late 19th century, on through Arts and Crafts, mid-20th-century 'cottage' styling, late-century colour complexity and on up to the naturalistic new perennials and meadow movements of the past decade. These compositions can be 'read' by those with knowledge, and of course they can be enjoyed by everyone.

Something of the exciting new strain of conceptual design in landscape architecture can also be seen in this book, specifically in the work of Edinburgh firm Gross.Max and arguably also in the Hidden Gardens project in Glasgow. These are gardens which are based primarily on ideas (or an idea) rather than the traditions of decorative horticulture or Modernist architecture. This is a design philosophy which effectively acts as a riposte to much that is commercially and politically expedient and casually eco-inflected design work being executed in the early 21st century, in part as a response to the apparent apocalypse facing our rapidly deteriorating planet. Conceptualist designs question whether self-referential themes of nature, or plants, or the idea of the garden itself, need always be the start and end point for garden-making, positing instead the apparently heretical notion that a garden can be about anything, and that plantlife may not always be particularly high up on the list of subject matter.

This is not just a book of photographs. Close is a beacon illuminating the multifarious ways gardens and designed landscapes can be conceived and run on the scale of gigantic, ever-changing art installations of epic complexity and ambition.

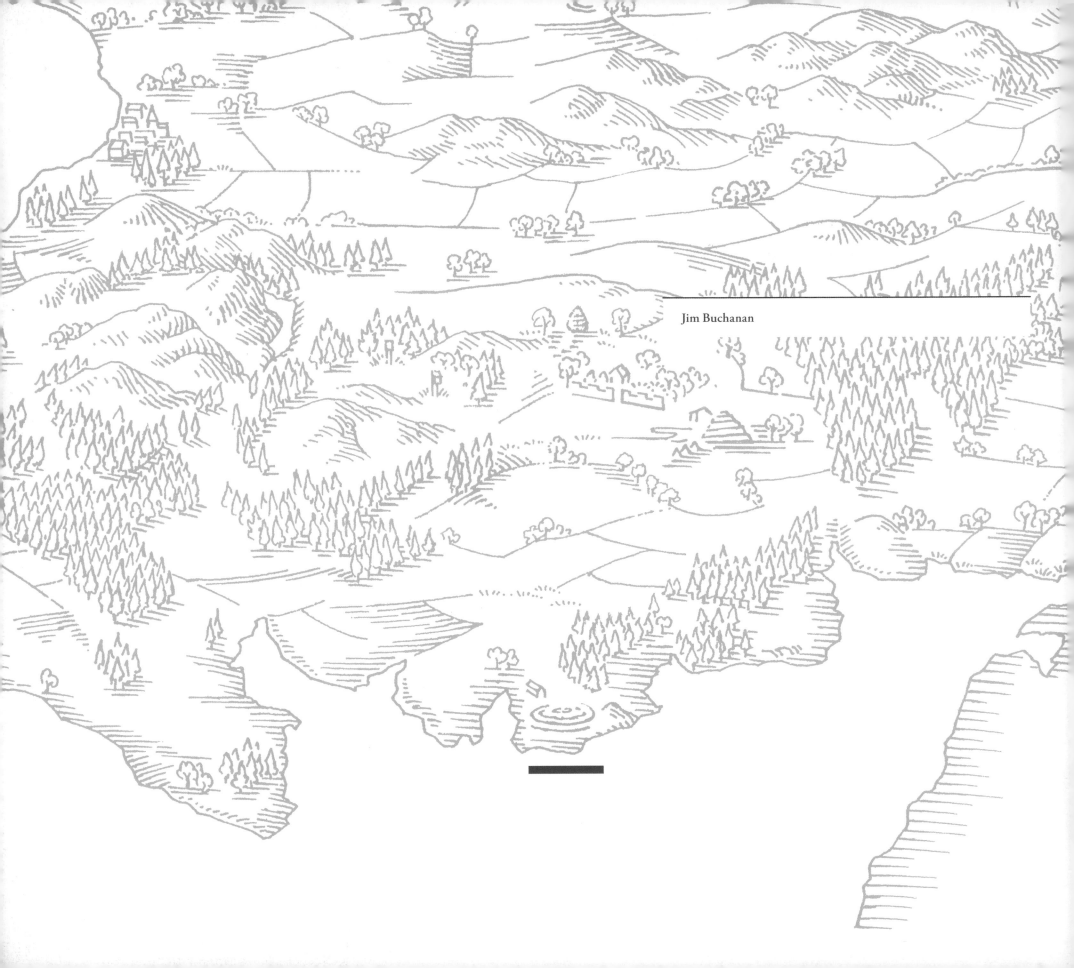

Jim Buchanan

True

Magnetic

30°

60°

90°

120°

150°

180°

210°

240°

270°

300°

330°

Jim Buchanan

Labyrinths, Sandyhills, Dumfriesshire

The labyrinth motif has a history that extends back over 4000 years. The earliest surviving examples are rock carvings, and all are of the same classical labyrinth design. New forms evolved in Roman mosaics, then later in medieval cathedrals, on village greens and on hilltops. Through history the labyrinth has appeared throughout the world in India, Sumatra, Java, the American Southwest. They were predominantly located for communal access and use.

The modern day labyrinth has found many more expressions within the private garden. For example, I have walked a labyrinth drawn with white cobbles within a driveway area of darker cobbles – the white labyrinth walls glowing with celebratory moonlight. A more organic application of the labyrinth motif had the pathways curving around the edge of the house in Zen like raked gravel, complete with laughing Buddha and wind chimes.

Labyrinth designs may be greatly varied. To become receptive to variations I initially employ a simple drawing technique. This is fast and repetitive and emerges through a subtle balance between hand, eye and brain co-ordination. An ink pen or soft pencil on paper produces a fluid graphic mark, where the development and alteration of an idea run consecutively with the act of realising a form.

Mark making with a stick or rake in sand on the beach extends the physical act of drawing. The beach is an extension of my studio, which allows 1:1 scale drawings to be made. The geometry, curves and rhythm of a design are explored at a life-size, and 'walking-feeling' amendments can be made in the sand.

Drawing a labyrinth in the sand allows the chance to adjust the layout, whilst developing an internal discussion about its final construction. The advancing tide adds tension to the beach location. It focuses physical action and brings clarity to thought processes, ultimately erasing the physical origin. In the end, no matter how 'precious' one becomes, the sea will reclaim the space.

Each labyrinth has a cadence particular to its dimensions, construction material and location in the landscape. The beach drawing illustrated is an idea for a private garden labyrinth. The sheltered garden is dominated by a river; the river is sometimes gentle and sometimes a raging torrent threatening to flood the garden. I am perplexed by the river's dominance, and seek to unite the garden and river with a labyrinth design that encompasses tension, fluidity, reflection and stillness.

However, my realisation is that the context of the beach, and not the details of the design, hold the answer. I shall propose a temporary sand plateau in the client's garden, where labyrinth variations can be created and explored.

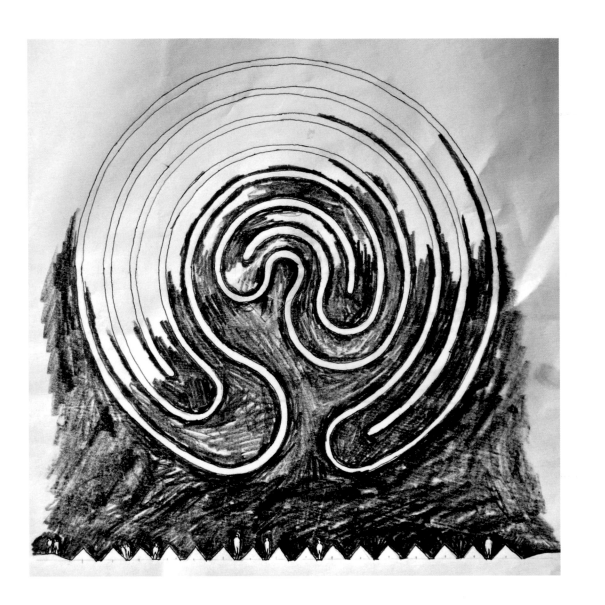

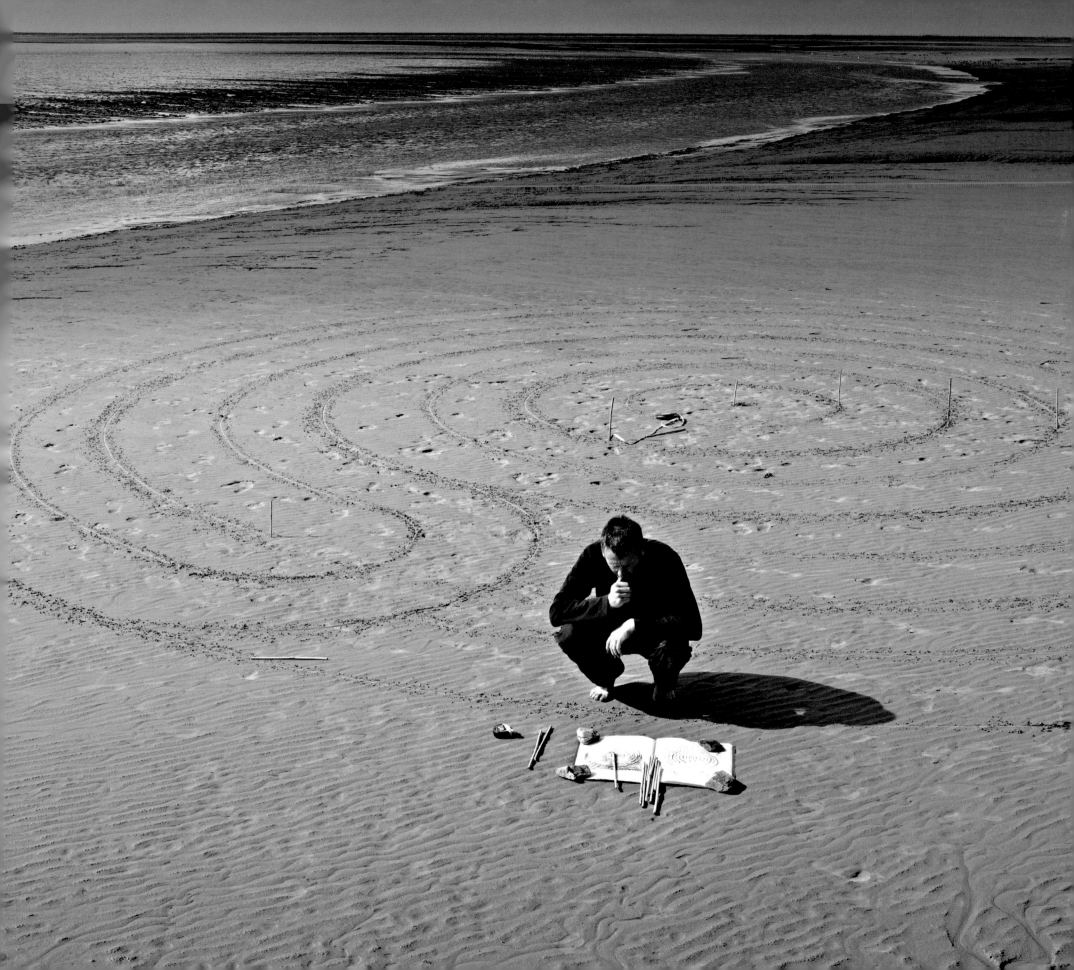

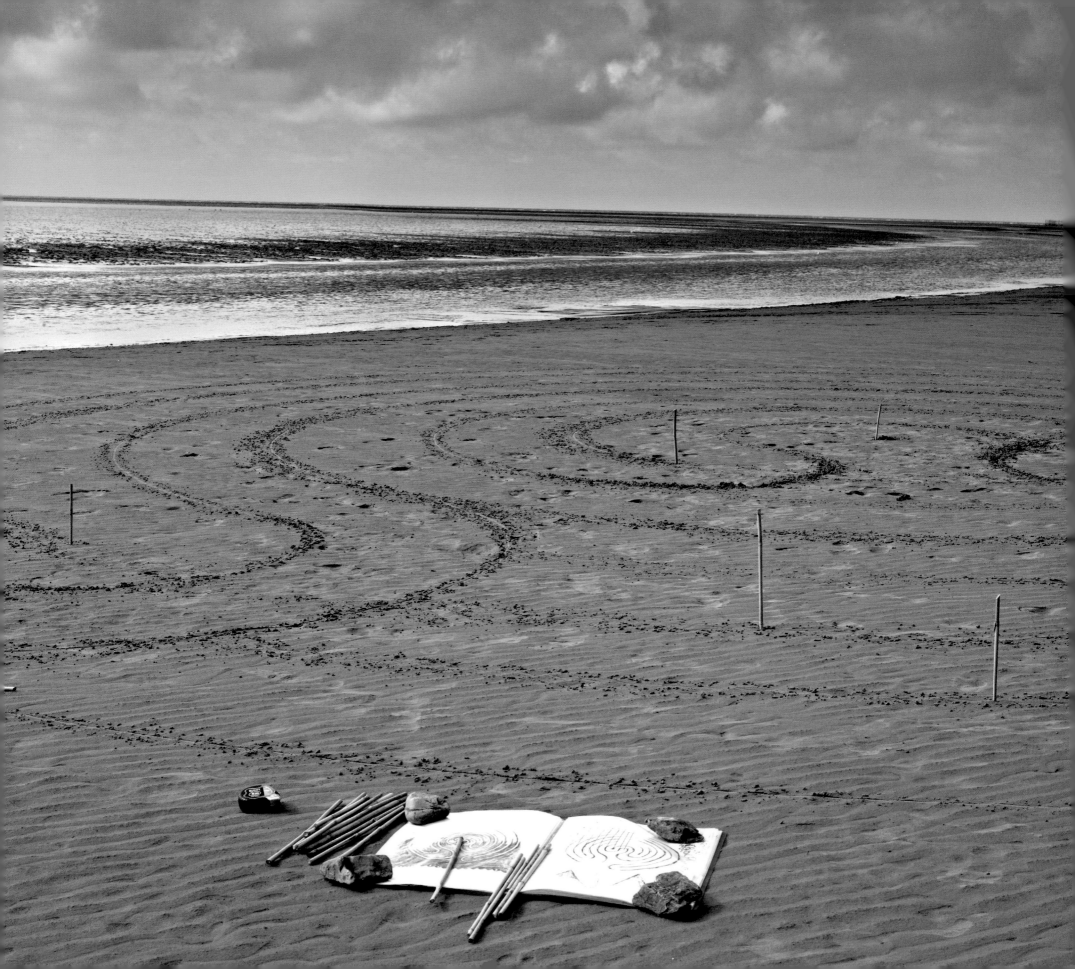

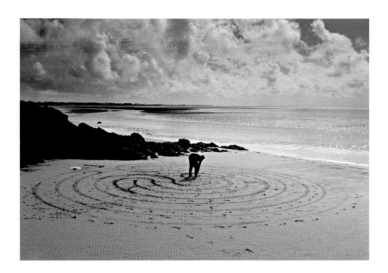

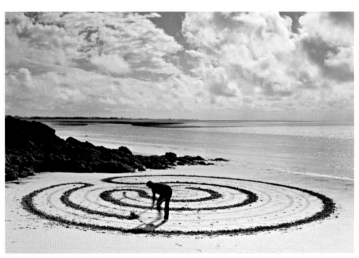

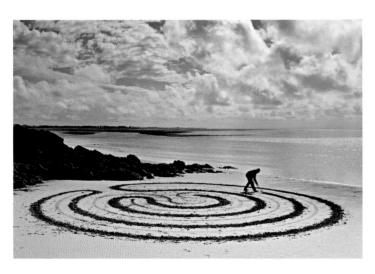

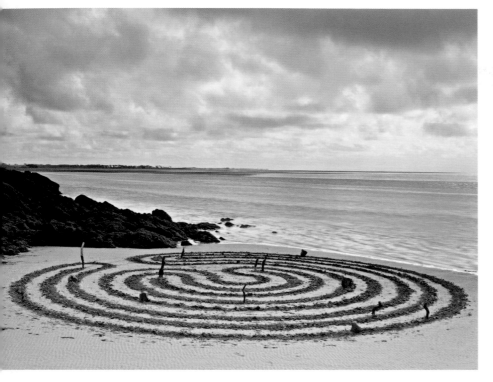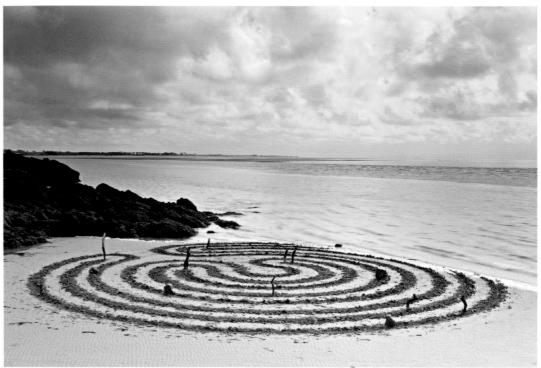

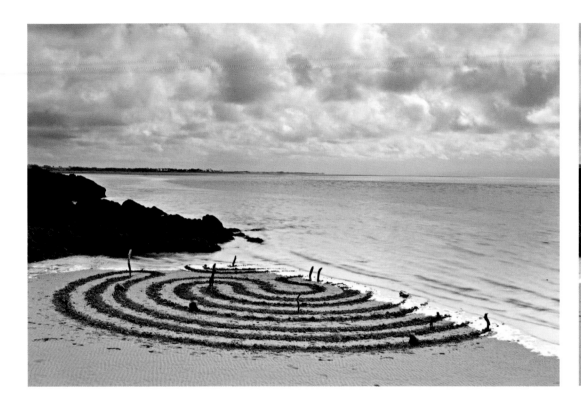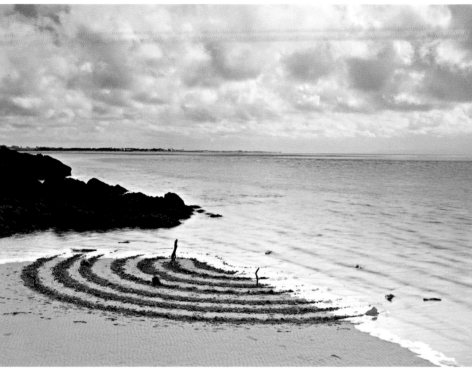

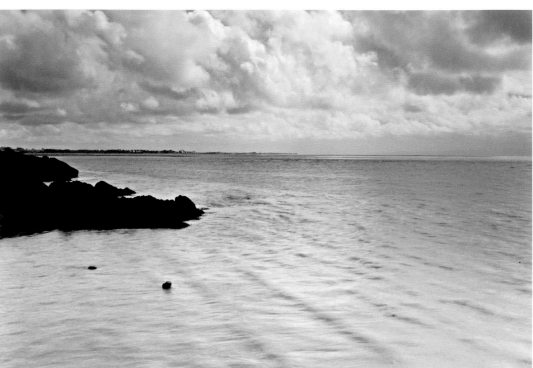

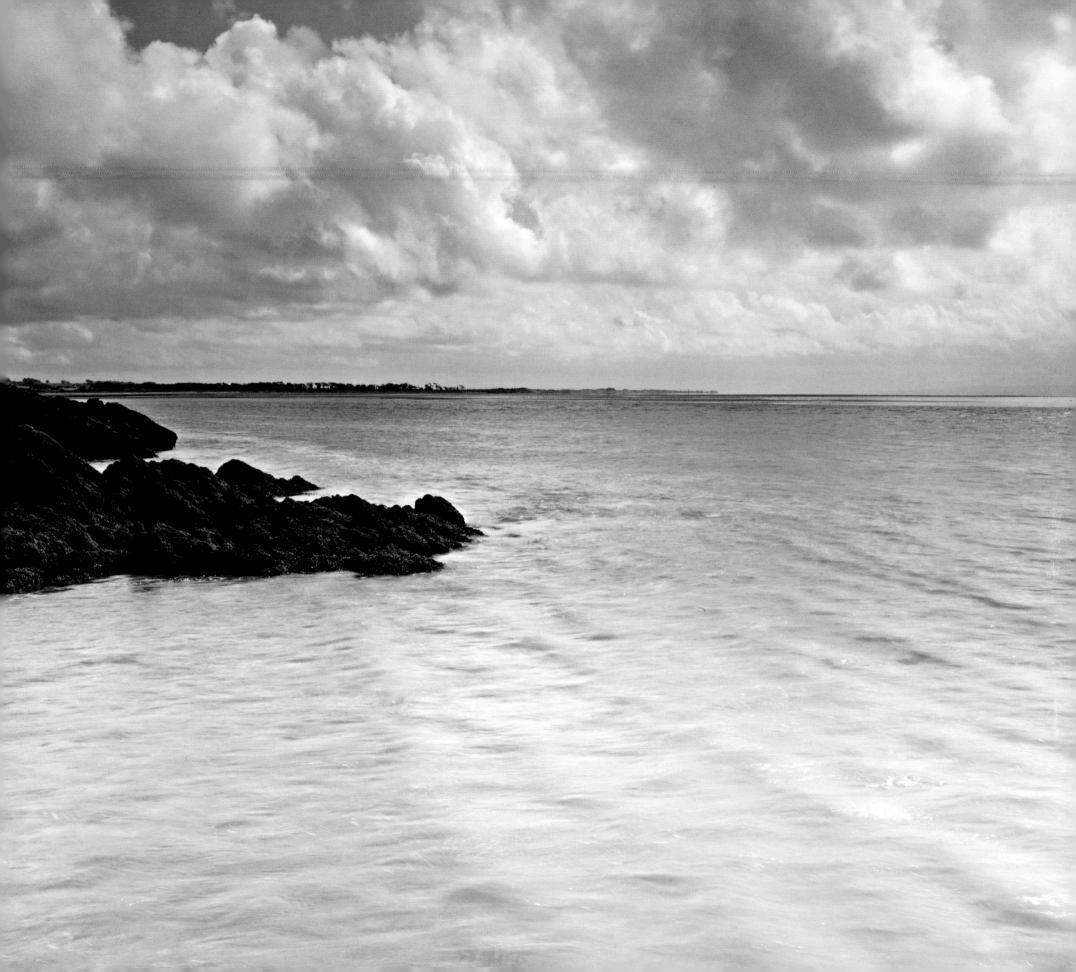

Andy Goldsworthy

Charles Jencks

Zara Milligan

Alec Finlay

Douglas Coltart MLI., MSGD.

True

Magnetic

Andy Goldsworthy

Works in Dumfriesshire and the National Museum
of Scotland, Edinburgh

Also see Jupiter Artland pages 100, 104, 105

Extracts from Penpont Cairn

23 December 1999

I have been very anxious about this sculpture and have given enormous thought to its making.

I feel self-conscious about working so prominently in my home place. I will see the resulting sculpture whenever I leave and return to the village. My children will grow up with it. These associations can become rich and beautiful, but if the sculpture does not work then I shall have to live with that. Most artists have to deal at some time with bad reactions from the public, that is normal, but home is where I am most exposed.

I have surprised myself by choosing such a prominent site. I tried to talk myself out of it, but somewhere along the process the self-conscious Andy Goldsworthy was replaced by Andy Goldsworthy the artist whose purpose is to make the strongest possible sculpture. It is an honour and responsibility to have been asked by the village to make a work and I must do all that I can to respond as well as I am able.

22 January 2000

The cairn is taking on its character, and although it is too soon to be certain, I feel a welling up of excitement at how good the form is. I live, work, sleep and breathe this piece at the moment. Stones laid in the day are turned over in my mind in the evening.

It is strange to talk of such hard and heavy work as enjoyable, but the making of this sculpture is the closest I have been with a large stone work to being able to say this. This is due mainly to it being where I live. I go to work as farmers and others are also going to work. I am doing my job as they do theirs. Although the making of a sculpture is obviously out of the ordinary, this particular work has a wonderful sense of the normal and everyday about it.

28 January 2000. The cairn is finished.

It is difficult to describe my feelings. It is far more impressive than I thought it would be. For a work so prominently sited I thought it might be too imposing and appear as if it were shouting for attention in a 'look at me' kind of way. In this instance, however, I am delighted that it should have a strong presence. Standing on the brow of the hill, it appears almost to float. Even I wondered momentarily what is holding it up!

As you walk to the sculpture it changes so much; I like the many different ways in which it can be seen. Of course the form is not perfect, but it has to be the best cairn that I have made so far.

A farmer stopped and when he asked what it was, I explained my ideas of it being a guardian or sentinel to the village. I knew by the tone of my own voice that I was unable to explain fully what the sculpture is about. The farmer stayed for some time and the conversation went from farming to quarries; to things taken away from the land and things given to it; to the standing stones and landmarks in the area and how his young daughter will have the memory of having seen the work being made. Any explanation I can give inevitably falls short of describing the work fully and in many ways it is better described by conversations I had with this man.

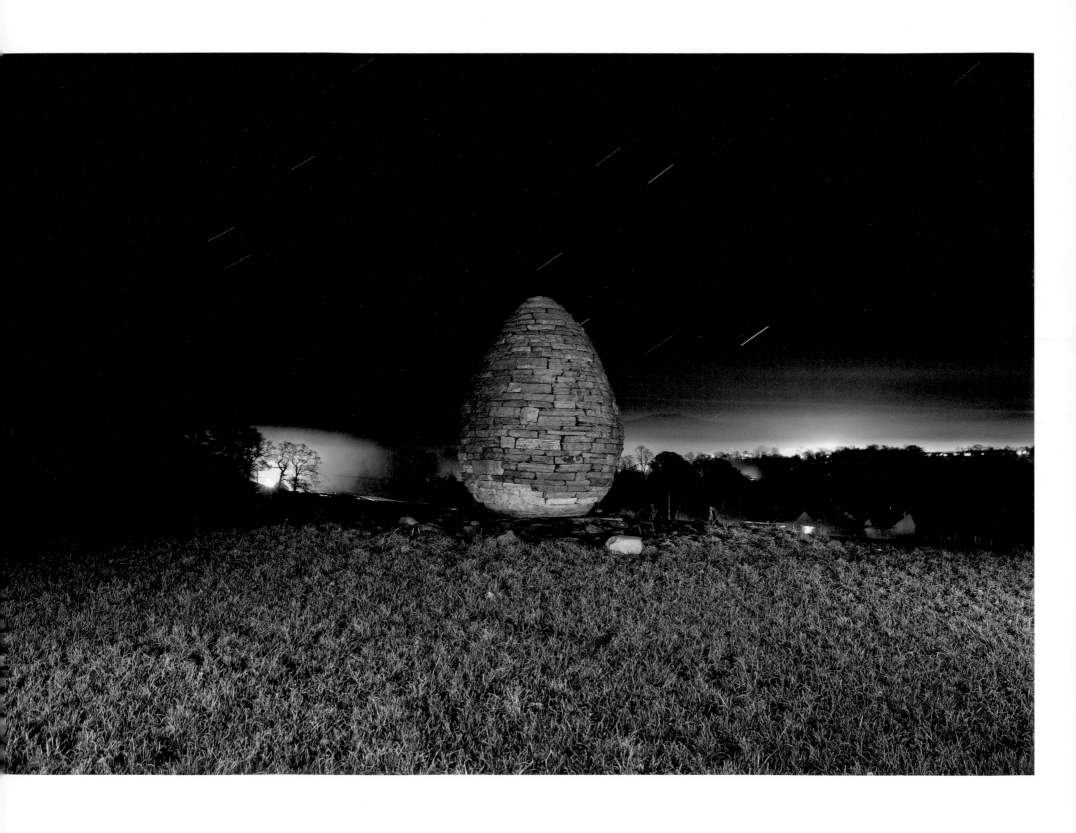

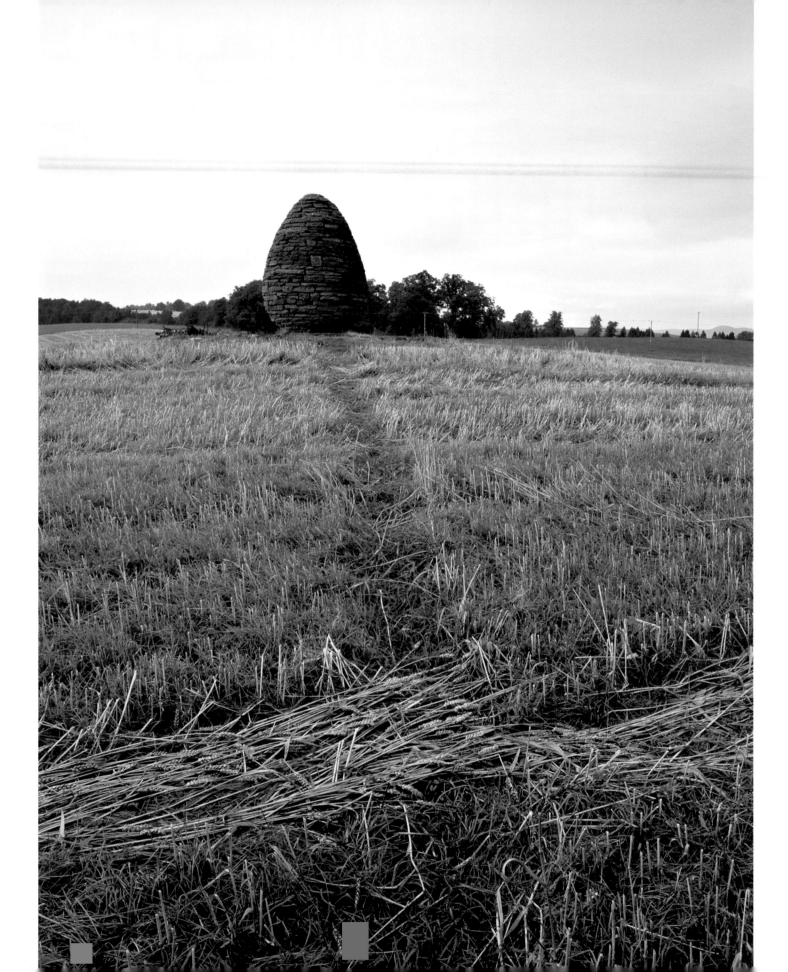

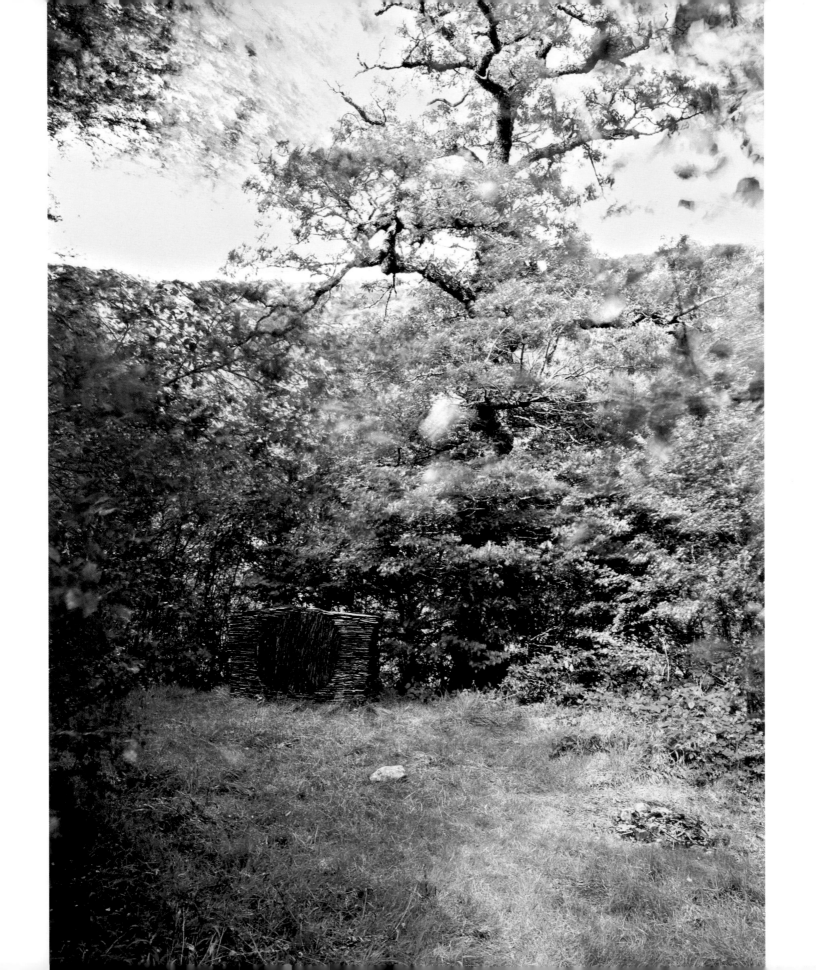

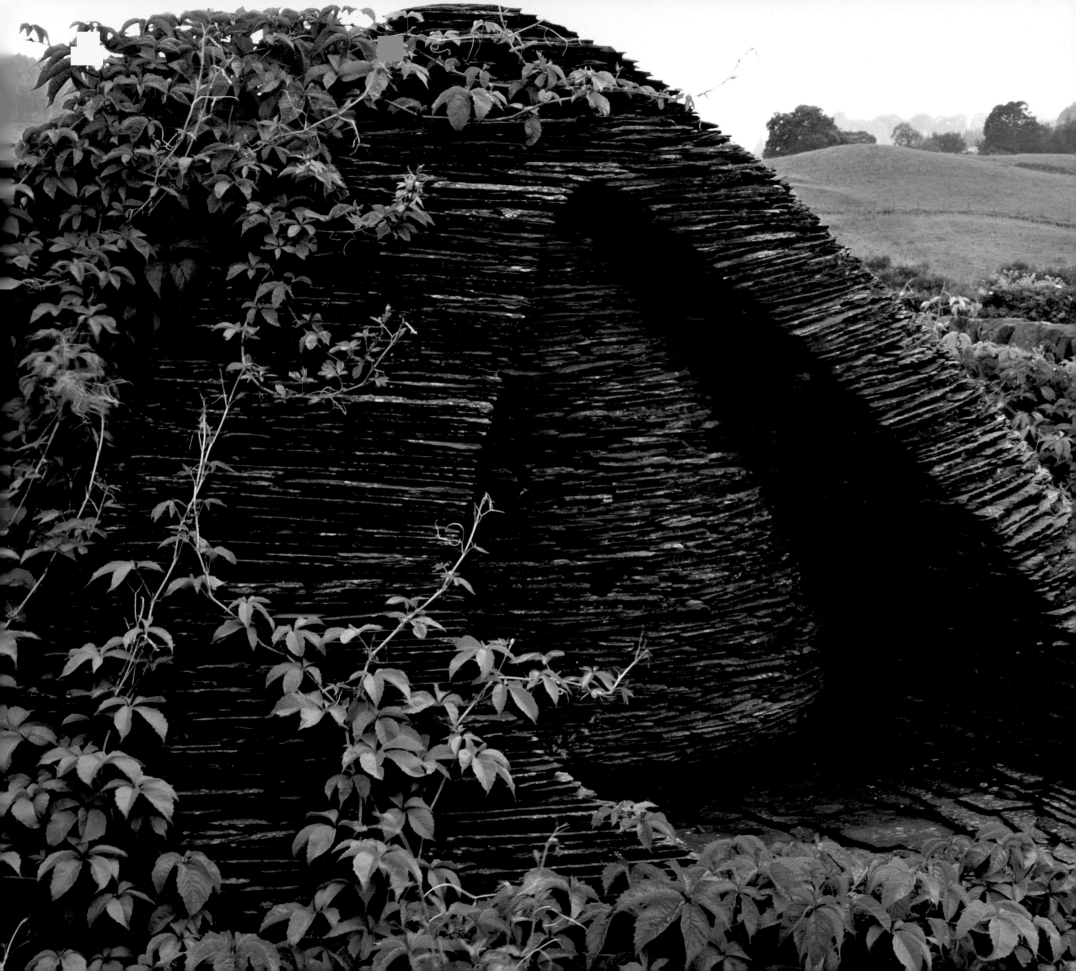

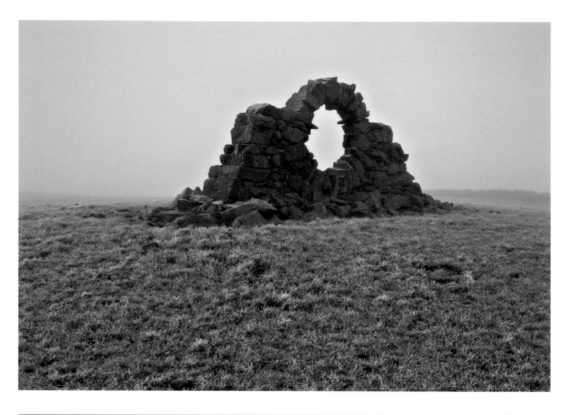

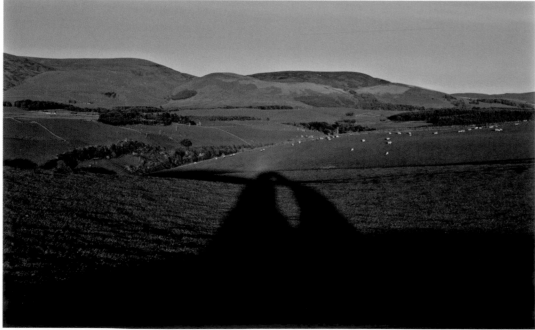

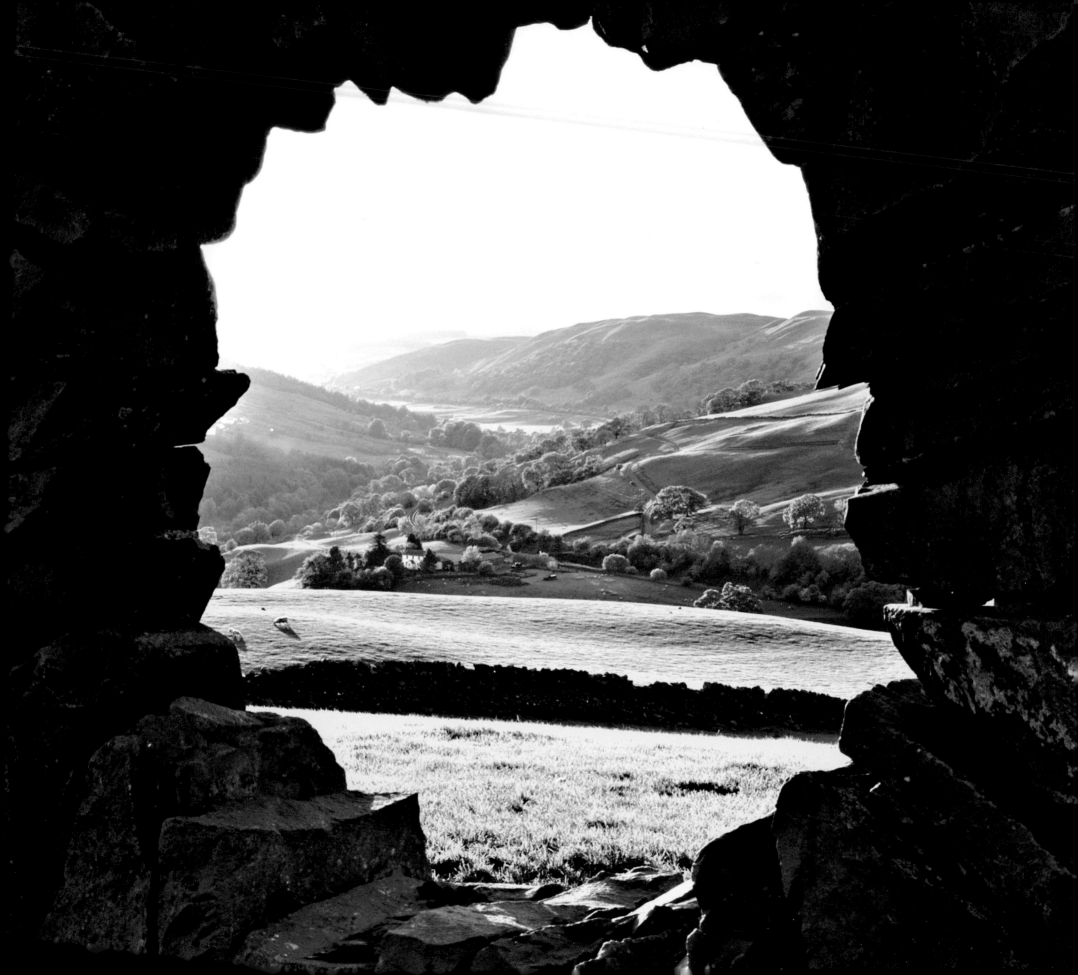

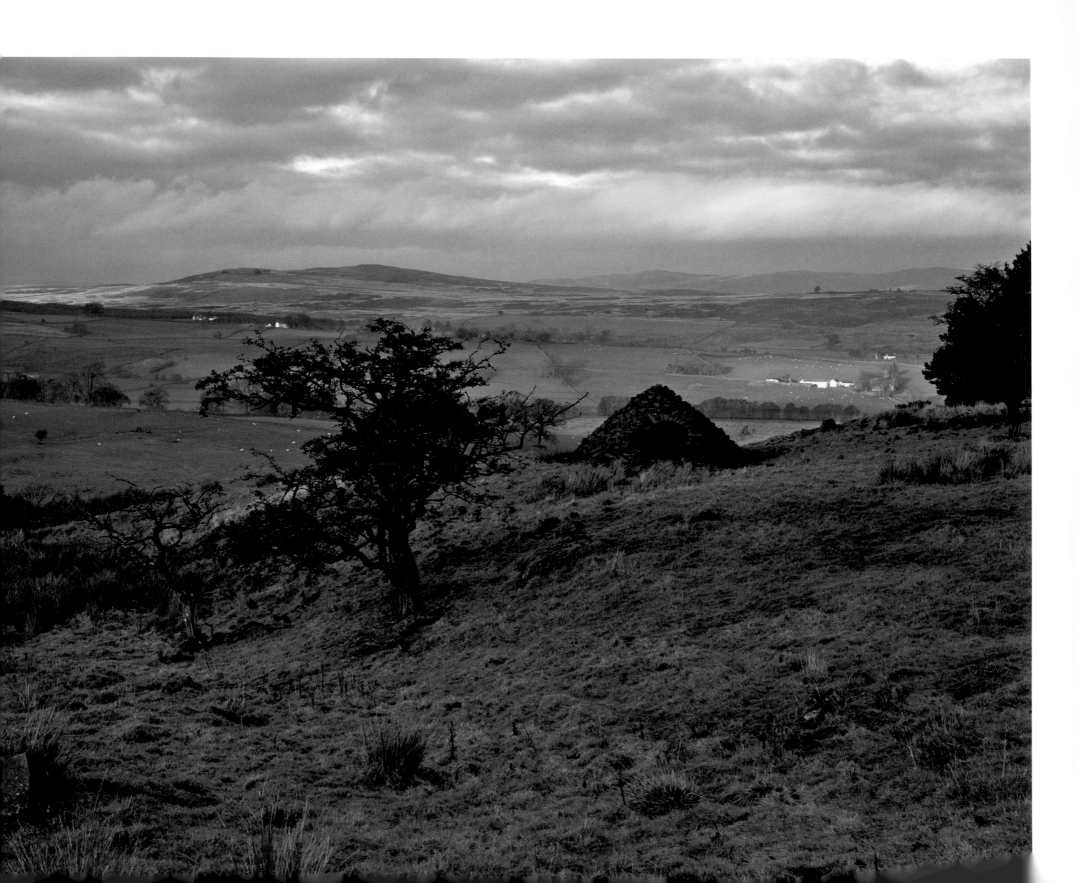

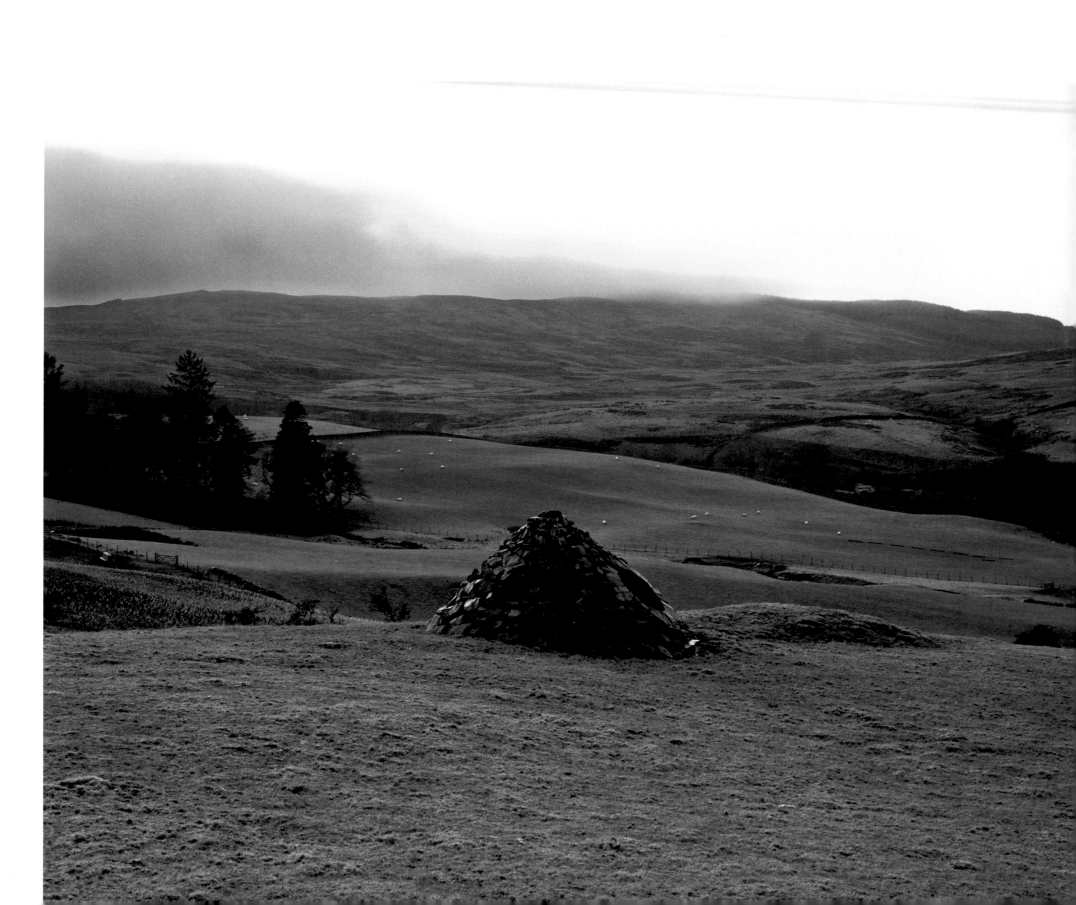

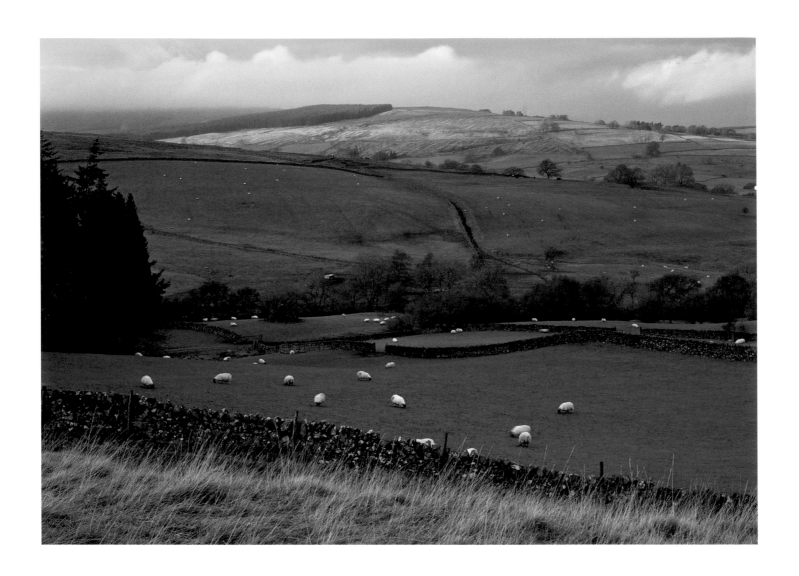

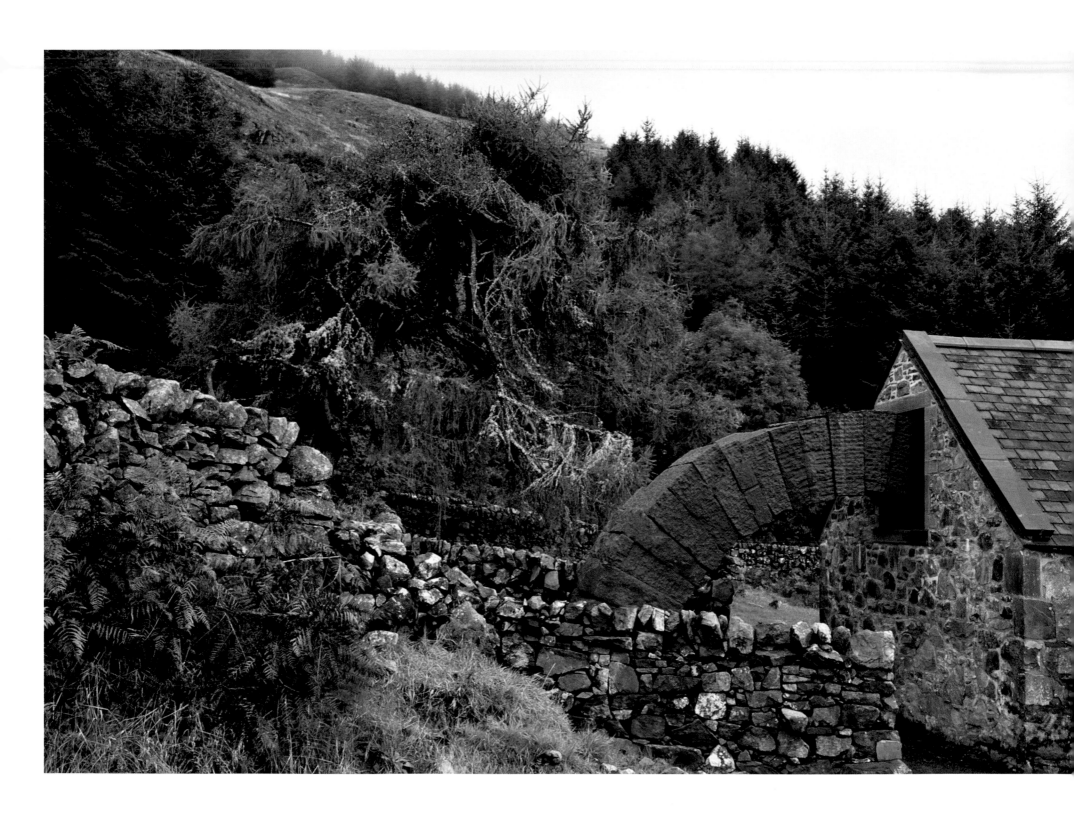

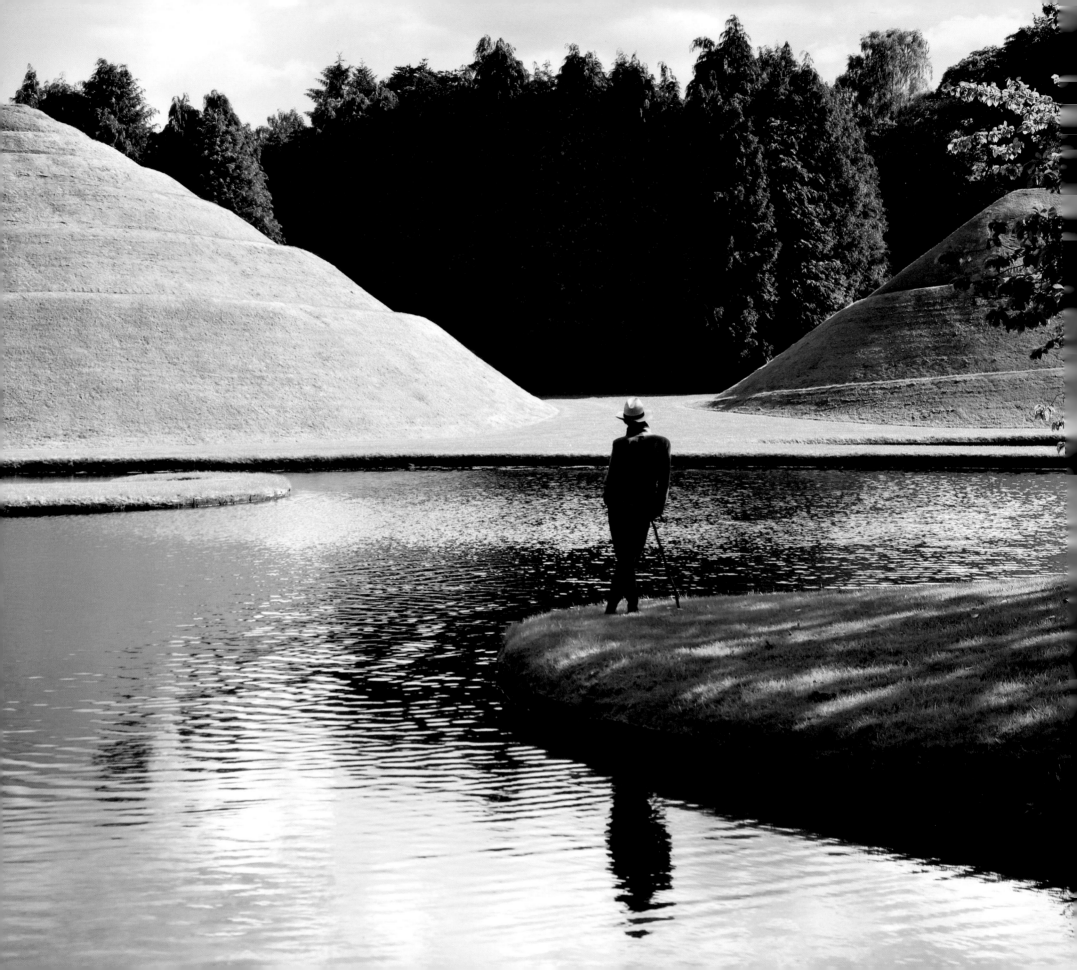

Charles Jencks

The Garden of Cosmic Speculation

Landform UEDA, Gallery Of Modern Art, Edinburgh

Maggie's Highlands Cancer Caring Centre garden,
Raigmore Hospital, Inverness

Also see Jupiter Artland pages 96, 97, 98, 99, 115

The Garden of Cosmic Speculation

Covering 30 acres in the Borders area of Scotland, the Garden of Cosmic Speculation is conceived as a place to explore certain fundamental aspects of the universe. What are atoms made of and how should we conceive of them? How does DNA make up a living organism and why is it essential to celebrate it in a garden?

The garden uses nature to celebrate nature, both intellectually and through the senses, including the sense of humour. What emerges is a new language of landscape design based on twists and waves, optical illusions, and sudden surprises. It presents a view of the universe quite different from the standard mechanistic model; the complexity sciences show it to be more dynamic and creative than previously conceived.

The garden abstracts this new world view. A water cascade of steps recounts the story of the universe, a terrace shows the distortion of space and time caused by a black hole, a 'Quark Walk' takes the visitor on a journey to the smallest building blocks of matter, and a series of sweeping landforms and lakes recall fractal geometry while echoing visually the nearby Scottish hills.

Landform UEDA, Gallery Of Modern Art, Edinburgh.

This Design, commissioned to enliven a flat lawn and shield noise from the side road, faces two ways: to the gallery and across the road to its sister, the Dean Centre. Its connecting 'S' form also derives from two strange attractors discovered by physicists Ueda and Henan. Earth, water and airflows generate wave forms that self-organise around certain attractor basins so there are natural affinities between this shape and the way the earth is moved and people walk. The landform can be used as an open-air gallery.

Maggie's Highlands Cancer Caring Centre garden, Raigmore Hospital, Inverness.

Some day the story of how these Maggie's Centres work and how the architecture and gardens help their healing activity, might be told. But there is an important lesson that we hope to prove in the near future and it relates, if obliquely, to the work going on in the garden, the interactions between DNA and the cells in which it is nurtured.

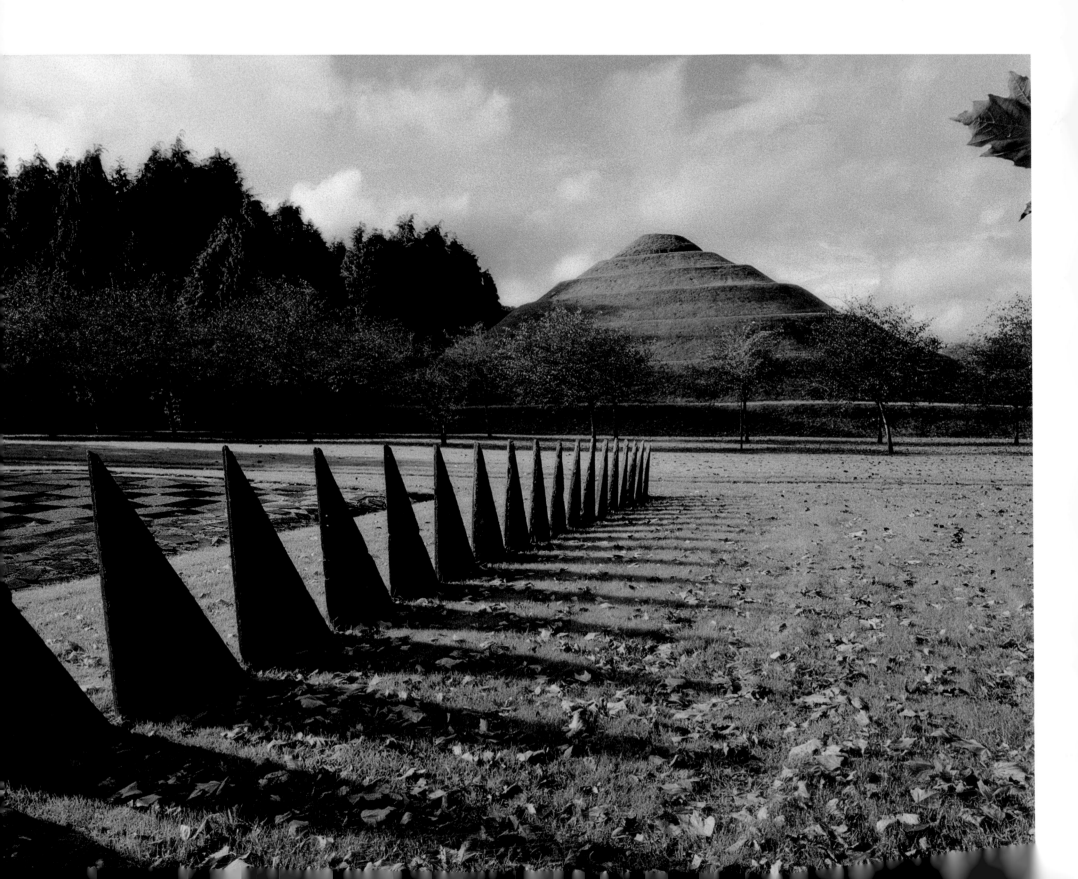

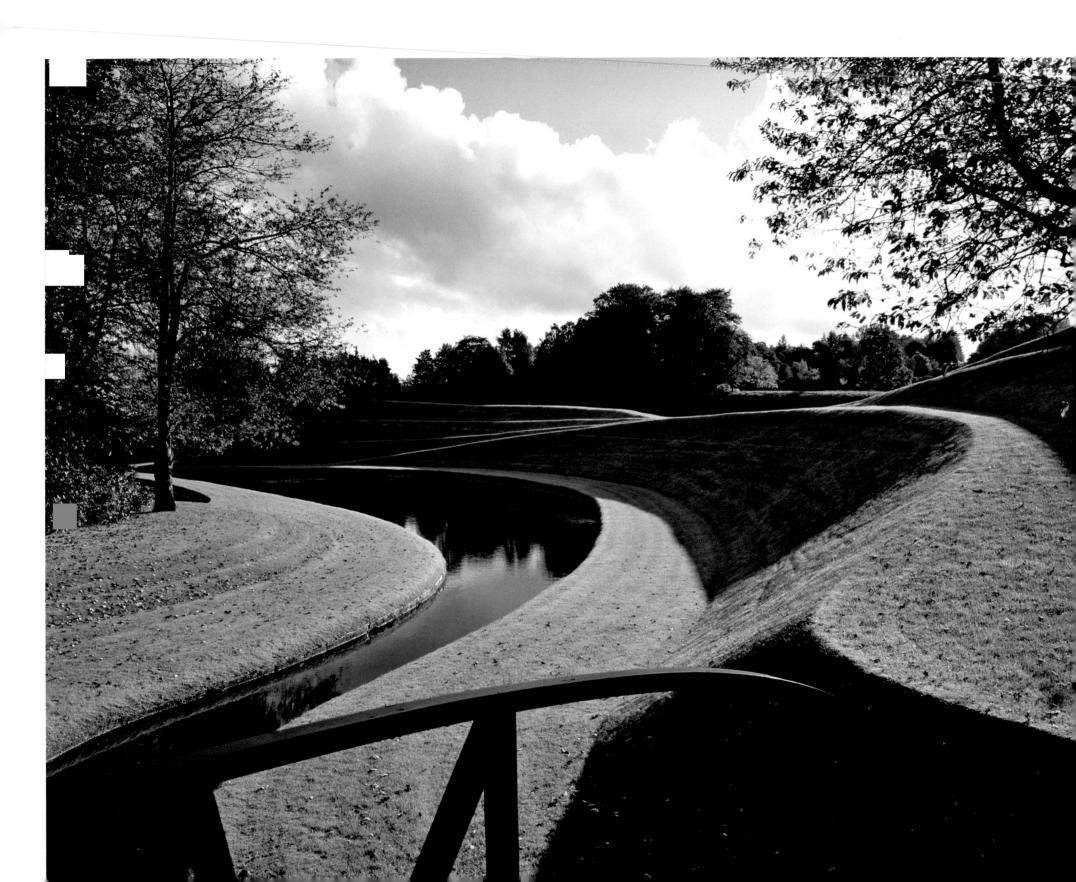

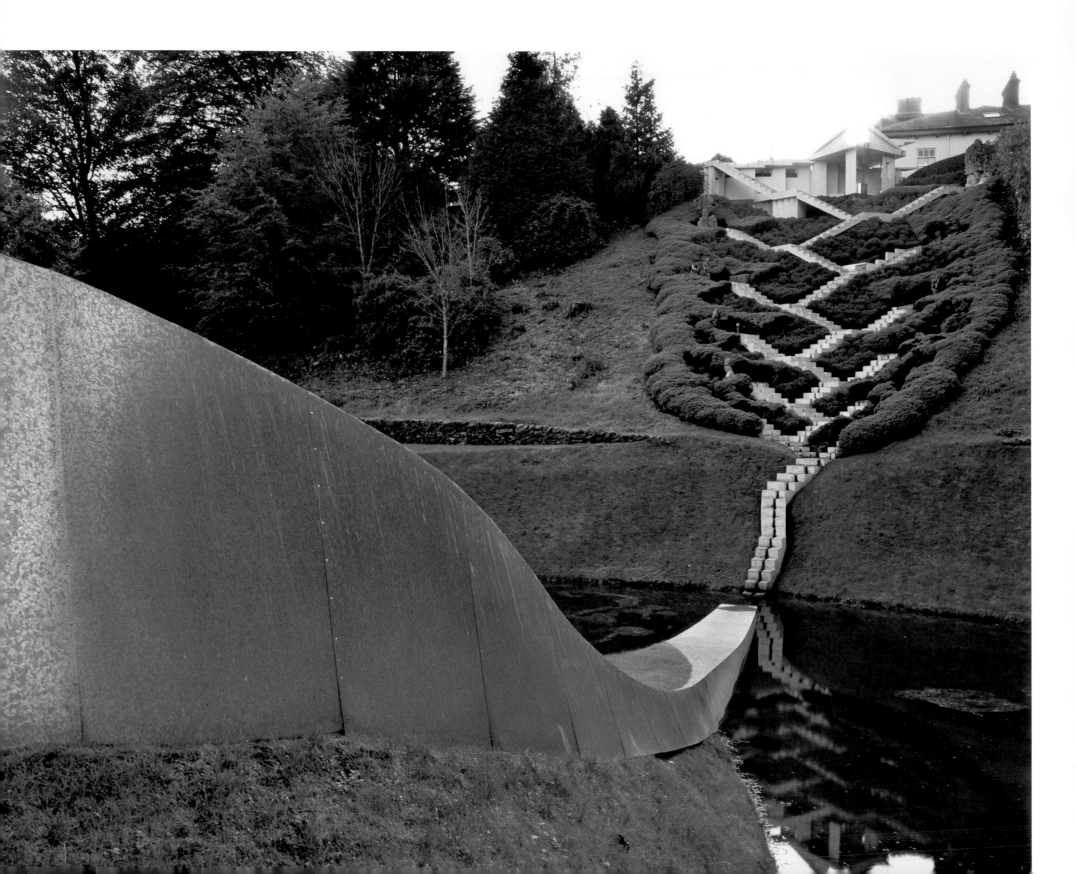

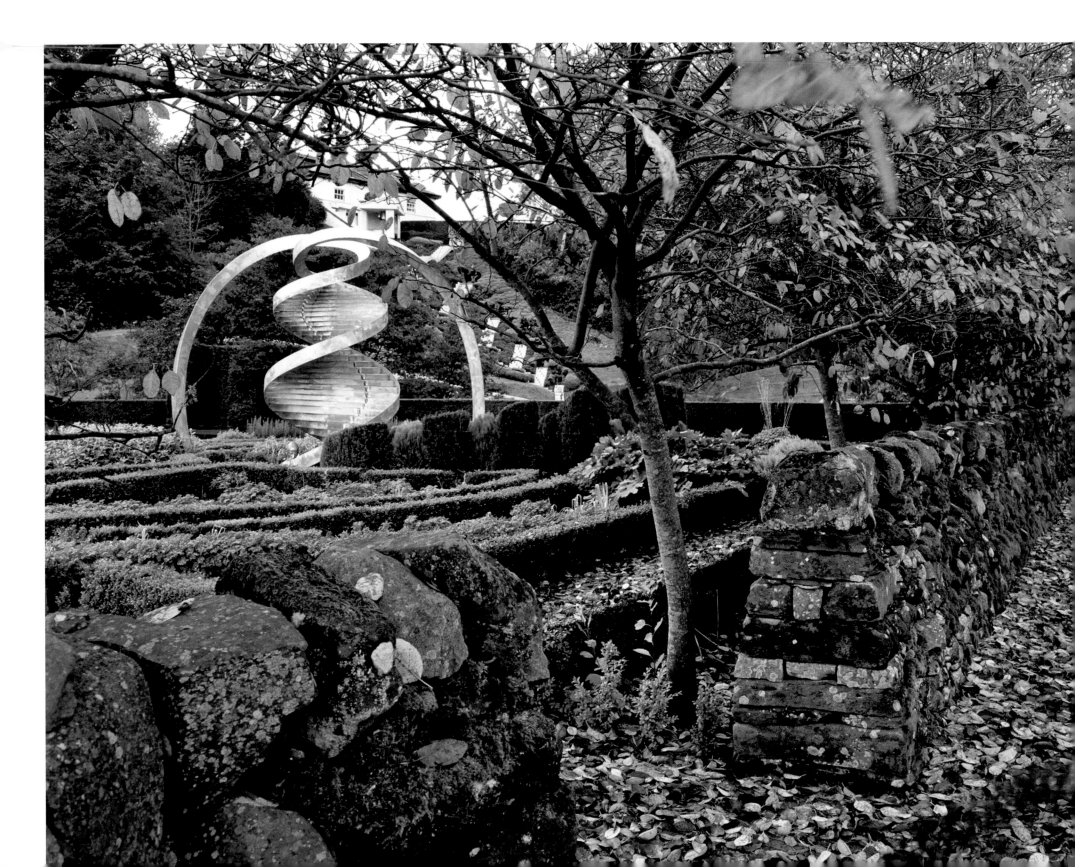

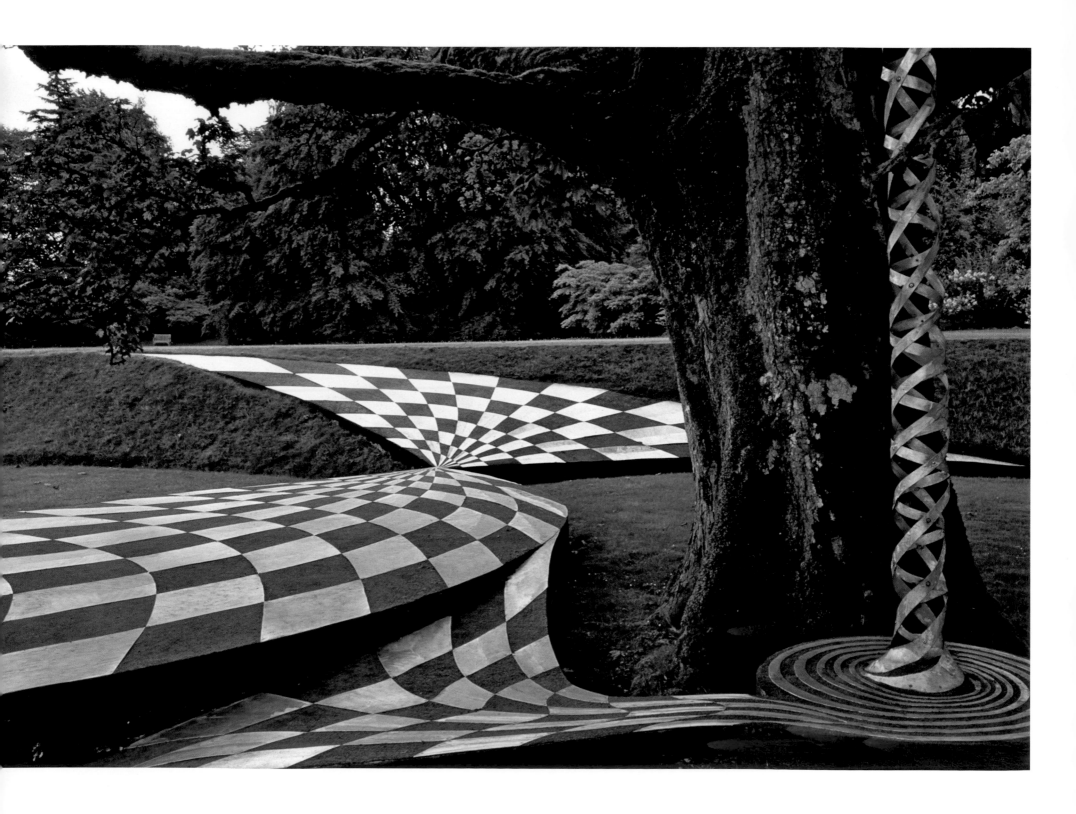

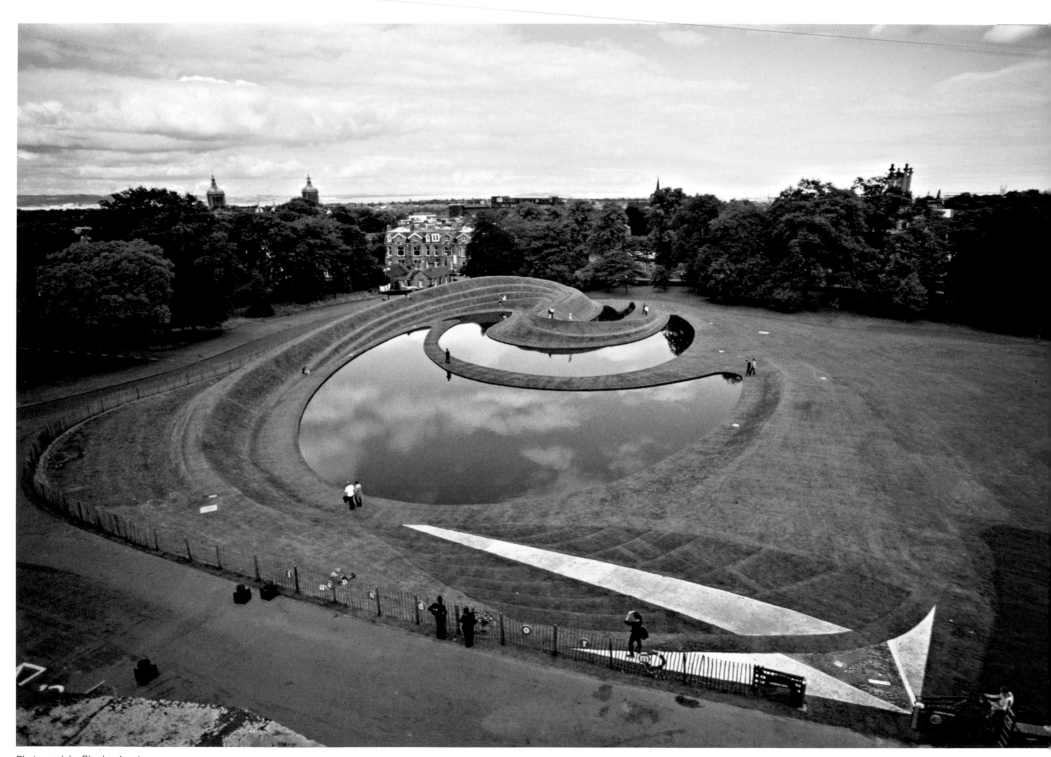

Photograph by Charles Jencks

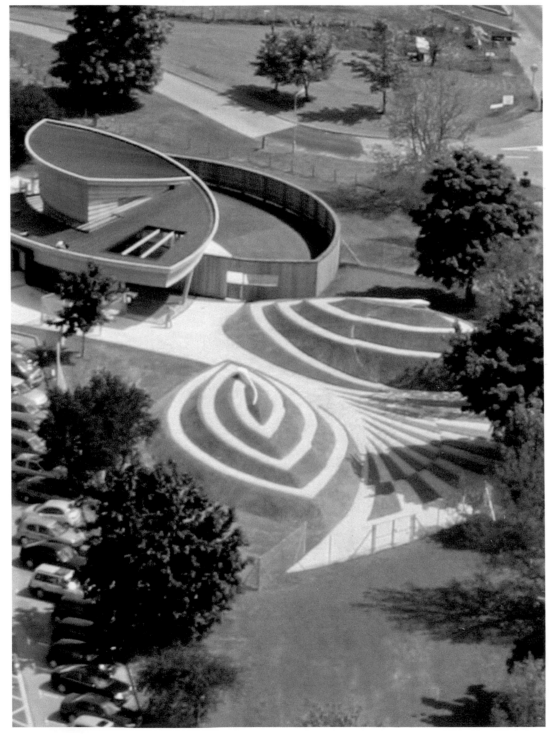

Photograph by Charles Jencks

Zara Milligan

Dunesslin, Dumfriesshire

The garden at Dunesslin has developed largely over the last fifteen years. Before we started work on it, there was nothing to speak of, save for some mature trees, a few large species of rhododendrons and a splendid euchryphia. Initially, structural changes were made, building terraces and a ha-ha, planting hedges and building a large wall to enclose what is now the central part of the garden.

Although the garden was, at an early stage, broken up into a series of rooms or separate spaces, its character has evolved over the years, the development of the planting in one area suggesting ideas for another or expansion into some new area such as the adjoining woodland. My approach is somewhat restless: I am forever thinking of ways in which I would like to improve some aspect or another.

There is a wonderful sense of remoteness and timelessness in the surrounding landscape and it is the scale, shape and in part, the wildness of the hills which enhance the intimacy and seclusion of the garden.

This is epitomised by the individual plants. I just love their beauty and seeing them flourish. Finding a little treasure, such as Anemone trullifolia, returning bravely year after year is what really draws me into the garden when the rain is pouring down.

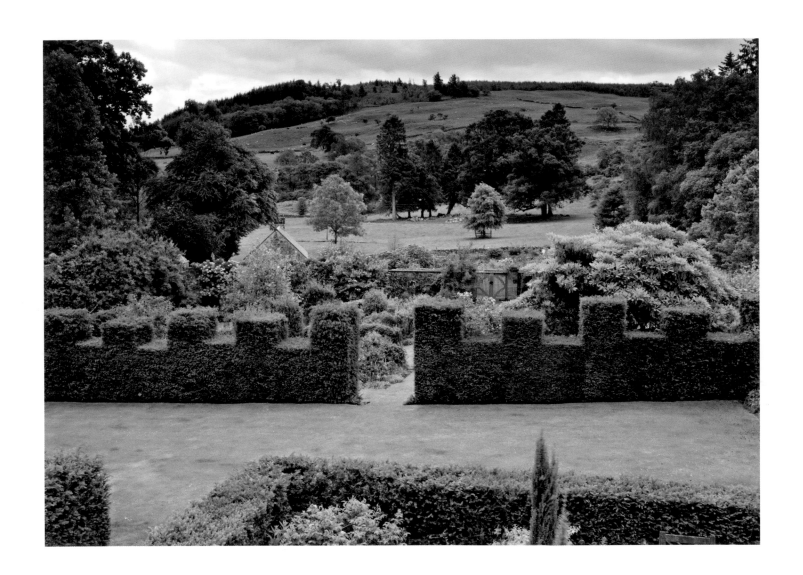

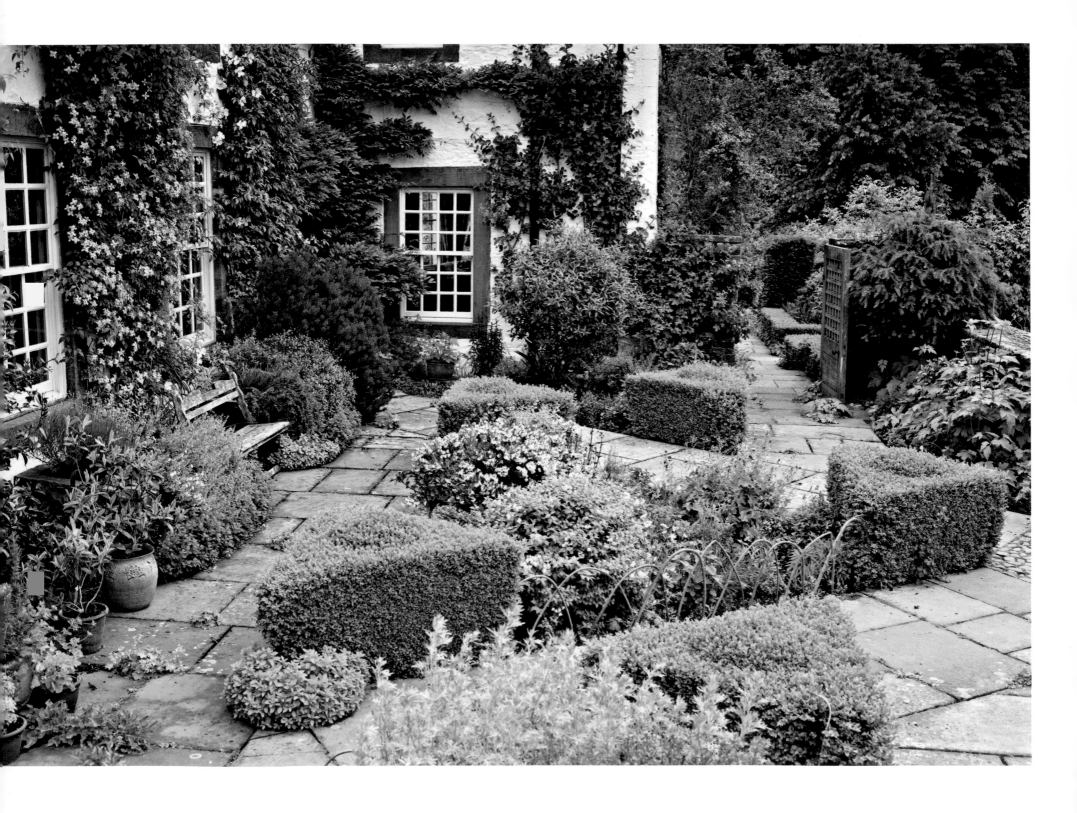

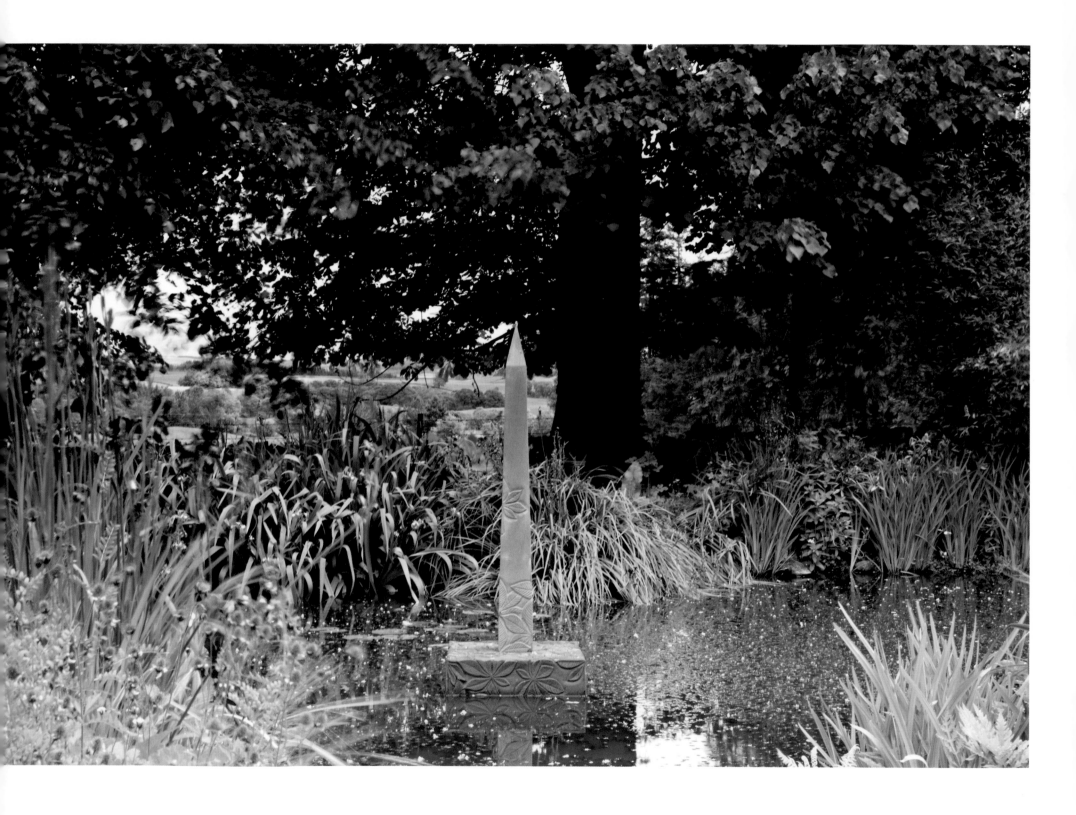

ha-ha by Charles Morris

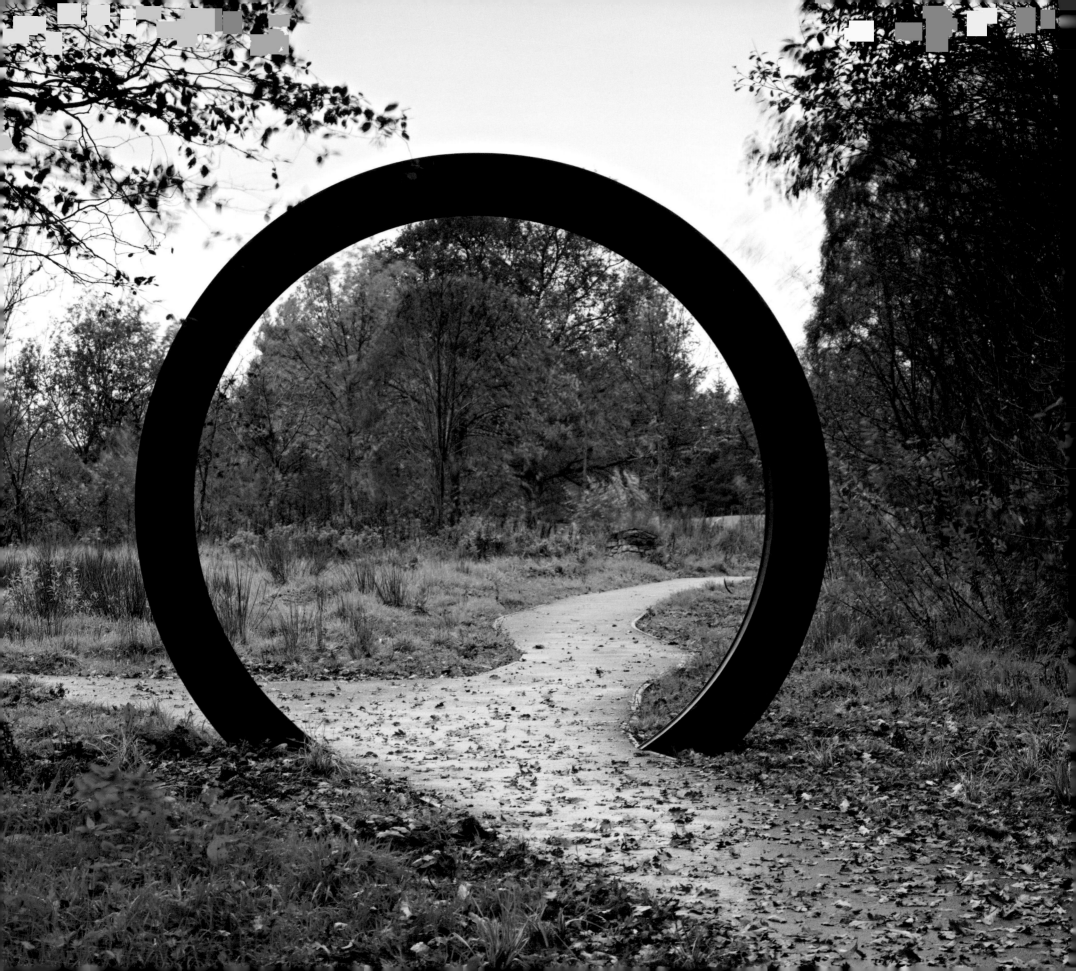

Alec Finlay

The Moon Gate, Springburn Park, Glasgow

WWLetterboxes. The Hill of Streams,
Cairnhead Community Forest, Dumfriesshire

The Woodland Platform and Xylotheque,
The Hidden Gardens, Glasgow

Home to a King, Saint Andrews Botanic Garden,
George Square Gardens, Edinburgh,
The Hidden Gardens, Glasgow

'This is my listening face'

glenjaan burn

dalwhat

dalwhat

fingland burn

dibbin lane

dalwhat

ramscleuch burn

dalwhat

back burn

dalwhat

dalwhat water

dalwhat

dalwhat

dalwhat

lagdubh burn

dalwhat

Worldwide letterboxing. Letterboxing is a hybrid form of hobby walking and rubber stamp collecting. Alec is placing 100 letterboxes at sites around the globe (51 have been installed to date). Each box protects a circle poem. Some of the boxes are sited singly, in locations that are described in guides written by their keepers, some are composed in walks.

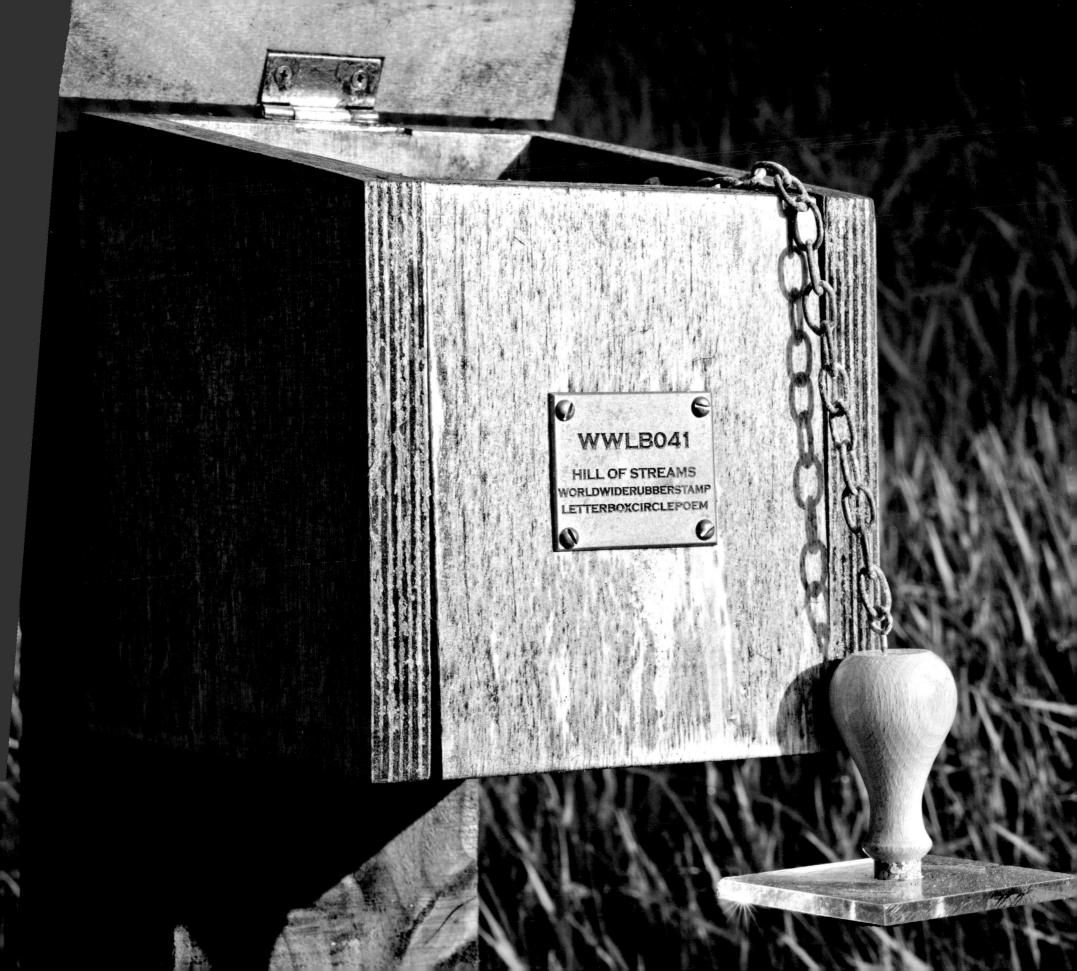

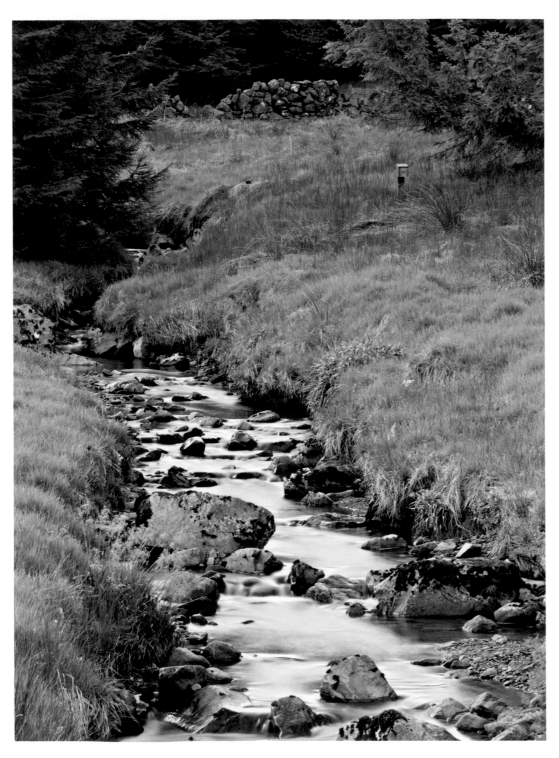

The Hill of Streams.
Alec Finlay and Alexander & Susan Maris.
A letterbox walk by way of seven confluences,
Cairnhead Community Forest (Scotland).

WWLB037 Where Glenjaan becomes Dalwhat
WWLB038 Where Benbuie becomes Dalwhat
WWLB039 Where Conrick becomes Dalwhat
WWLB040 Where Dibbin becomes Dalwhat
WWLB041 Where Lagdubh becomes Dalwhat
WWLB042 Where Back becomes Dalwhat
WWLB043 Where Fingland becomes Dalwhat
WWLB044 Where Ramscleuch becomes Dalwhat

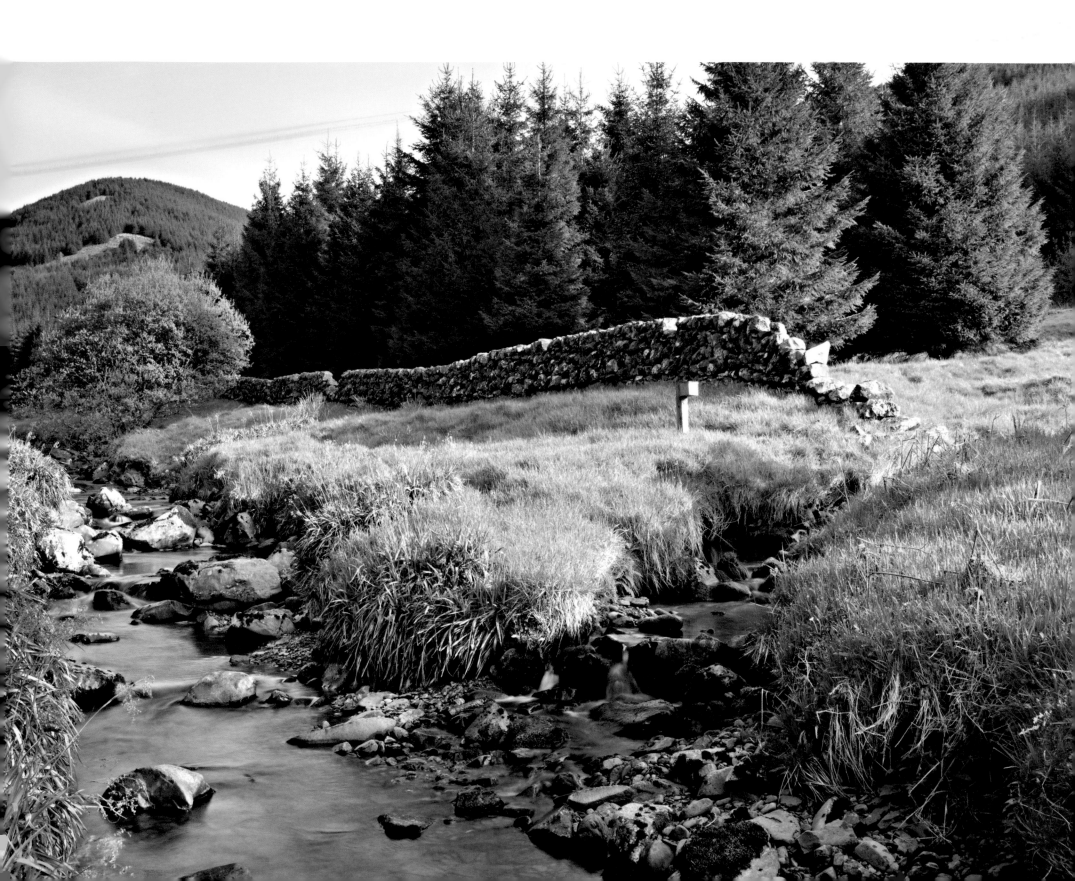

Home to a King (3)
Alec Finlay (2006-)
The names of trees embedded
within crossword clues, painted
on nest-boxes, colour specified
to a leaf of their host species;
sites at locations throughout the
British isles.

A clue is a form of camouflage.

What we hide is revealing.

An answer is not always
a solution and a solution
is not always an answer.

A poem is coded language.

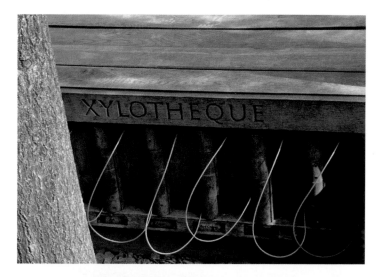

The Woodland Platform
and Xylotheque

The Hidden Gardens Glasgow

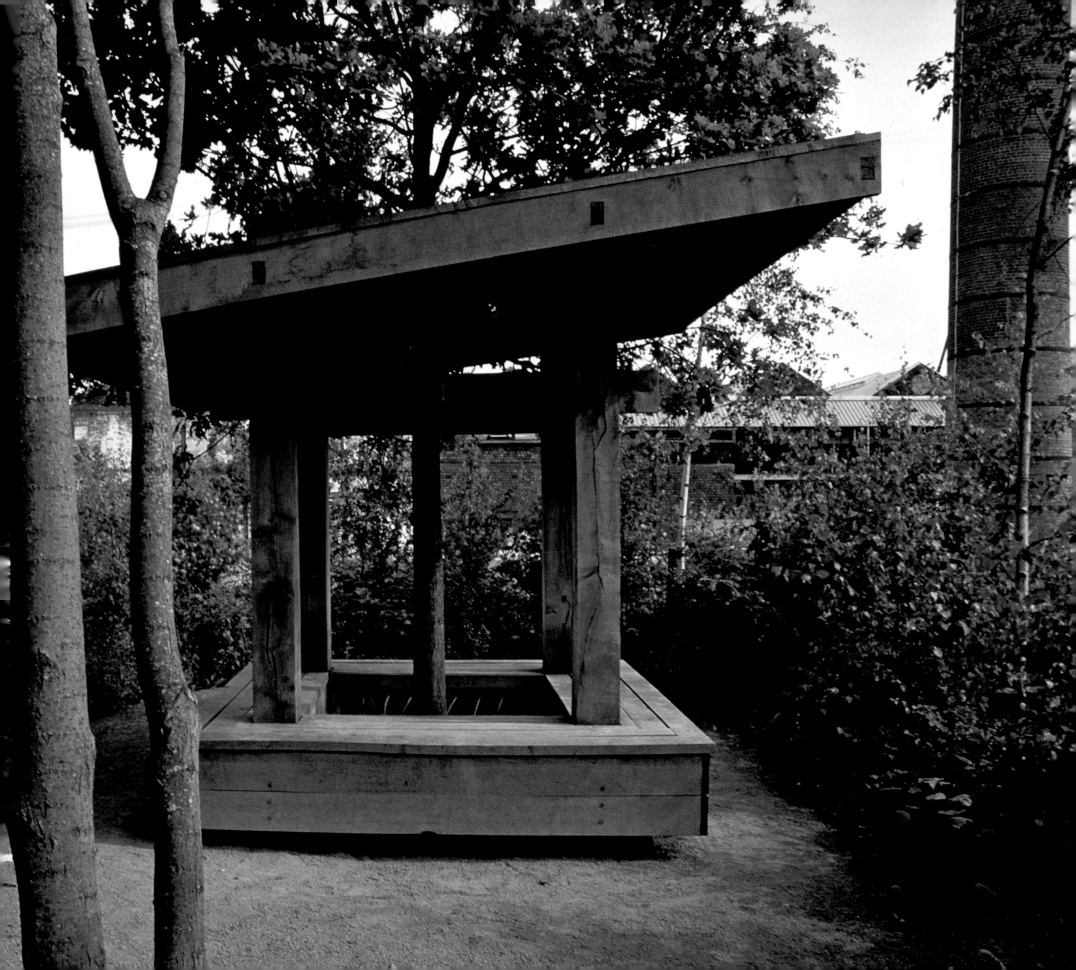

Douglas Coltart

New Lanark Roof Garden and private garden, Ayrshire

The rich and varied landscape of Scotland provides a wonderful backdrop to its cities and gardens. Designers usually strive to bring a sense of place into their gardens; however, in Scotland it is often hard to escape the dramatic character of the landscape that envelops our cities and homes. Scottish cities can never be viewed in isolation from their surrounding landscapes as many have squeezed themselves in to the often rugged terrain of Scotland.

One of the biggest challenges as a designer – when faced with a land or cityscape filtering back towards the house – is restraint. Often the key is not to compete with the surrounding views but to blend seamlessly into them. This does not mean that designs have to be watered down and bland but merely that they do not fight with their surroundings. Whether gardens are classic or modern in style, they can all sit within naturalistic or urban contexts; they simply require a careful use of planting or material choice to unite the two.

In Scotland, the weather is never very far away from anyone who has a garden, whether in a city or out in the countryside. As a designer it is often part of the brief for the garden to mitigate the effects of one extreme or another. Huge volumes of rain or ferocious winds do bring problems and they also constrain briefs to such an extent that they require a great deal of thought and consequently often produce more imaginative designs. Even when extremes are not present, the constantly shifting pattern of weather brings an ever-changing dimension to spaces, even when viewed from indoors.

As well as the landscape and weather, it is the owners of the gardens who shape their designs. The best garden designs are achieved by working closely with the owners throughout the design process. Only by understanding what makes a client tick can you design a garden that ticks all of their boxes. Designing spaces that work for the way in which owners want to live means that you have to gain an insight into the lives of many people. As such, relationships often carry on long after the physical completion of the project. This is one of the nicest things about the job. Garden design clients are a great bunch of people who either love their external environment or tend to be passionate about plants.

The people of Scotland tend to understand the benefits of good design and have a huge appreciation of the landscape. Ultimately, that is what it is all about. It is never to impose and stamp a garden into a space and onto its owners or users. It is to work with them and their surroundings to create spaces that are loved.

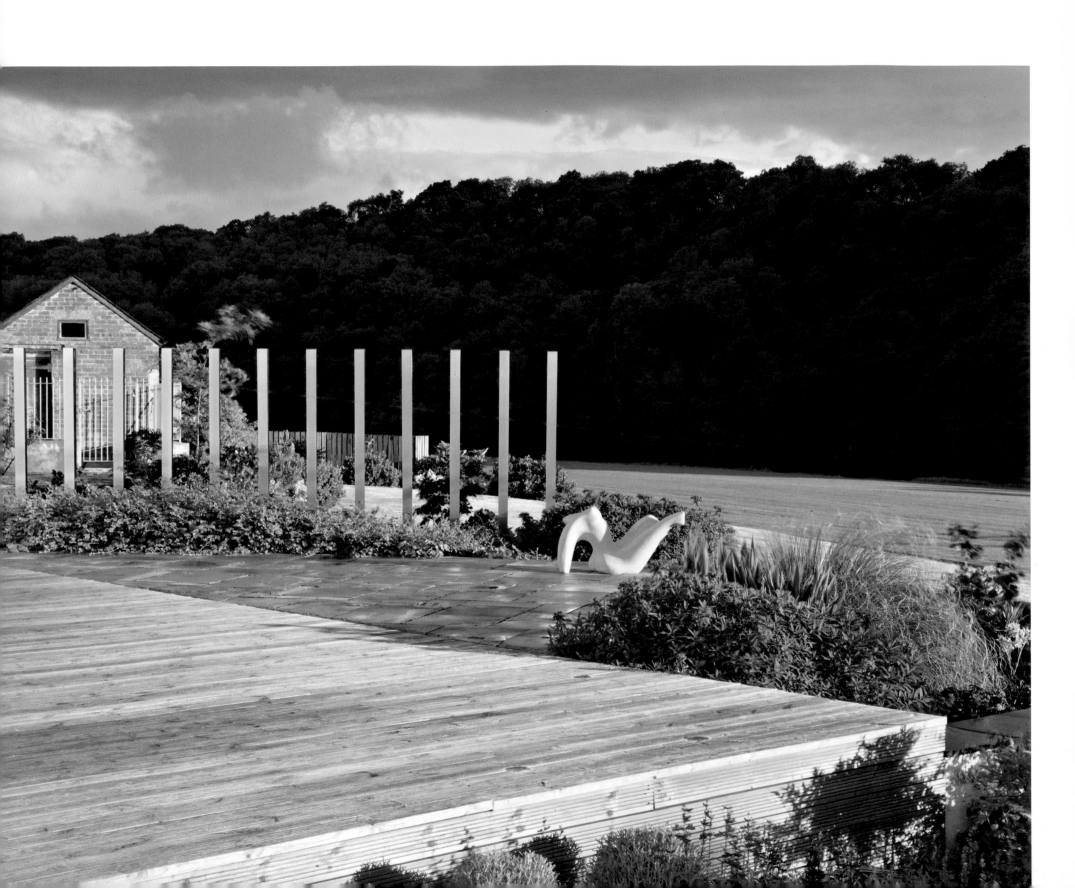

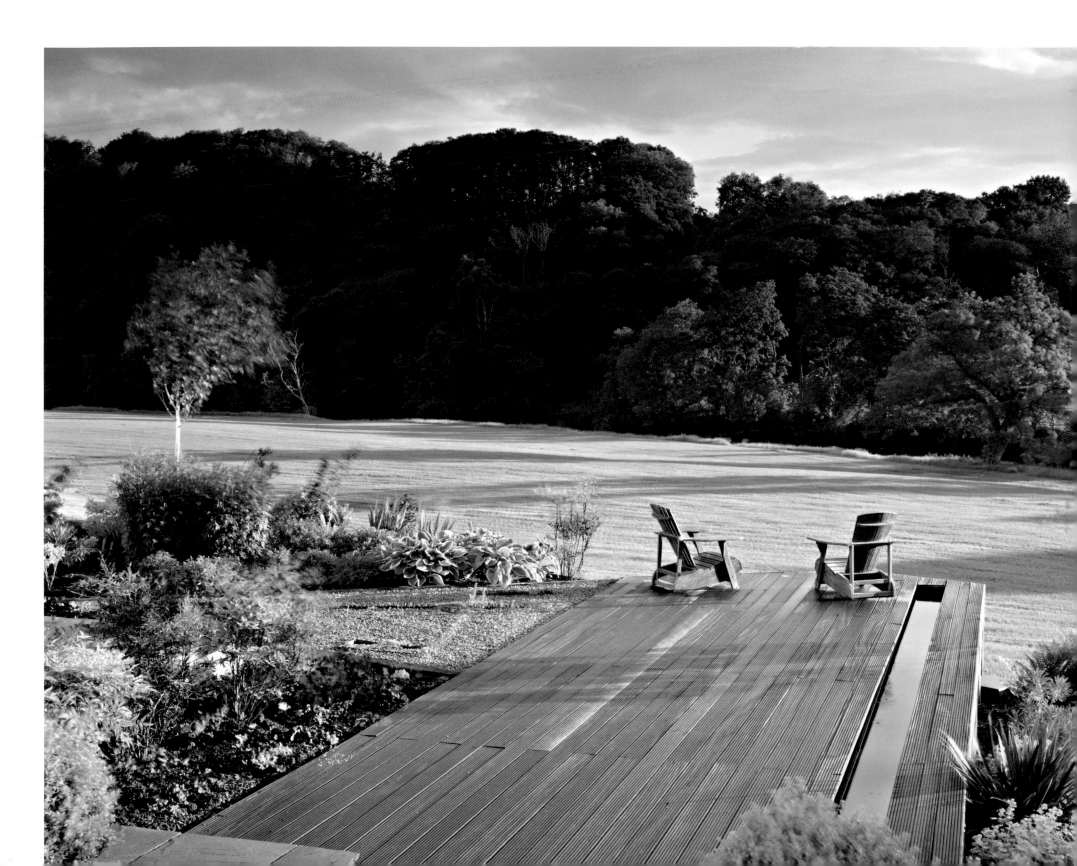

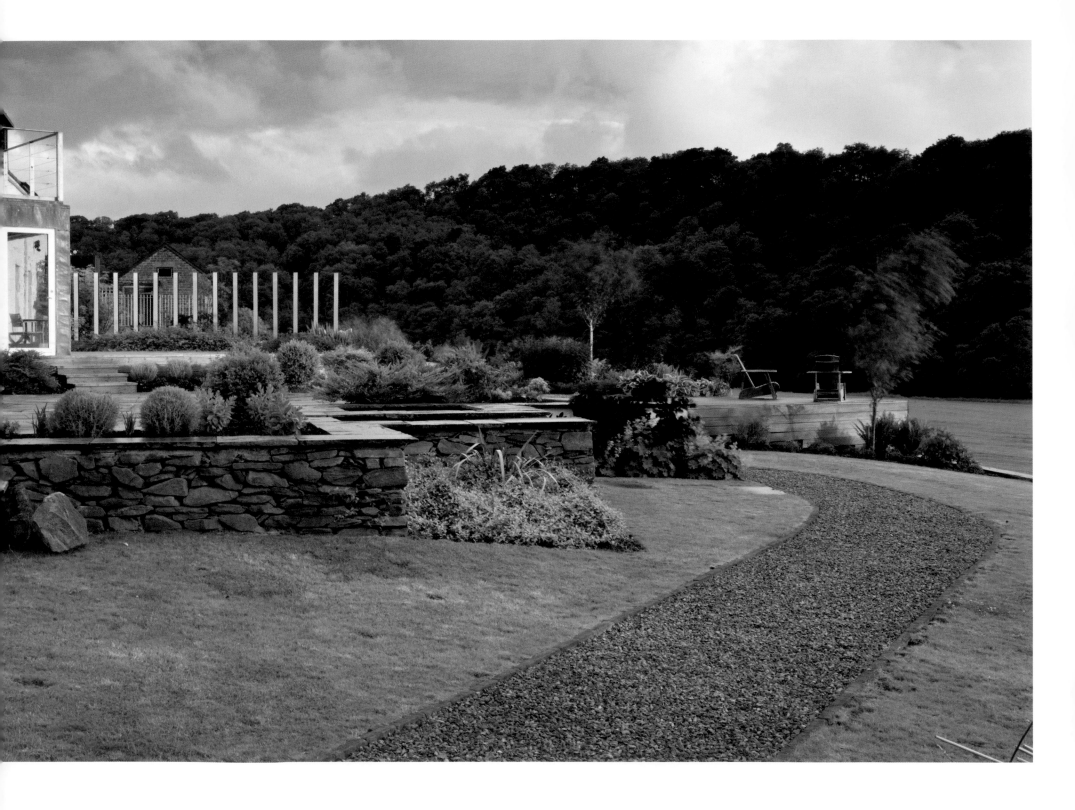

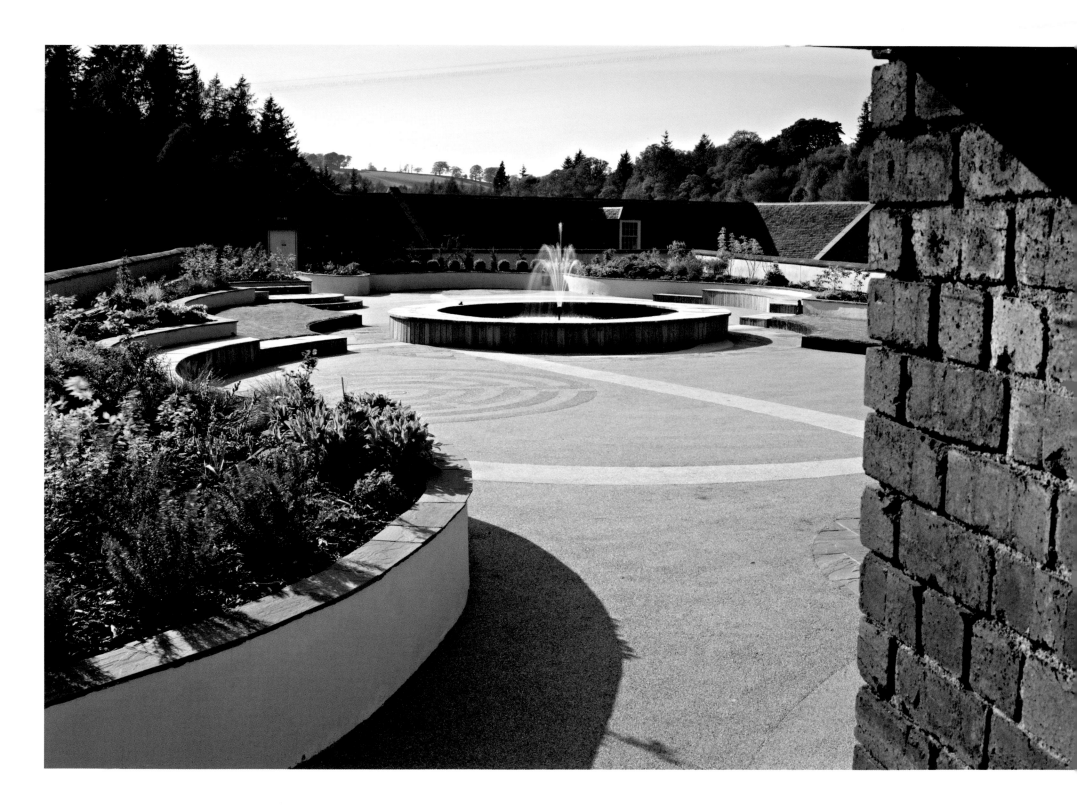

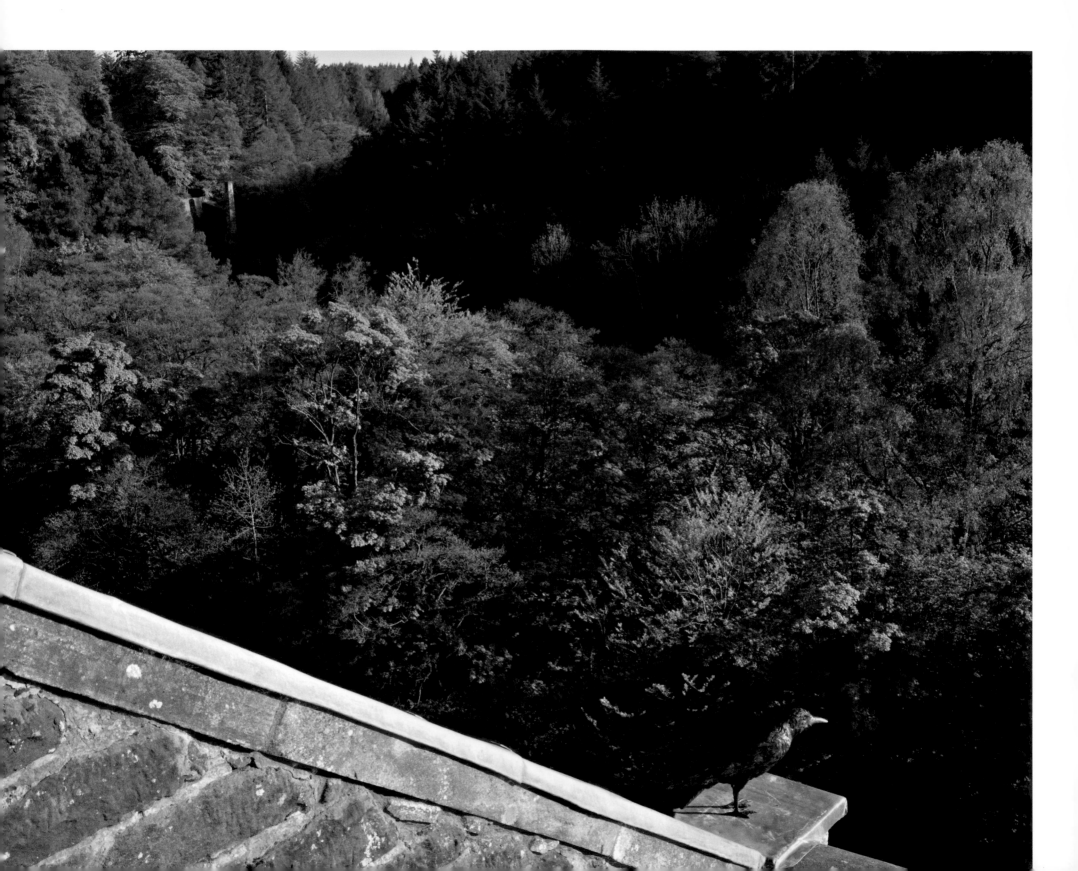

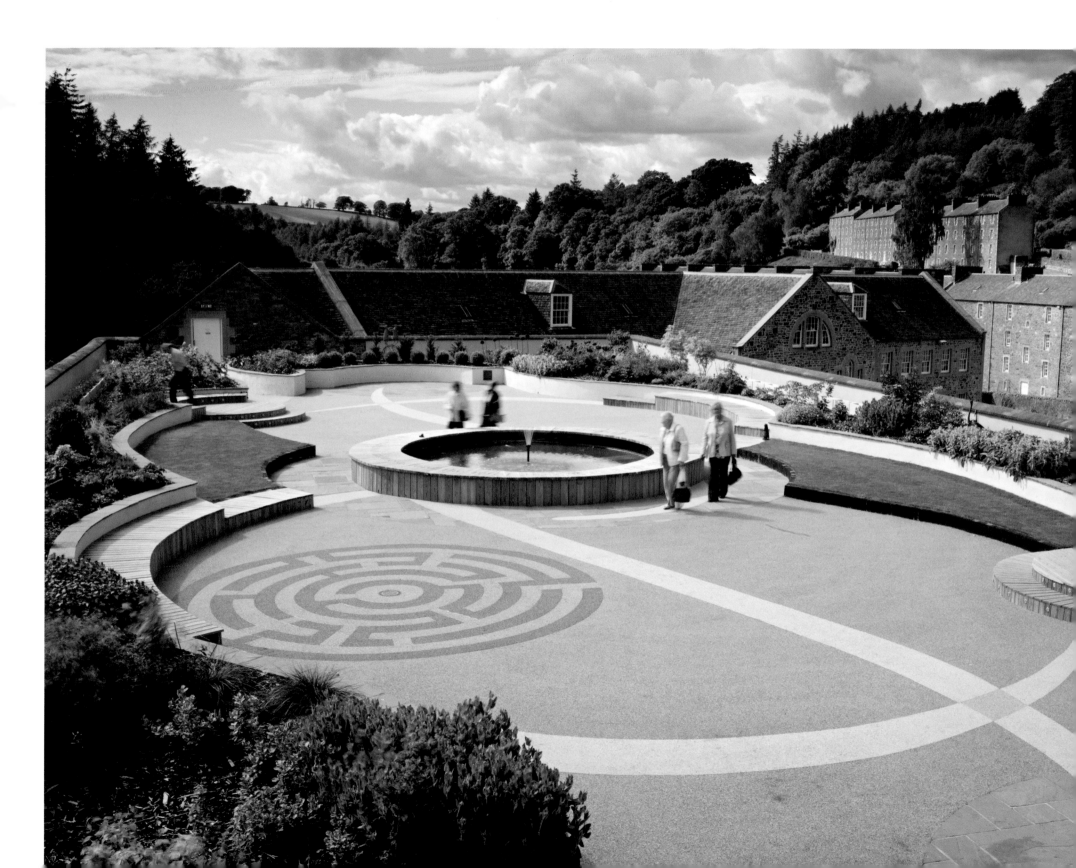

Ian Hamilton Finlay 1925–2006

Nicky Wilson & Robert Wilson

Bridget Baines, Eelco Hooftman & Nigel Sampey

Rolf Roscher & Chris Rankin

Andy Sturgeon

James Alexander Sinclair

Peter Cool

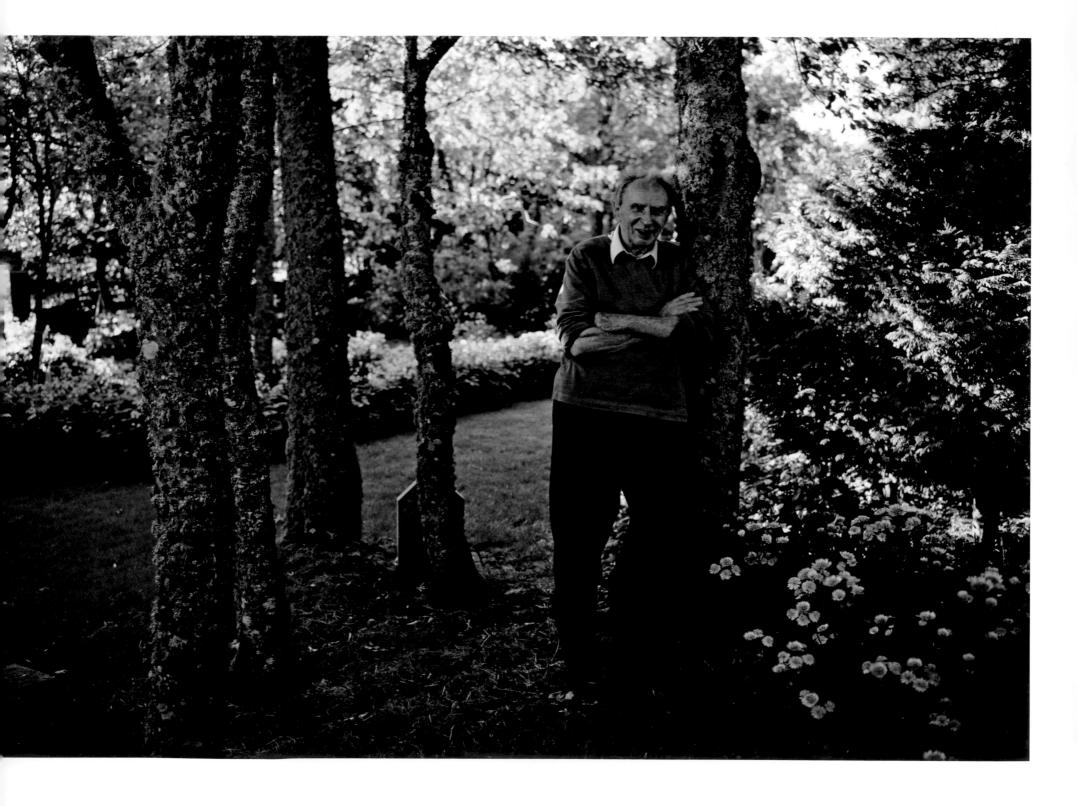

Ian Hamilton
Finlay 1925–2006

Little Sparta, Lanarkshire

Also see Jupiter Artland pages
102, 103, 106, 107, 112, 113, 264

Superior gardens are composed of glooms and solitudes and not of plants and trees.

Lights
the lights of Paimpol
the lights of Concarneau
the lights of Le Conquet
the lights of Roscoff
the lights of Ouessant
the lights of Walston
shine in the rain

for Ailie

By day Walston is a landlocked village
on the hillside opposite the author's home.

The moor of routine nests the lark.

Ripple, n. A Fold.
A Fluting of the Liquid Element

Trees are preserved by manners, not by economy wrappers.

A WATERLILLY POOL
h'arbour.

Inscriptions are the best part of a garden as decals are the best part of Airfix kits.

A rose is a rose is a rose
GERTRUDE JEKYLL

Arrows are arrows are arrows
HERACLITUS

a rose is a rose an

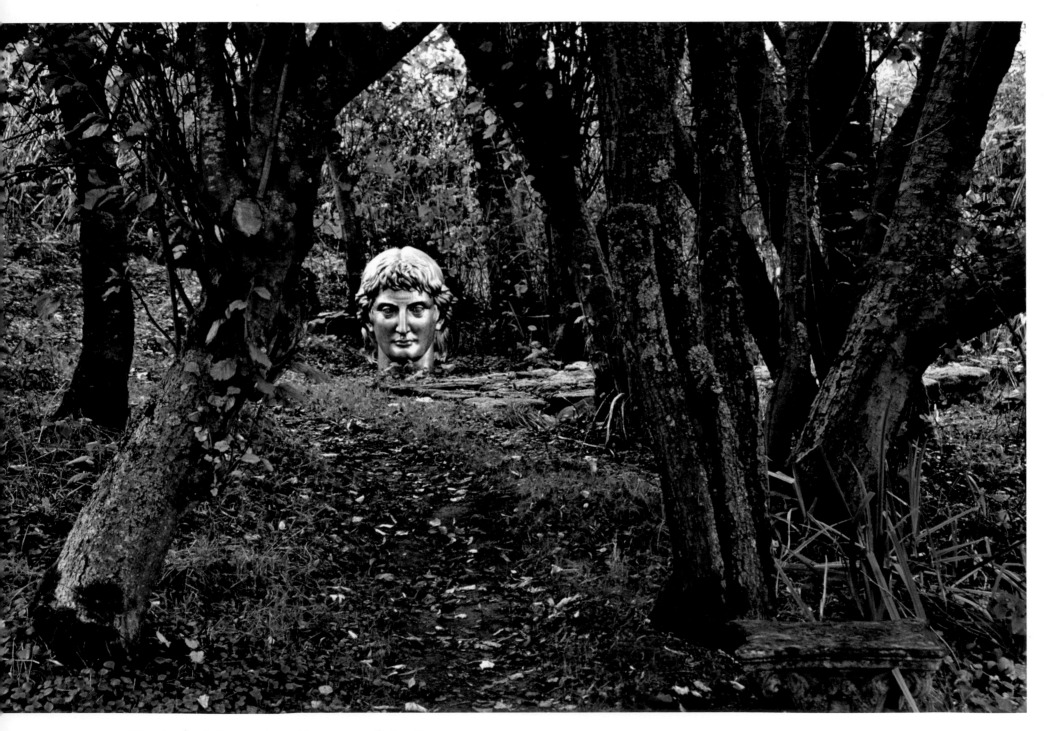

He Spoke Like an Axe. Barere on Saint-Just.

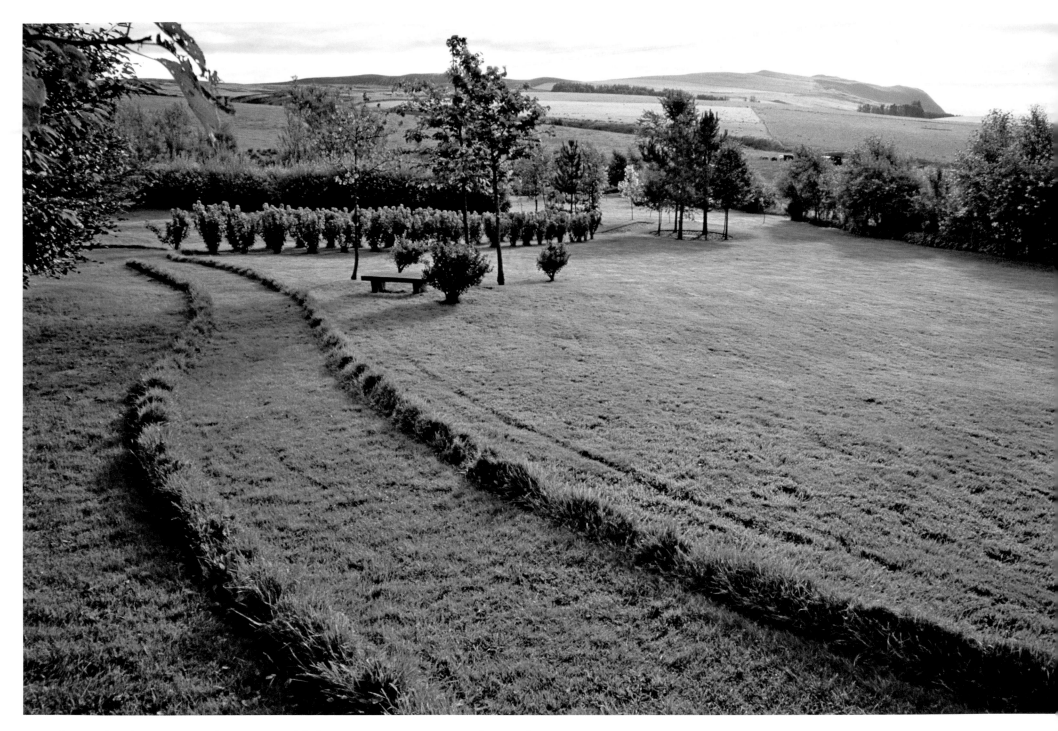

On the path of language there are wild flowers: consonants and vowels.

Nicky &
Robert Wilson

Jupiter Artland, Edinburgh

With works by:
Charles Jencks, Ian Hamilton Finlay, Andy Goldsworthy,
Marc Quinn, Peter Liversidge, Anish Kapoor, Antony Gormley,
Laura Ford, Shane Waltener

Jupiter Artland at Bonnington house is first and foremost a family home. Very simply, it is the trinity between art, land and the family that we hope have created an environment that nurtures the art and draws the underlying power of the land into a series of intense spaces. We open to the public for the summer because we are energised by others' enthusiasm and enjoyment and as mere guardians of the space we think it is frankly selfish not to. But, I admit it is the quiet of the dawn at the giant Orchid by Marc Quinn with the Pentlands in pink behind or the Jencks in the snow, iced like a Christmas cake or Stone Wood in deep autumn that take my breath away. These pockets of beauty are what the landscape seems to relish with new vistas, treelines and shadows being created.

It is high maintenance but worth it. The summer purrs with grass cutters and disembodied voices but the once derelict landscape has a purpose now. I feel that it likes being appreciated. Planting is deliberately simple and the tapestry of plants is in the main by accident, hopefully leaving the onlooker with an appreciation of the simplicity and honesty of the work. We are lucky to have commissions by Antony Gormley, Anish Kapoor, Andy Goldsworthy and the late Ian Hamilton Finlay alongside younger, newer artists. We hope our beloved landscape will be interpreted over and over again by fresh eyes.

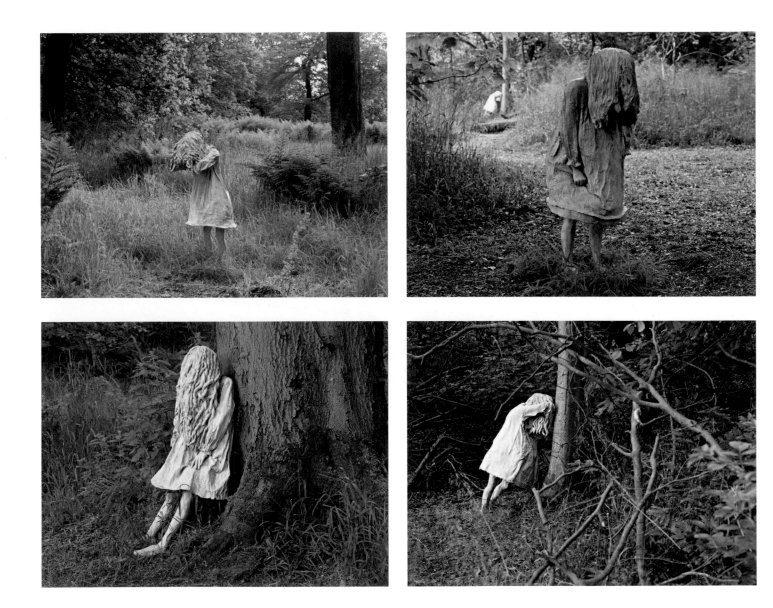

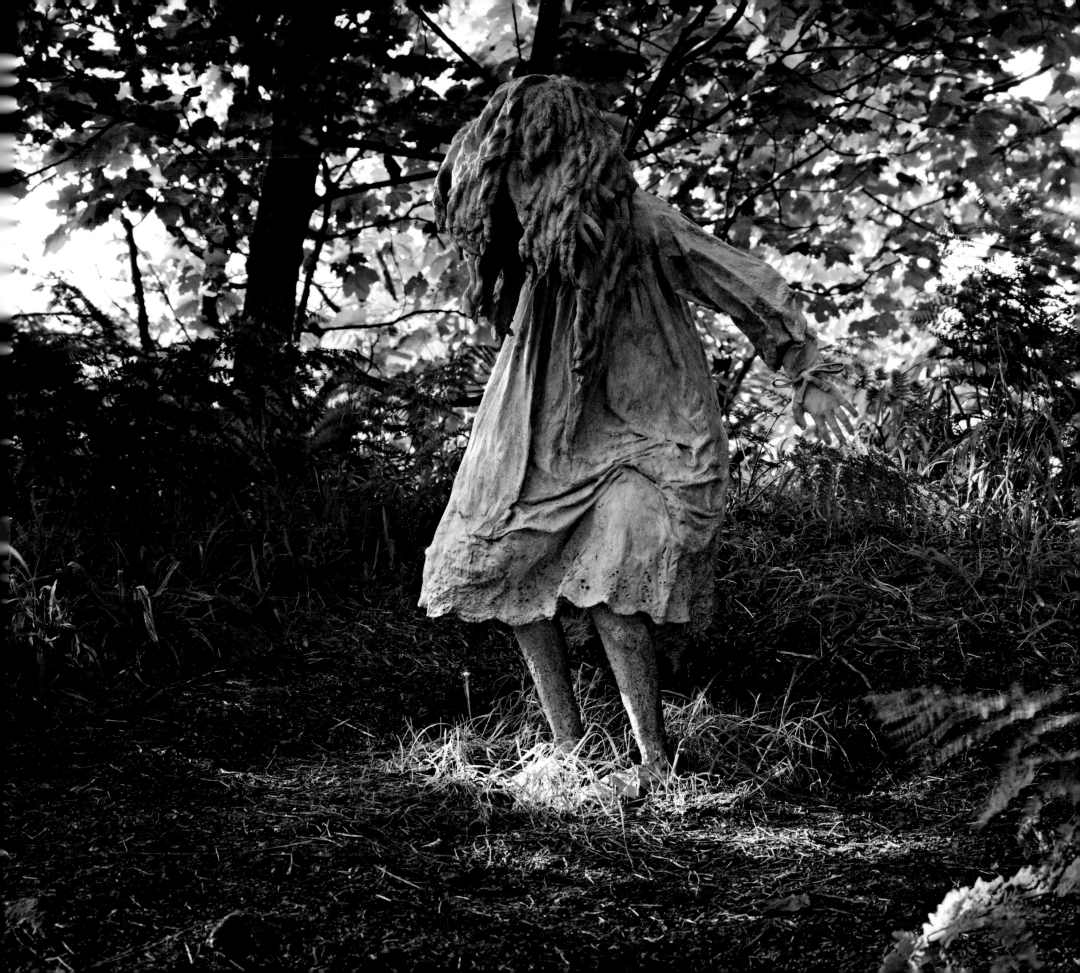

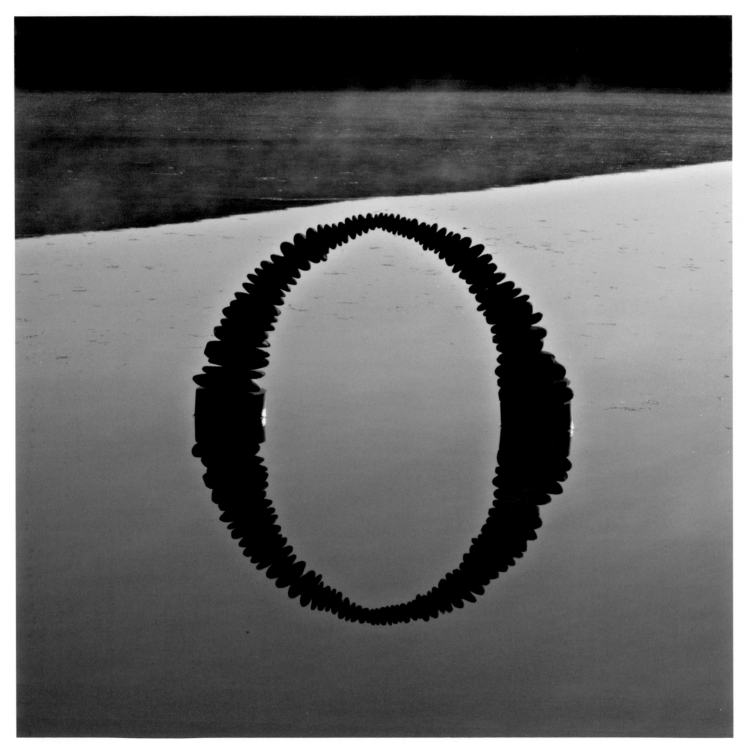

'Cells of Life'
Eight landforms and a connecting causeway surround four lakes and a flat parterre for sculpture exhibits. The theme is the life of the cell, cells as the basic units of life, and the way one cell divides into two in stages called mitosis (presented in a red sandstone rill). Curving concrete seats have cell models surrounded by Liesegang rocks. Their red iron concentric circles bear an uncanny relationship to the many organelles inside the units of life. From above, the layout presents their early division into membranes and nuclei, a landform celebration of the cell as the basis of life. From above the layout of the mounds and water presents the early division into 8 cells and their membranes inside the units of life, thus creating another link between the microcosm and macrocosm.

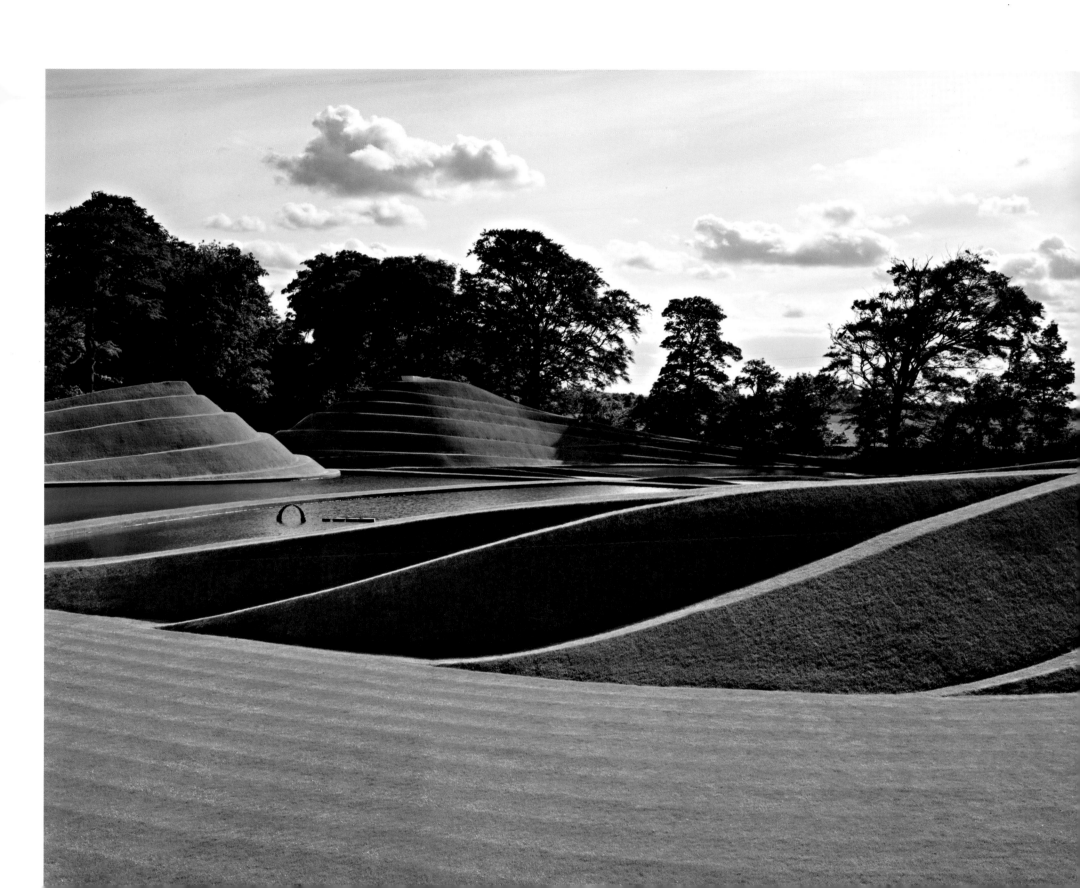

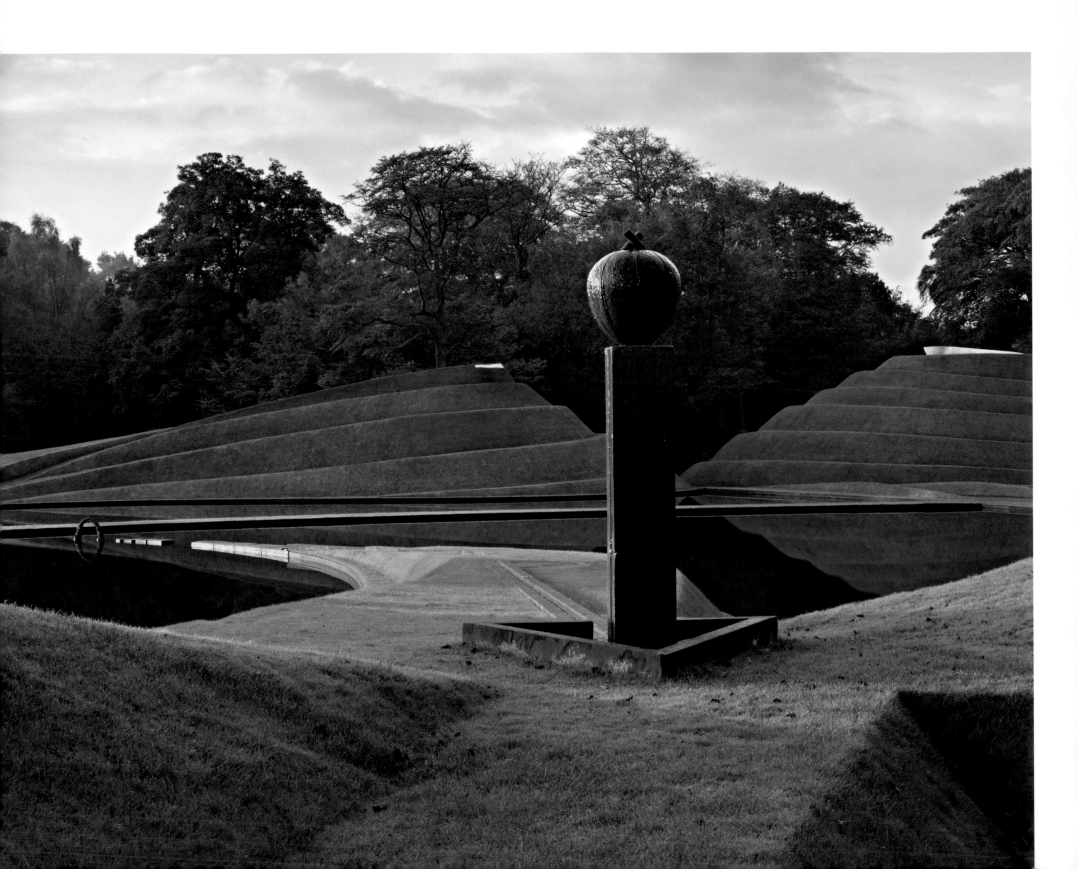

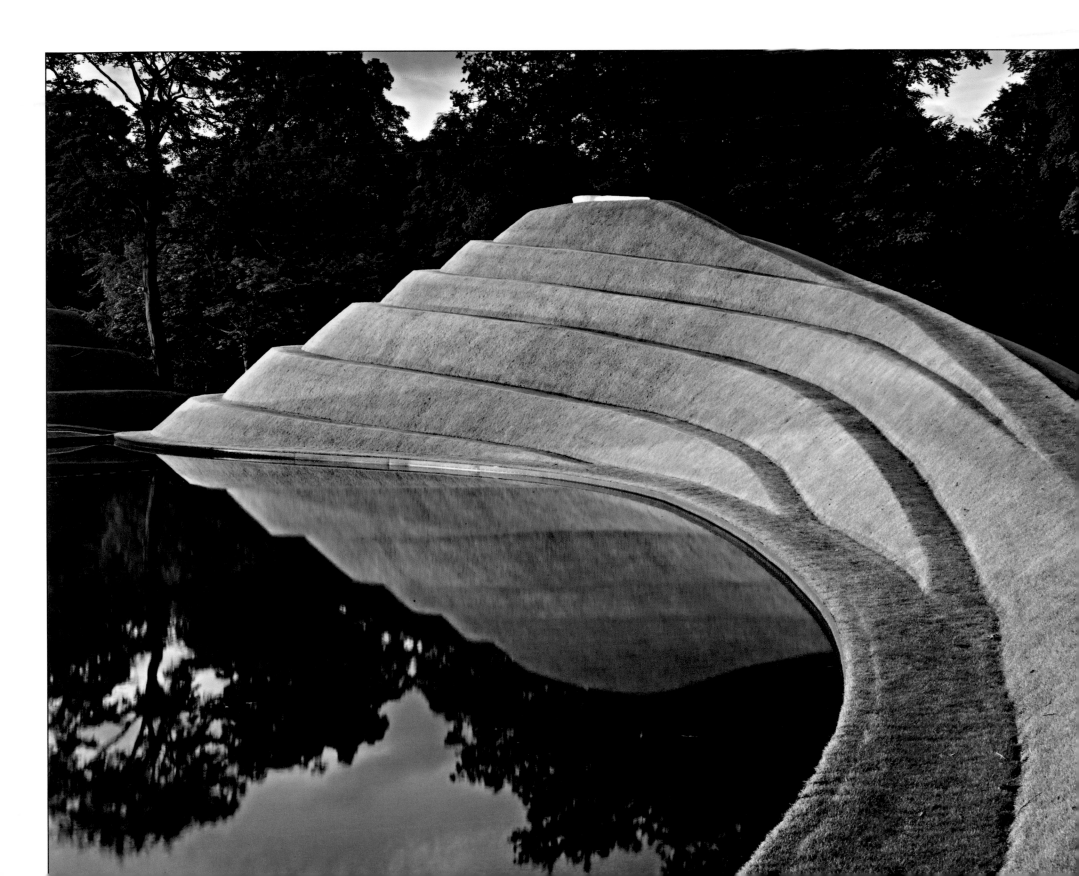

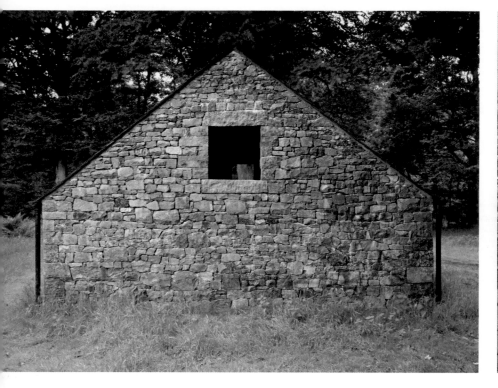

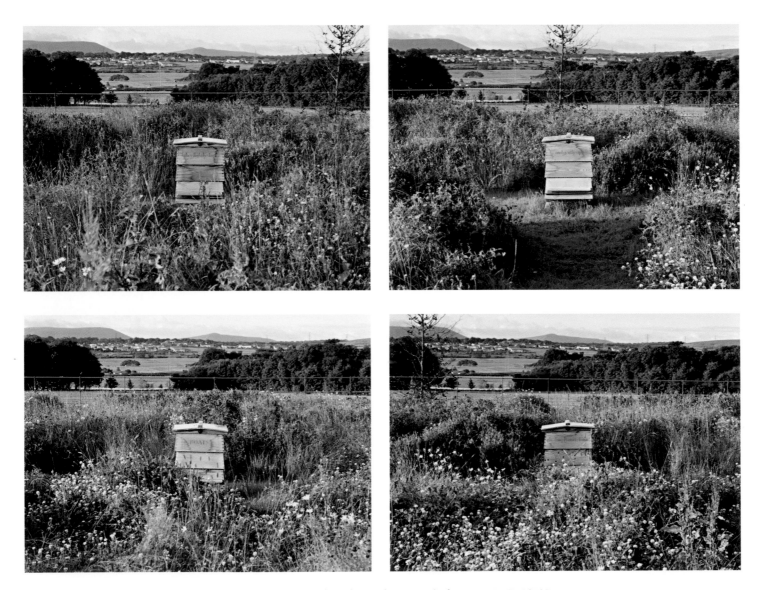

BEES; they lightly skim; and gently sip; the dimply river's brim; BOATS.

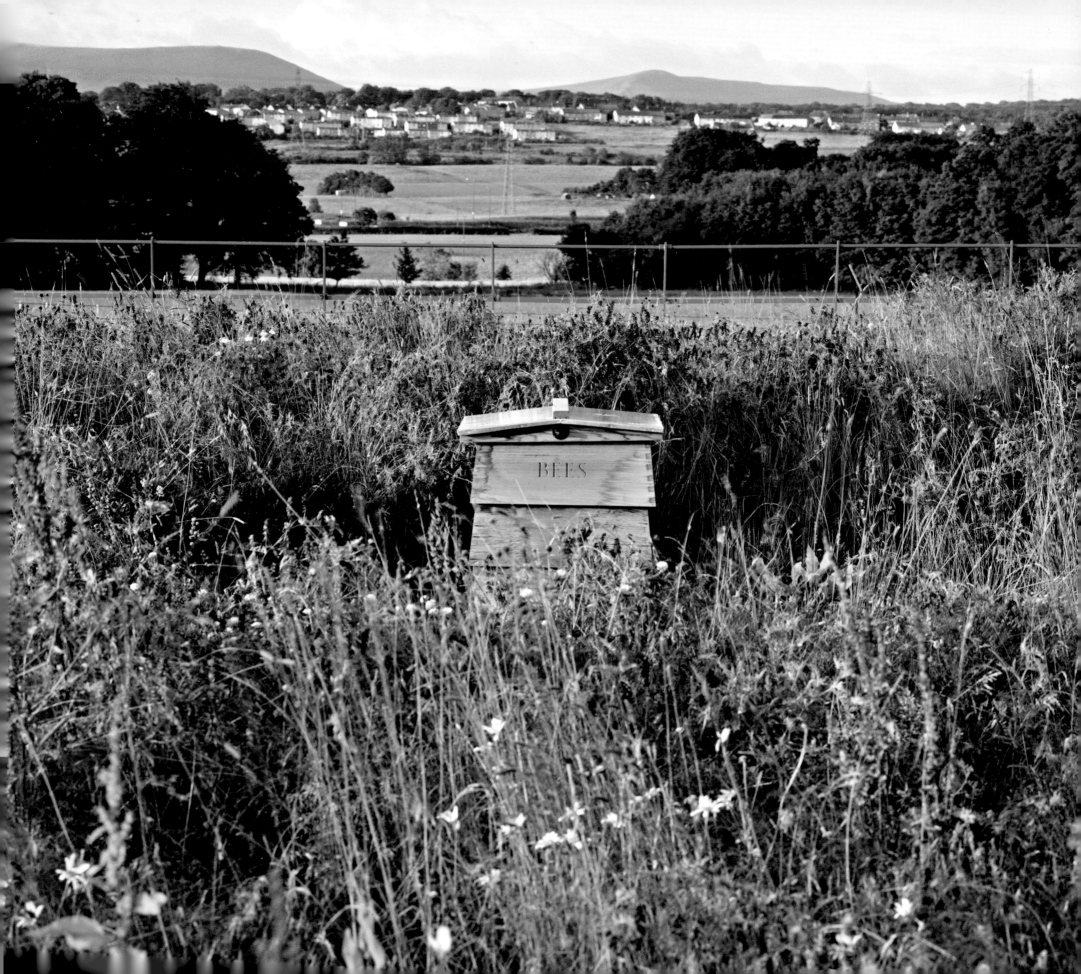

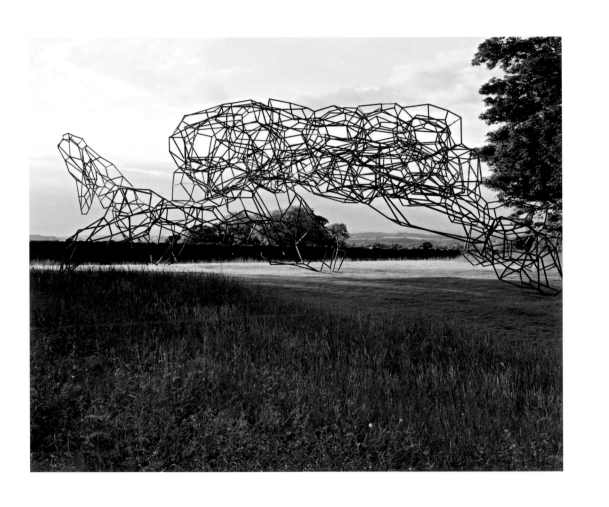
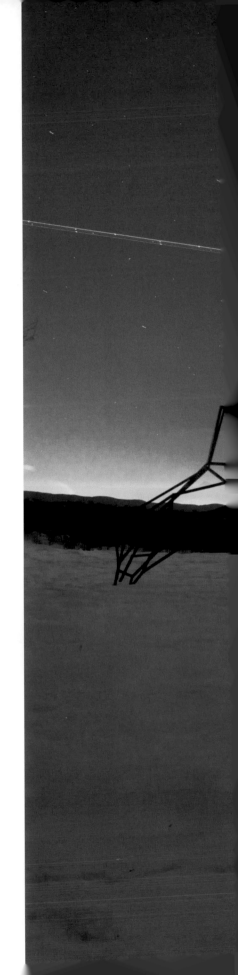

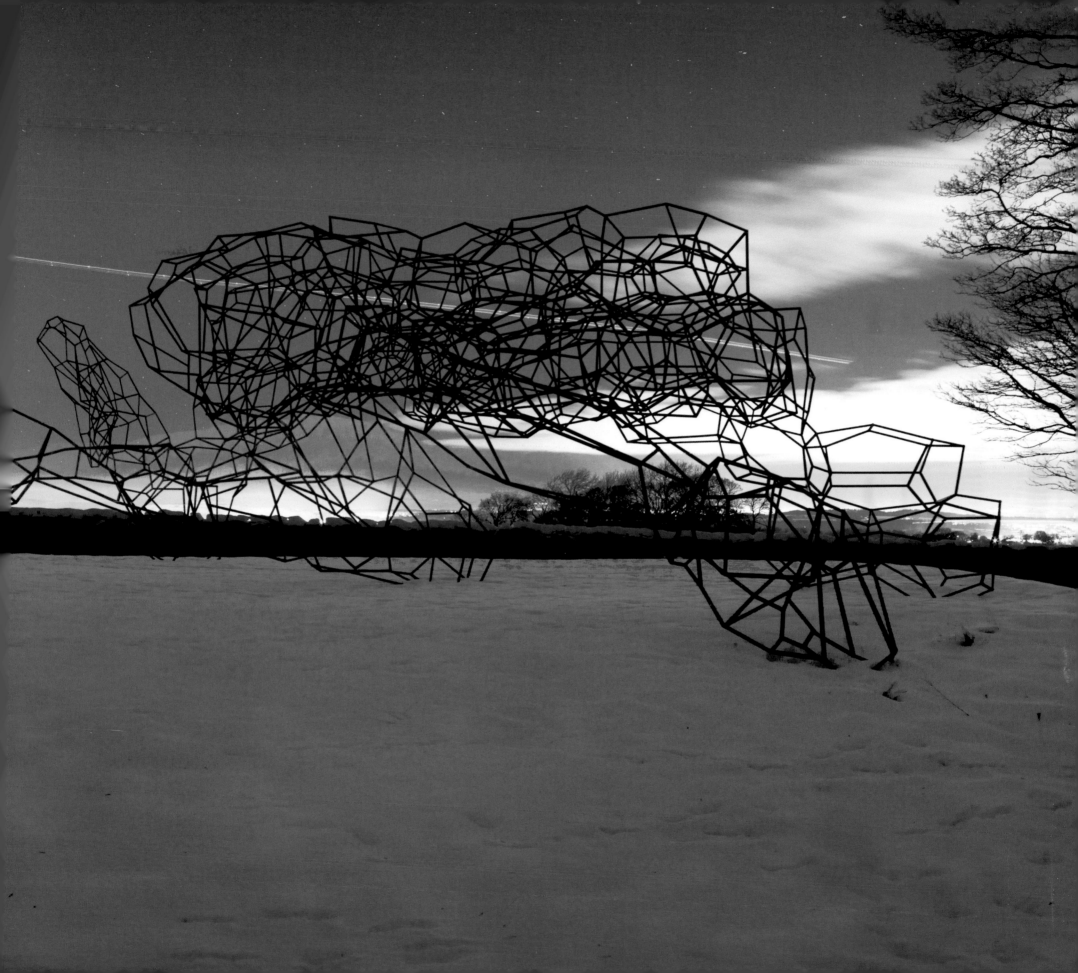

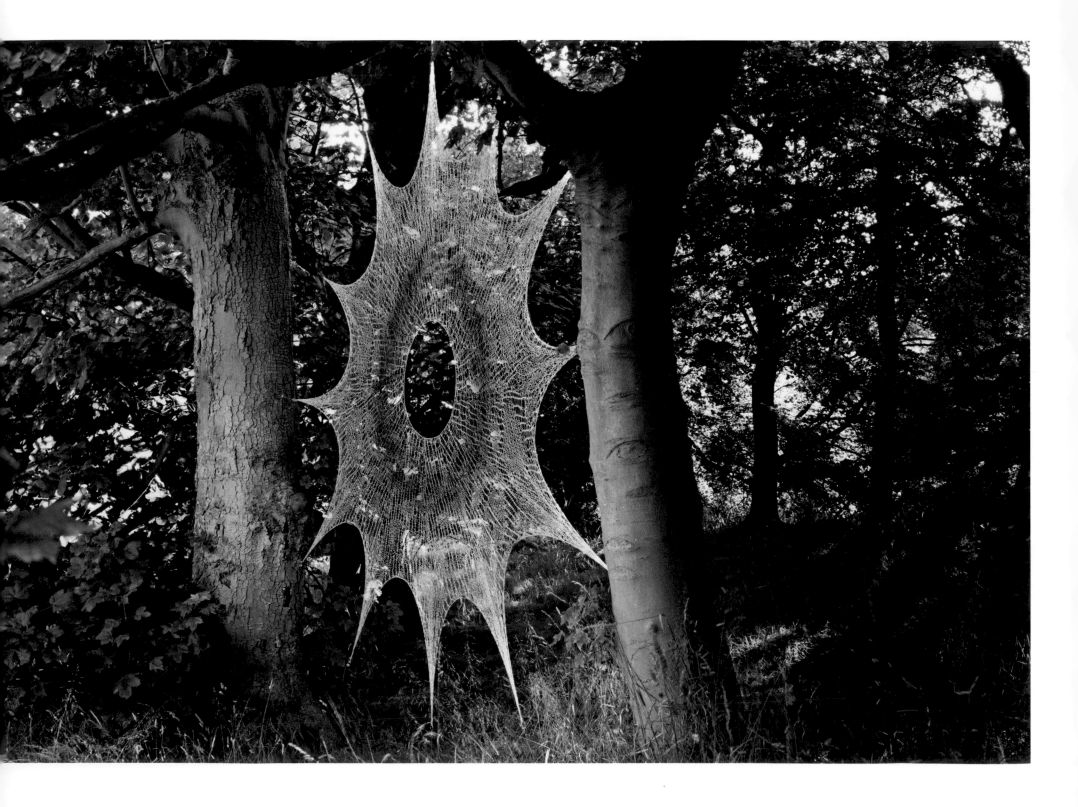

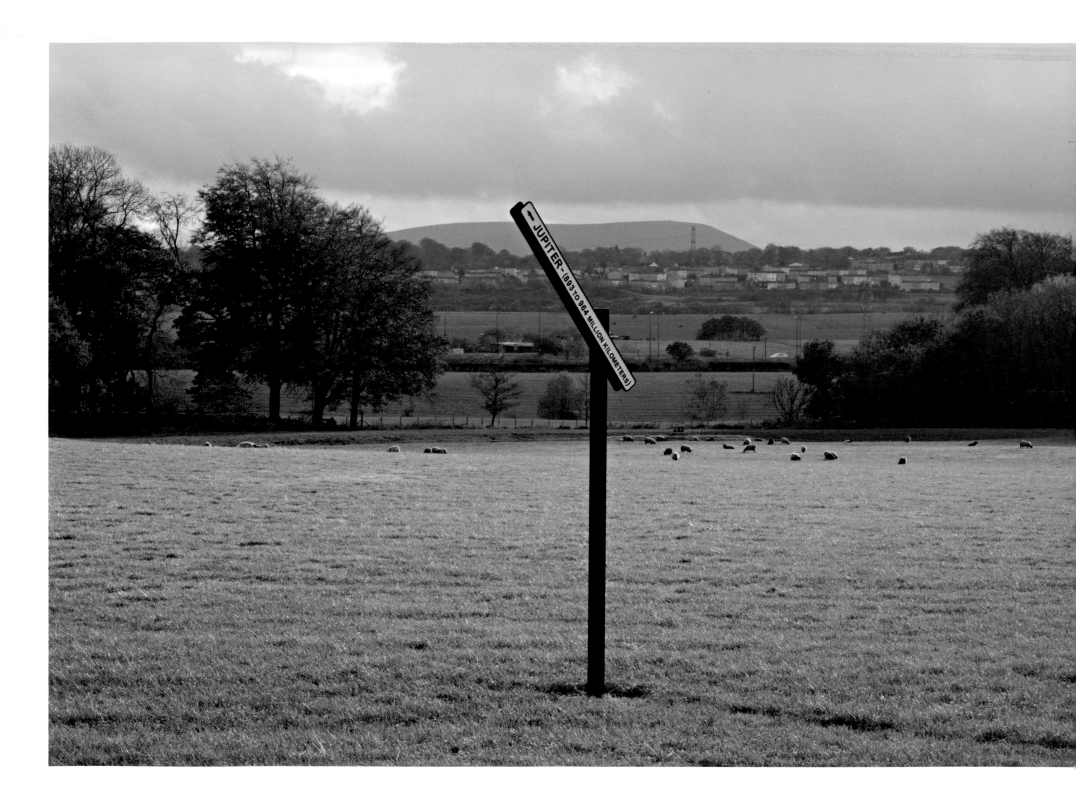
JUPITER - (893 TO 964 MILLION KILOMETERS)

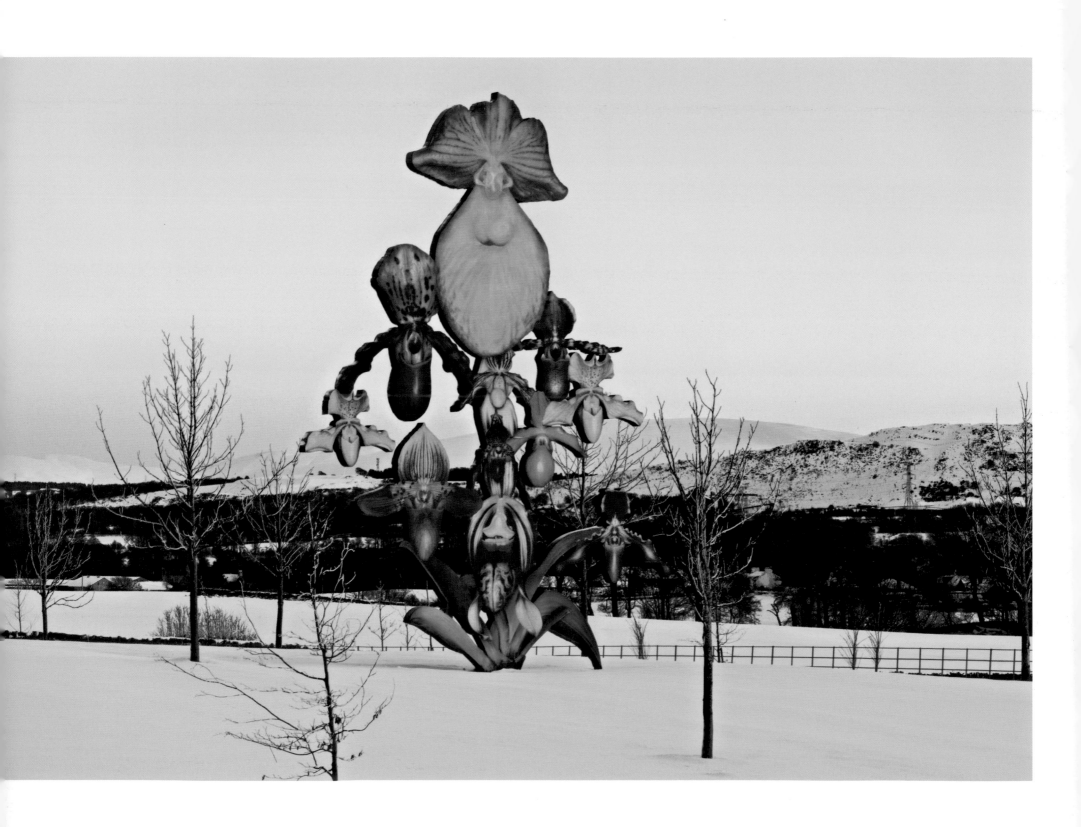

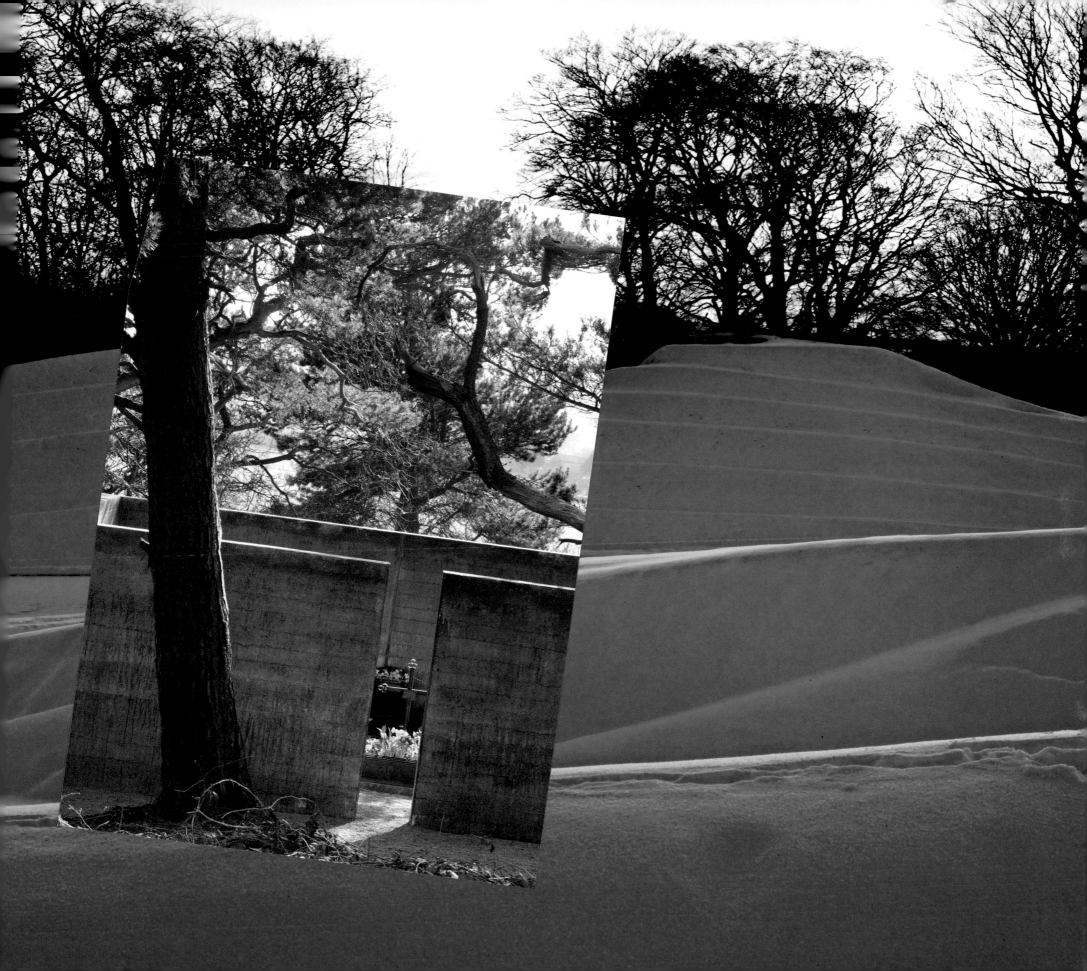

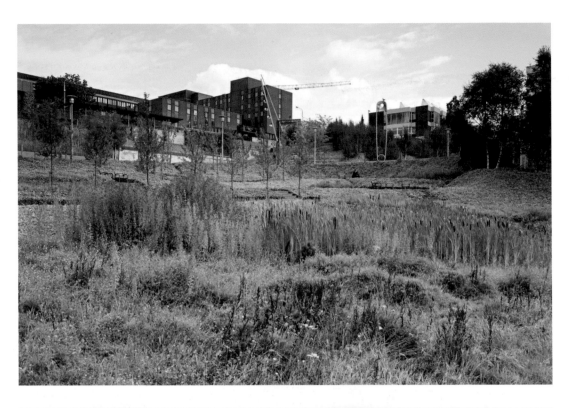

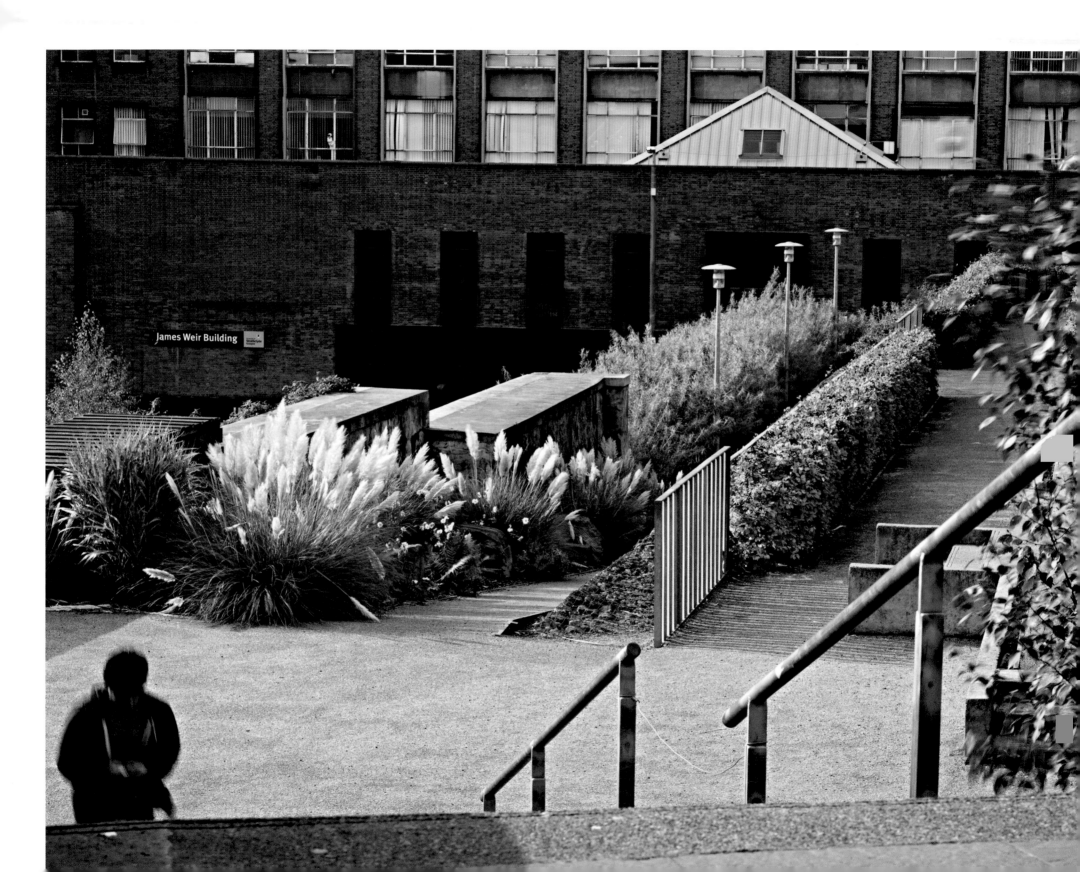

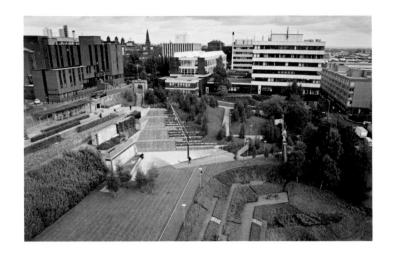

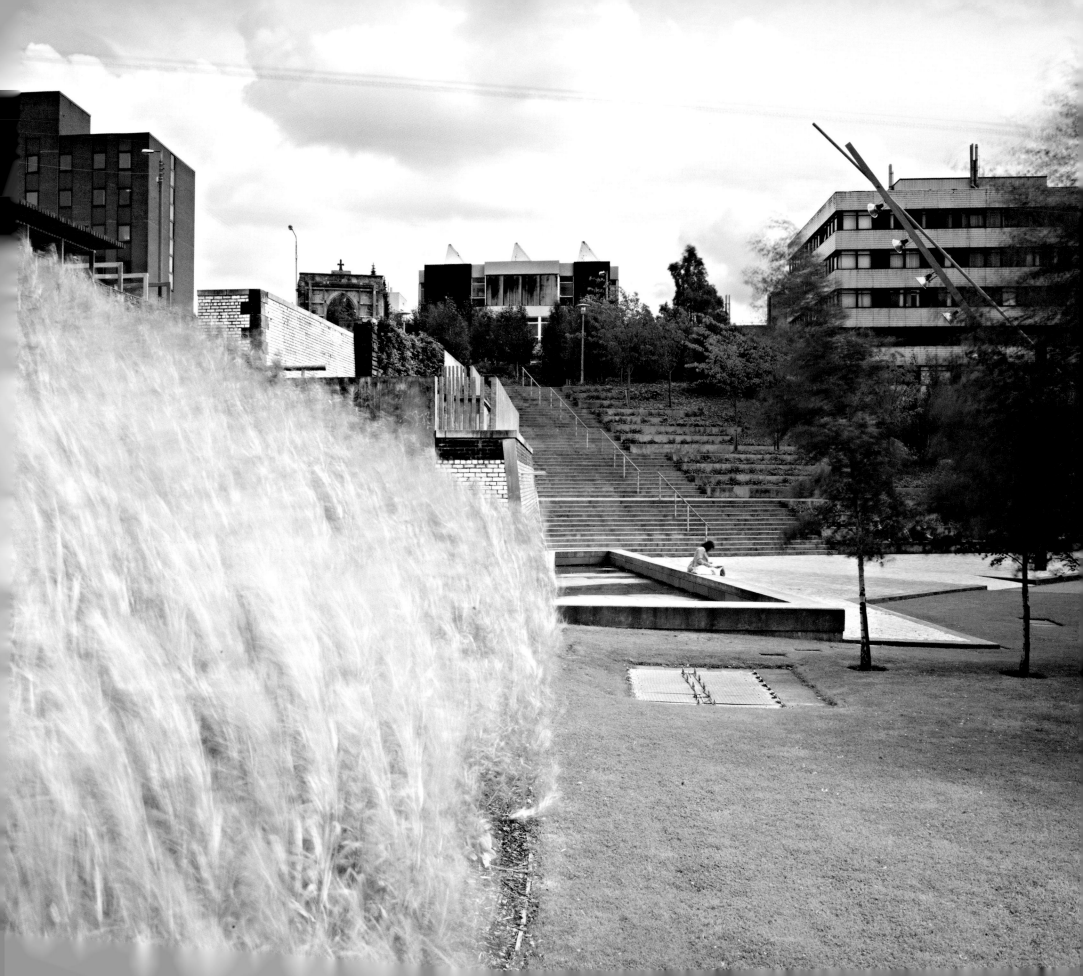

Rolf Roscher

The Hidden Gardens, Glasgow

The original brief for the Hidden Gardens was to create a space that would have 'spiritual resonance' for the communities surrounding it. The site was, at that time, an incidental patch of derelict ground – lost to the city and its inhabitants. This challenging idea prompted an investigation of the relationship between 'belief' and 'landscape'.

In the broadest terms, it could be argued that this relationship exists in two forms, which for ease of discussion we termed the 'transported' and the 'specific'.

The 'specific': where belief is derived from place. Where a belief system has developed in response to a specific landscape – and is in effect a metaphor for that landscape. Many early cultures developed a set of beliefs that celebrate the landscape and invest it with spiritual meaning.

This is a celebration of a specific, given, landscape – it places spiritual value on a particular hill, valley or tree. The design of the Hidden Gardens celebrates the given landscape. Not hill or valley – but nursery, chimney and factory floor.

The 'transported': where a landscape is created as a metaphor for a set of beliefs. Such 'created' landscapes are often representations of idealised places from religious writings – for example the idea of the 'Paradise Garden' that is common to both Christian and Islamic tradition.

The Hidden Gardens makes reference to different traditions of garden design. But more particularly it makes reference to the traditions that were found to have resonance with local people. The aim has been to trace back common ideas and themes in these different cultural and horticultural traditions and to express them in the garden.

The Hidden Gardens celebrates the 'given' landscape alongside the cultural traditions of the people who live around it today. The garden could not be anywhere else – it has developed in direct response to the site and the local community. The design is however deliberately ambiguous, it contains layers of meaning – but may be read and experienced in many different ways.

Chris Rankin

55.5°N 4°W

Living in Edinburgh means one cannot fail to appreciate the importance of gardens in a city. Be they public or private, the presence and scale of the great New Town gardens form a vital component in the urban environment, not only as green spaces to relax in but as spatial components with an equivalence to the built form.

During the 20th century however, gardens suffered the same fate as the wider designed landscape. They were considered as some kind of compensation for urban life instead of being integral to how we think about city gardens and became the preserve of eccentrics and loners.

But in earlier centuries the garden played a significant role in the development of wider ideas on art, philosophy and politics. In his essay 'The Pleasure of Architecture' written in 1977 Bernard Tschumi claims that the history of garden design has led the development of urban form. 200 years previously Marc-Antoine Laugier proclaimed that whoever knows how to design a park well, will have no difficulty in tracing the plan for the building of a city.

The ground however appears to be shifting and gardens are once again being considered as important components of the urban environment. I hope that the design of the Hidden Gardens in some small way contributed to the reawakening of contemporary urban garden design in the UK.

I like the assertion of the late Ian Hamilton Finlay that a garden should not be thought of as a retreat but as an attack. It is a sentiment which I returned to whilst working on the design of the Hidden Gardens.

The aggression of the term attack may seem antithetical to the activity of garden design but I preferred to think of it as an assertion of ideas and determination in the face of lethargy and occasional antipathy. And much as Tschumi suggests that the principles of the renaissance garden were applied to the design of the squares and streets of the renaissance city, and the crescents of the 18th century city were influenced by the picturesque garden tradition, so perhaps the design of a garden like the Hidden Gardens offers an insight into the future of our contemporary cities.

Many of the ideas which underpinned the garden design have a wider currency and relevance to how we wish to design our towns and cities. Consultation was an important part of the design process and was co-ordinated brilliantly by Clare Hunter. The time taken to find out the local desires of a diverse local population, what people wanted, what kind of environment was needed in East Pollokshields contributed in many ways to our concept for the garden. The principles of re-use and re-emergence equally allowed us to retain those traces of the site's history and to find new uses and meaning for materials which might otherwise be discarded. Finally the universal and timeless quality of all gardens could not escape our attention; that the Hidden Gardens should be a place of unadulterated pleasure.

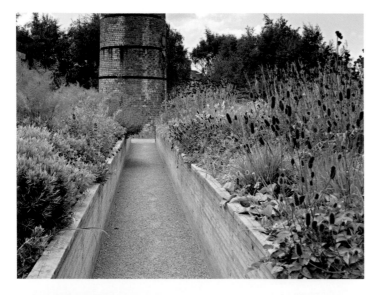
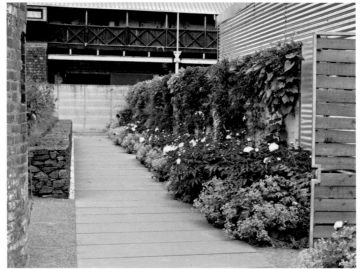

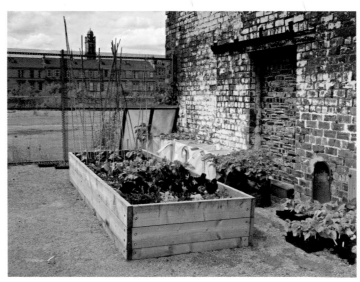

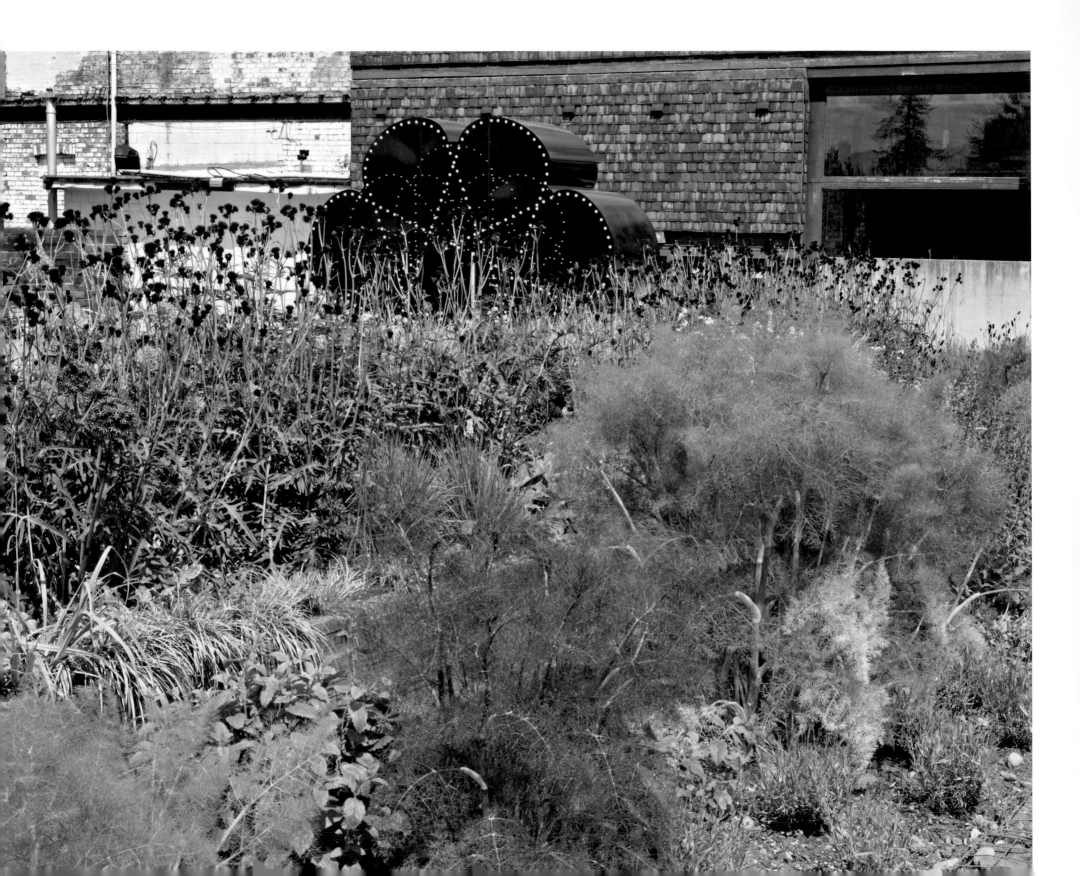

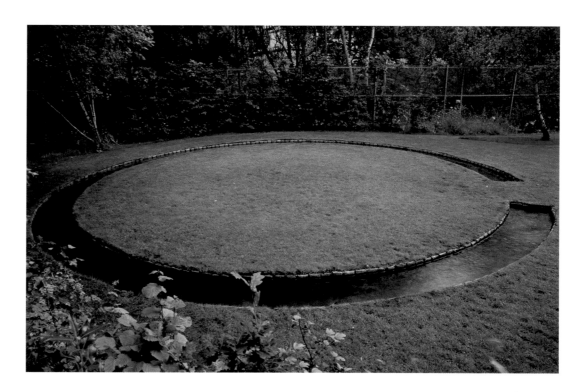

Andy Sturgeon

Private town garden in Paisley

My gardening life began in suburbia on the outskirts of London and I dreamt of designing rolling acres but soon found myself drawn into the city itself. Ironically, as my career progressed, the projects I worked on seemed to grow ever smaller as I was presented with greater and greater spatial challenges. Twenty-five years on and I've now worked on countless gardens all around the world, many are tiny roof terraces but others, finally, are large rambling estates. I adore the freedom of designing large country gardens. In fact that's where I set my sights but I am always drawn back – without protest it has to be said – to the urban environment. There are many reasons for this but the bottom line is that from a design perspective I find it both exciting and challenging.

Working with small contemporary urban spaces is far harder than designing large traditional gardens and don't let anyone tell you different. It's like 3 dimensional chess and as a designer you are playing against a grand master: space, or rather the lack of it. After all, if you've got 40 acres how hard can it be to decide where to put the lake?

Larger gardens tend to be rural and therefore have to be reverential to their surroundings or they risk competing; the greater landscape, the house, its history and almost certainly nature – borrowed views, the 'genius of the place' and all that. All these elements dictate the outcome of the garden. This may be no bad thing in itself and there is still plenty of scope for flexing one's design muscles but the parameters seem broadly set from the outset. Curiously, urban gardens on the other hand can be far less constrained as they are oases, insular in character, self sufficient, self confident and almost defiant of their surroundings. I can revel in this, feeding off the excitement of the city and working in influences from a broad spectrum of disciplines: art, architecture, theatre design, furniture design, graphic design, bars and clubs, window dressing. Almost anything in fact, even nature.

This garden for a large family on the outskirts of Glasgow had the typical lengthy list of wants including an outdoor gym, a putting green, a hot tub (that evolved into a small swimming pool), a trampoline and an entertaining area but I still had to make it all feel like a garden, not a playground. Getting that right was one of the most satisfying results of this project.

I firmly believe that in a small garden everything must be multifunctional and the design must be thoroughly practical. Broad steps and low walls can double up as occasional seating for a party, a built in bench can have storage underneath and a feature wall might act as a foil for planting which can be transformed by lighting at night and also hides the putting green. If you take this approach then you free up valuable space. Space is like gold dust, space is the goal and if you can fit some into a small garden then you are 95% of the way there.

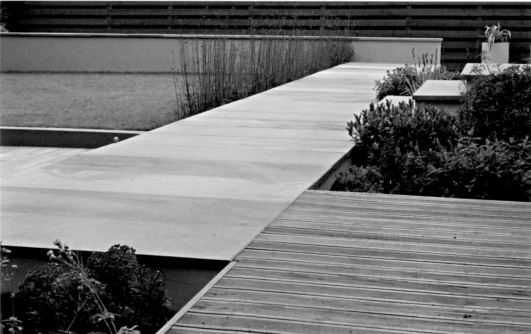

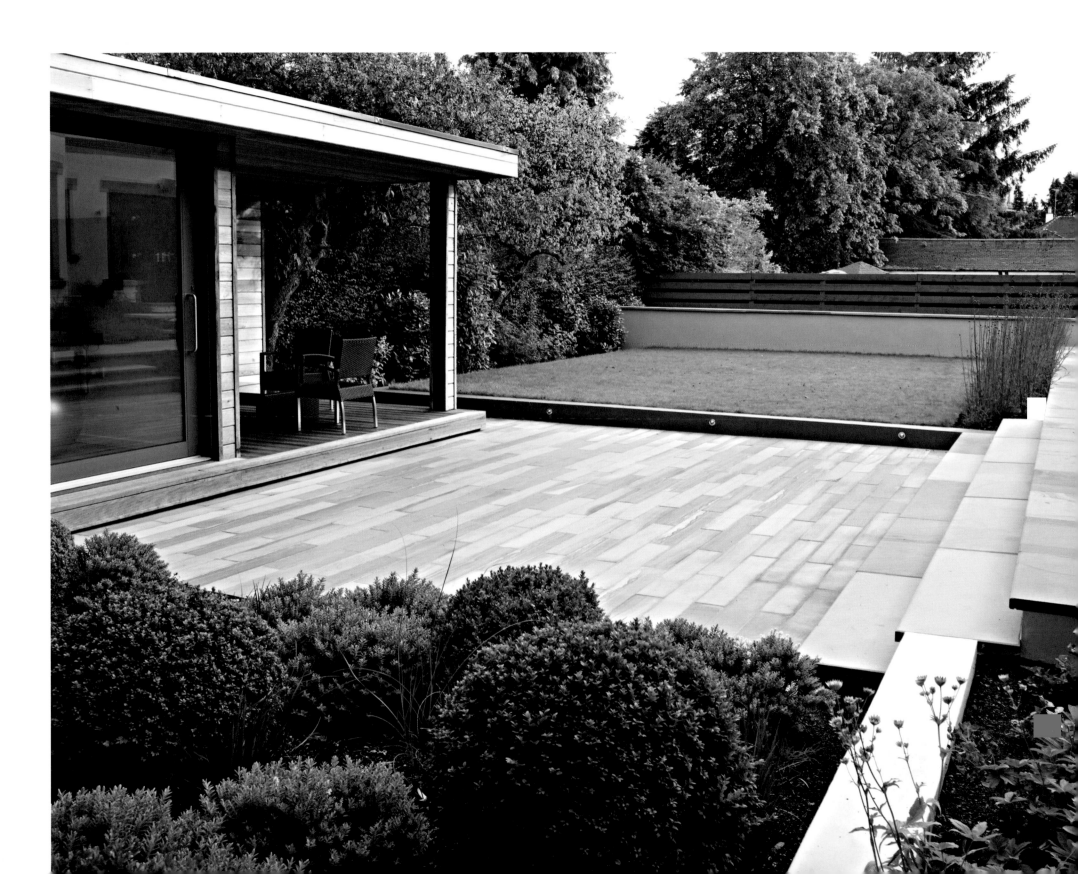

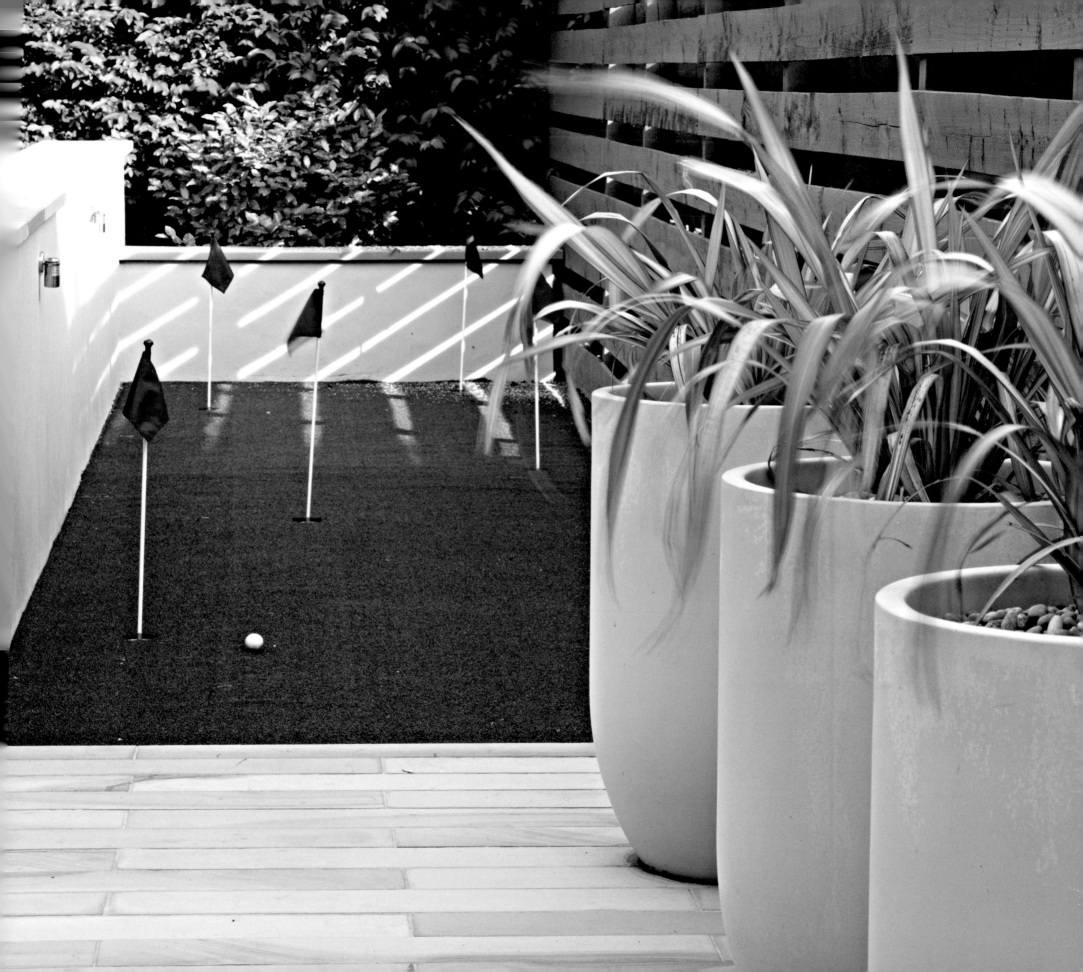

James
Alexander Sinclair

Mount Stuart, Isle of Bute

Over the years I have made a lot of gardens: some large, some small; some modern, some traditional; some happy, some sad; some that worked and (to be brutally honest) some that missed. There are very few that I have felt were an absolute privilege to work on and, strangely, two of those were in Scotland. Mount Stuart, however, was the best. Seldom does a garden designer get to sink his teeth into a project where architecture and history blends so well with adventure, innovation and excitement.

I have made two gardens at Mount Stuart: the first by remodelling and replanting the Kitchen Garden originally laid out by Rosemary Verey nearly twenty years ago. The second garden was brand new and based around the startlingly modern Visitor Centre. The two are very different animals but are linked together by an exuberant use of lots and lots of plants. In the Kitchen Garden there are great swathes of perennials planted in large borders around the central pavilion. Based loosely on a colour wheel, the flowers skip from blues to scalding reds through purples, pinks, greens and yellows. The Visitor Centre garden is more disciplined with long lines of grasses and spines of flowers laid out in the shape of an unfurled paper clip. This contrasts with the strong horizontal lines of the building itself.

The Butes and Mount Stuart have always been connected with gardens: the 3rd Earl helped found Kew Gardens, the Second Marquess brought Dahlias back from the New World, the Third planted the Pinetum and the Sixth brought in plants from all over Asia. The house is magnificent and the surrounding gardens are suitably diverse and diverting. I have spent many hours wandering around the gardens: both among the hustle of visitors and alone as the late sun sets across the island. The light, the island, the (occasional!) rain, the plants, the house and the sound of time passing has made the experience of working here a spine-tingling pleasure.

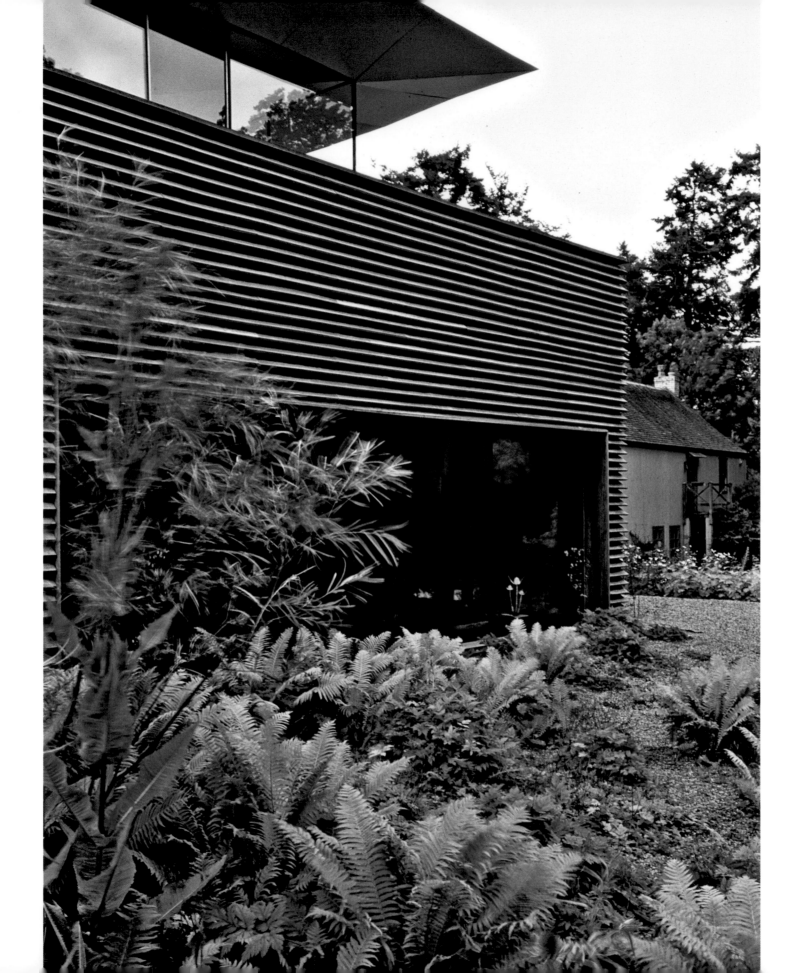

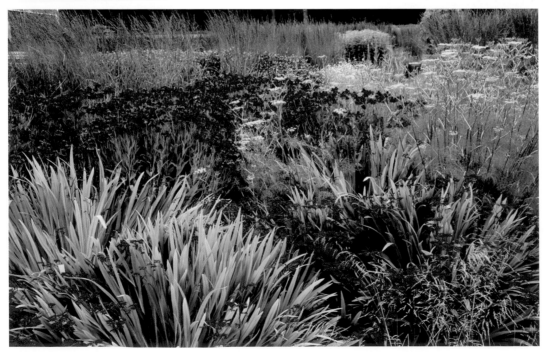

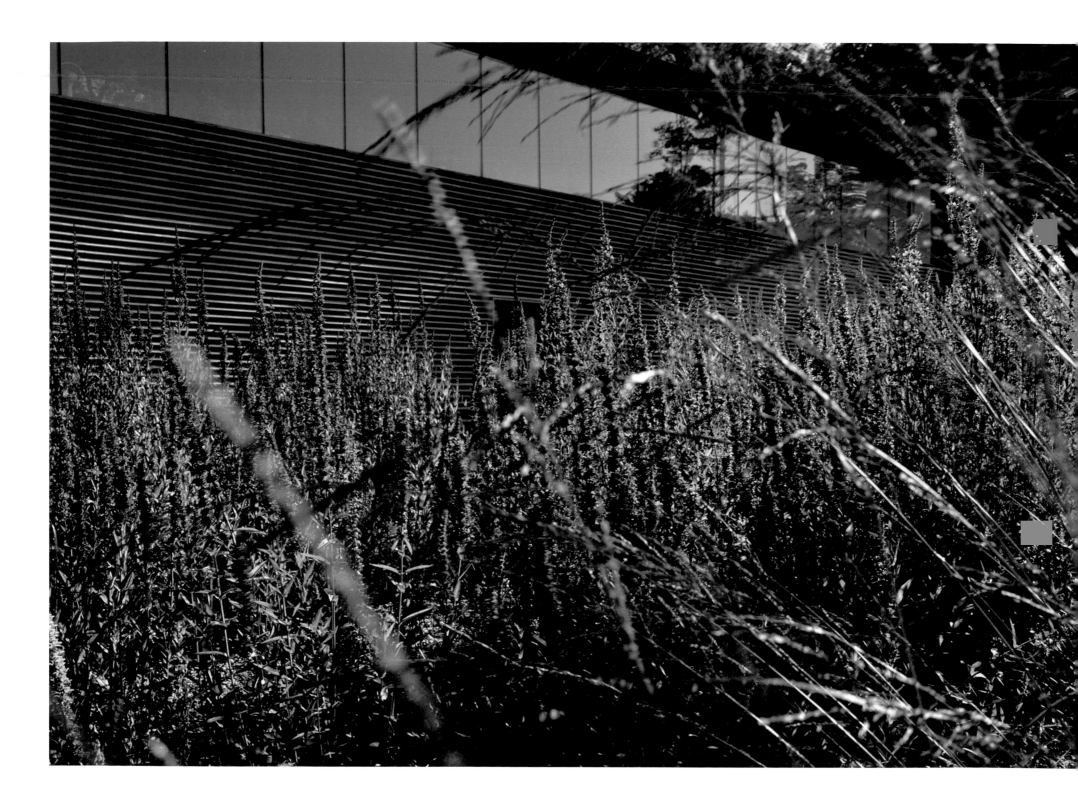

Peter Cool

Jura House and Garden, Isle of Jura

Jura House garden was started by the Campbells of Jura. The date on the sundial says 1812, so that is probably when the walls were built and the basic layout was created. In 1938 the Riley-Smith family bought Ardfin Estate from the Campbells.

I came here in 1976, having trained at an organic horticultural college in Holland. My original brief was to produce fruit and vegetables for Jura House and Jura Hotel. We produced enough organic vegetables to sell the surplus to the local residents.

Being aware of the potential for more exotic plants, I started to develop the borders, growing many plants from seed. The layout of the formal Victorian kitchen garden, with box and beech hedges was still intact and made a great foundation for my more informal planting style.

In 1990 Francis Riley-Smith sent me on a seed collection trip to Australia, Tasmania and New Zealand. Many of the now established plants originate from that time. They thrive here because of the Gulf Stream lapping on our shores and the use of lots of compost, seaweed and manure from our estate farm.

Slowly, as the garden became more ornamental, the visitor numbers increased and I began selling plants, so we moved from vegetables and vegetable sales to visitors and plant sales.

I allow plants to do their own thing, but with a measure of control, so allowing self-seeding and spreading of some plants, while controlling and weeding others – it creates an informal style.

I consider myself very lucky to have the opportunity to live on this beautiful island and to have been given the freedom to create this garden.

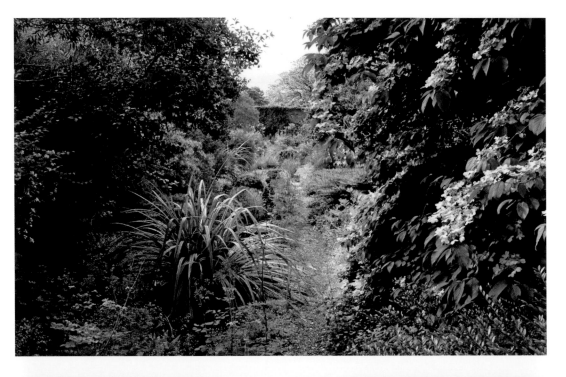

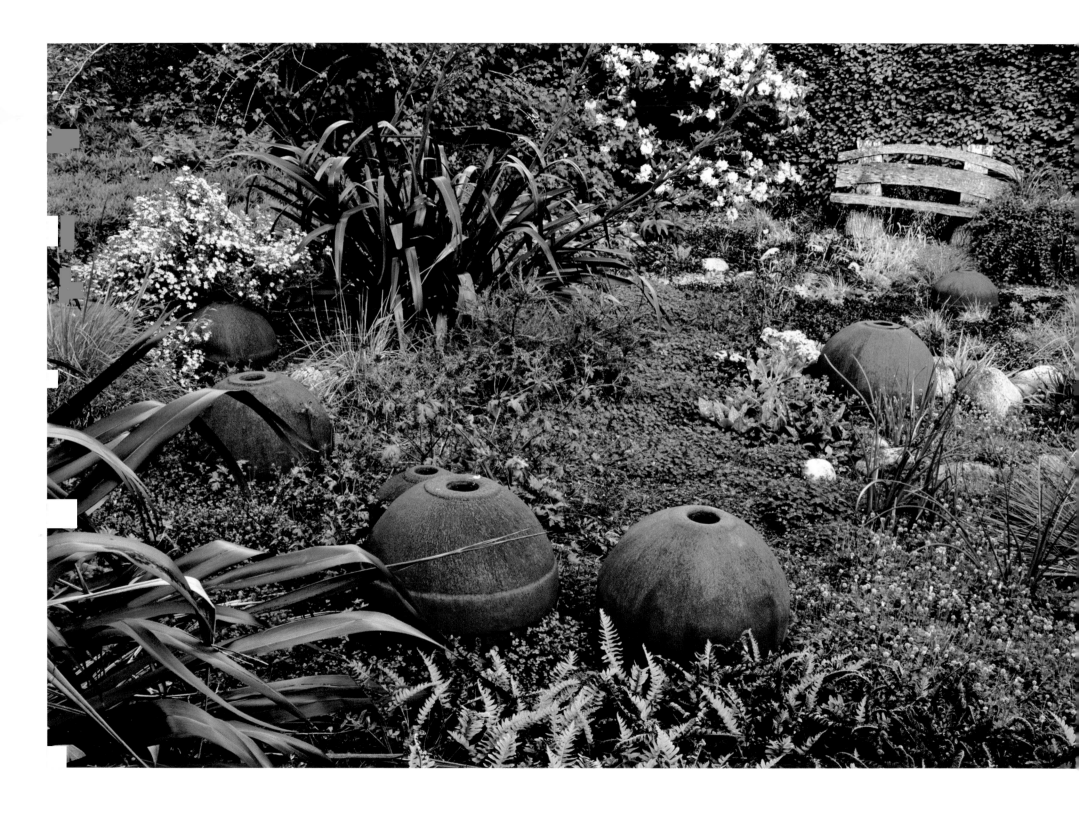

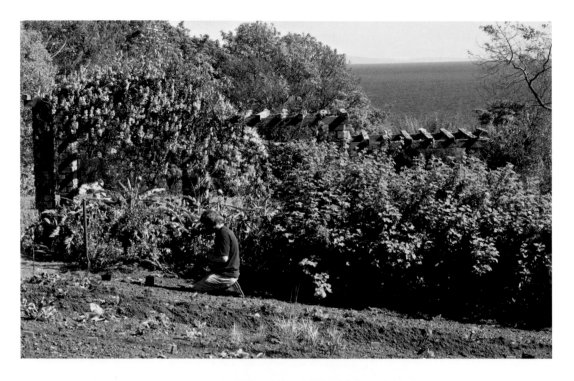

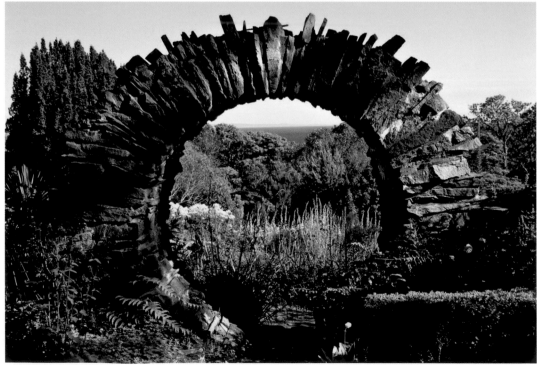

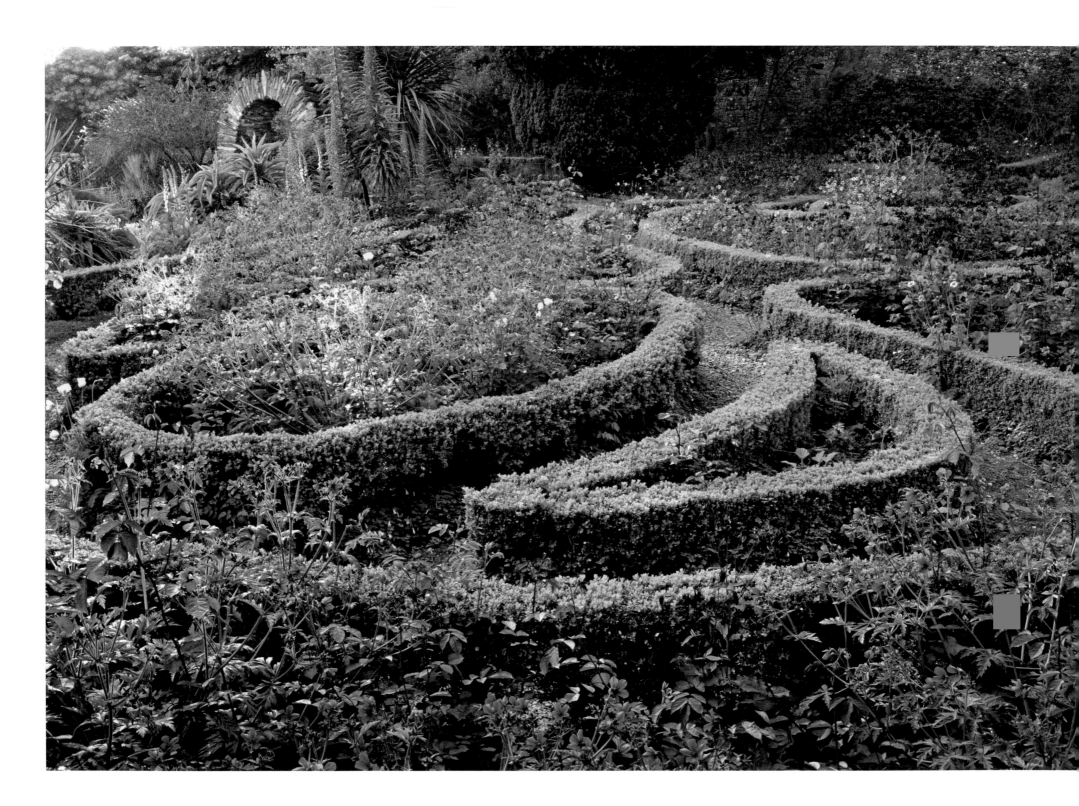

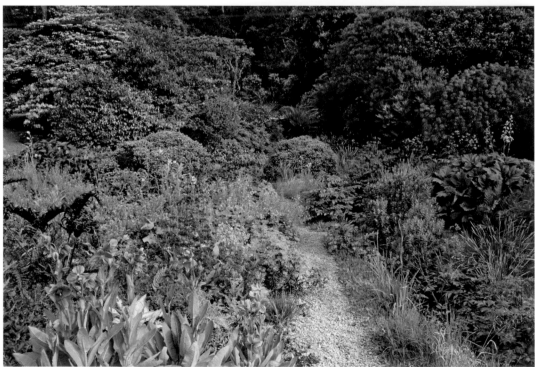

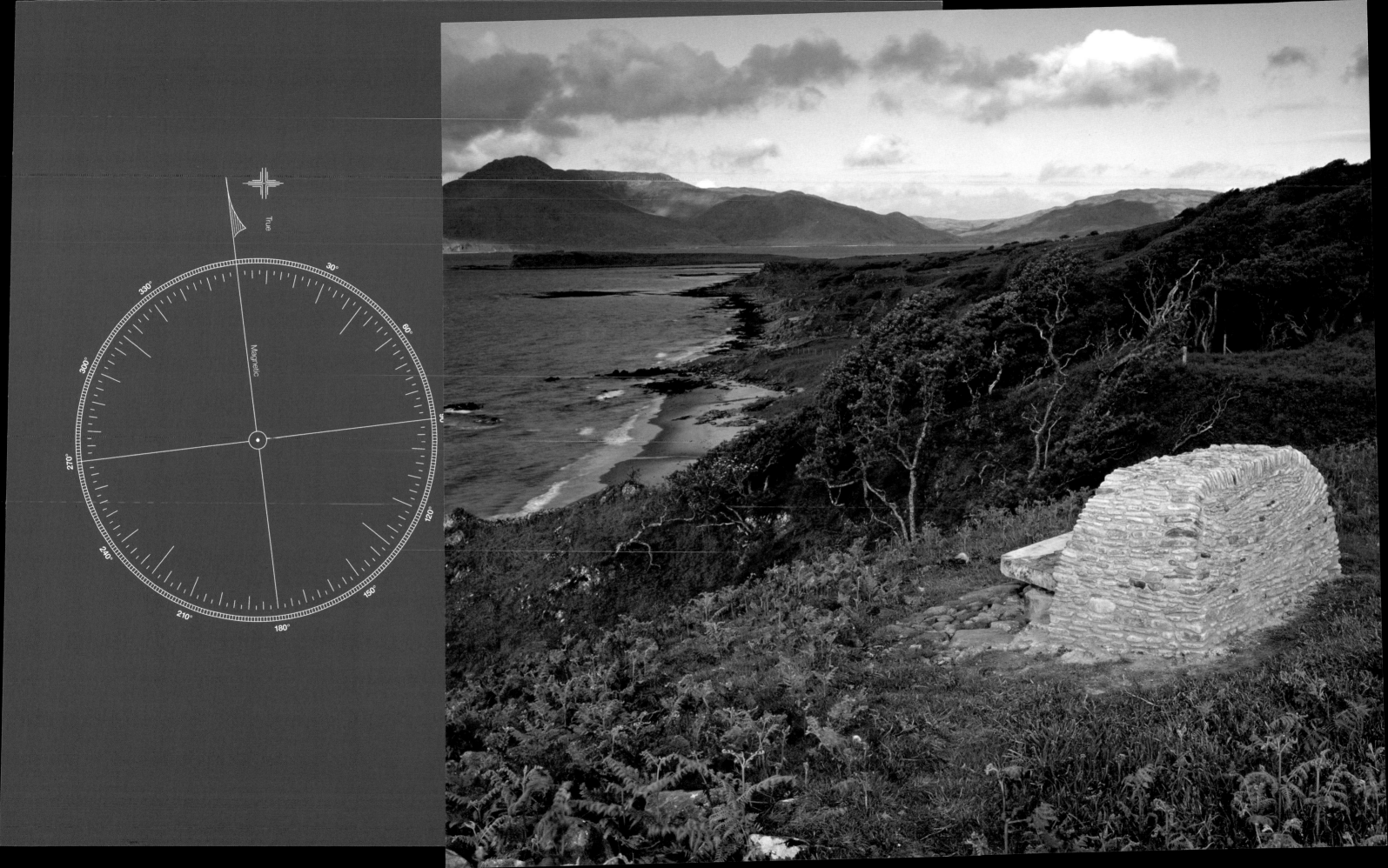

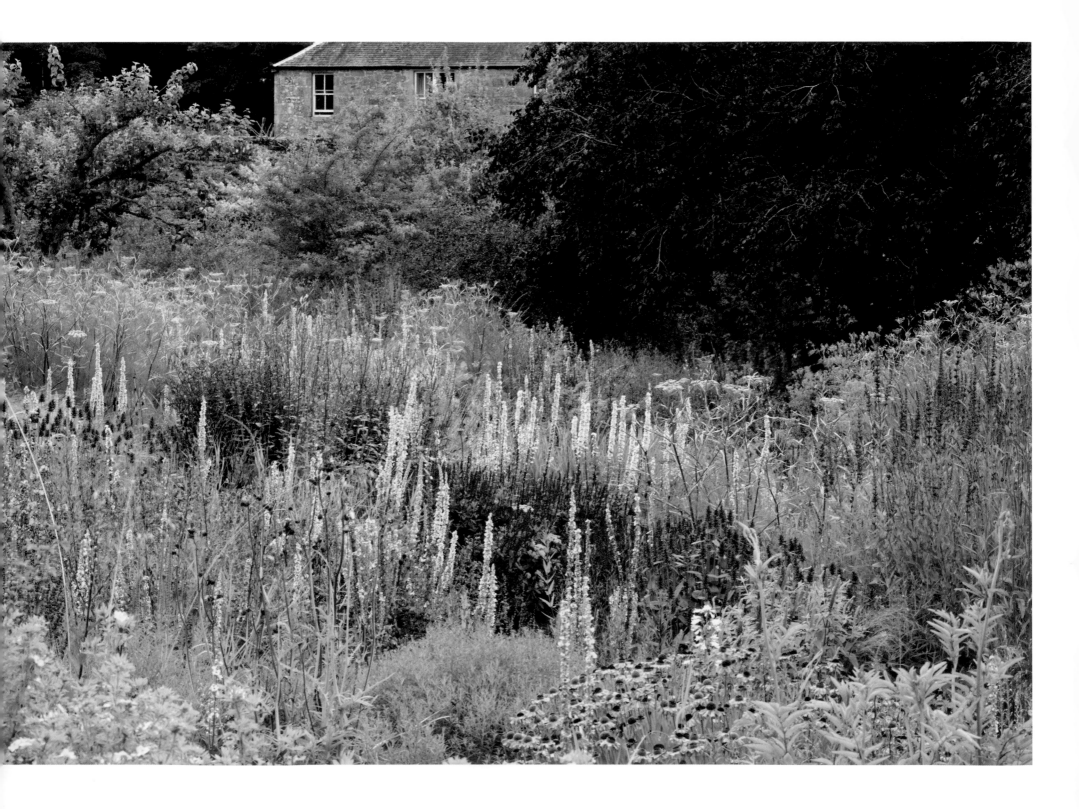

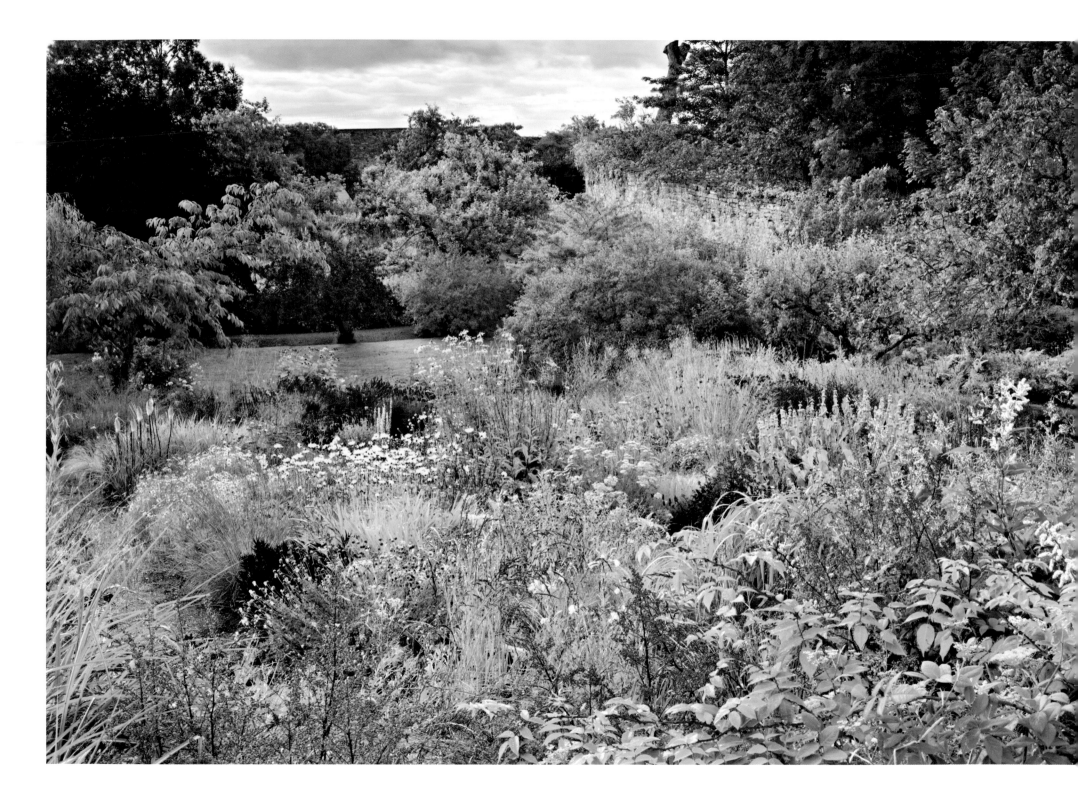

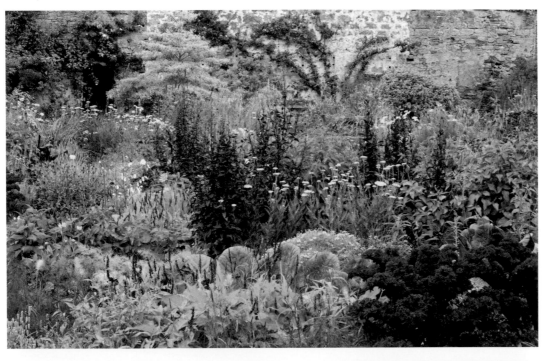

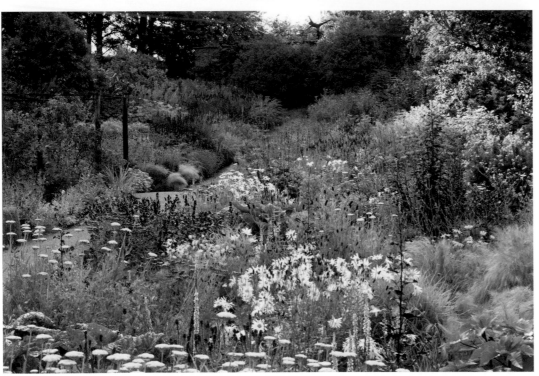

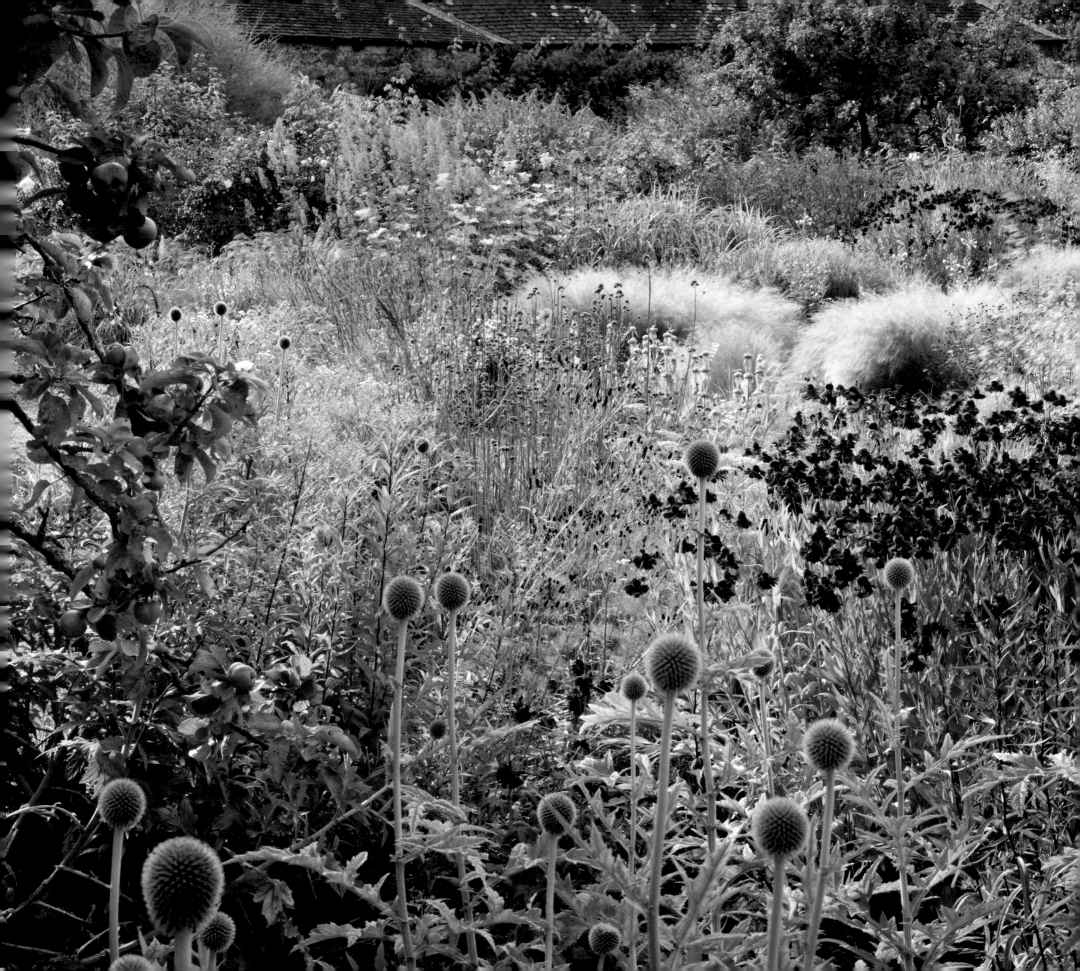

Arabella Lennox-Boyd

Landscape at the Maggie's Cancer Caring Centre, Ninewells Hospital, Dundee

It was wonderful to be invited to design the landscape at the Maggie's Cancer Caring Centre, Dundee which is the first major landscape project for a Maggie's Cancer Caring Centre.

This remarkable project, surrounding Frank Gehry's exquisite building, is testimony to the belief of those within Maggie's, the NHS Tayside and local people who came together to create this most exciting landscape as a fitting testimony to both Maggie Keswick's and my belief in the healing power of landscape.

My design is a combination of response to the site and inspiration based upon an ancient landscape tradition in Scotland and beyond of moulding the land into forms that provide both practical solutions and aesthetic delight.

I was faced with the challenge of linking a large and utilitarian hospital to the Maggie's in such a way that the requirements for adequate car parking and easy access to both ambulance and helicopter sites could be accommodated alongside the Maggie's desire to create a harmonious, tranquil and healing space.

My design involved re-working the site to create dramatic, stepped earthworks which mound around a new 33m diameter labyrinth, which visually links the hospital to the Maggie's. I very much wanted the Maggie's to be closely linked to the hospital in every way and accordingly, the amphitheatre-like space opens out towards the hospital, uniting the two both visually and physically. The enclosed central area provides contemplative space and its banks enclose an area that is also used for public events.

The earthworks screen discreet car parking, ambulance and helicopter access from the contemplative spaces whilst through them run new pathways, with improved lighting, linking the buildings more easily. A second small garden planted with flowering trees, shrubs and roses is used as an additional, private space for patients and their families.

The labyrinth, made of grass and locally sourced Scottish granite sets, is based on the eleven-circuit medieval design from Chartres Cathedral, France. Medieval labyrinths were designed to be walked, almost as a pilgrimage, a questing, searching journey to God. Today, labyrinths are used as a place for contemplation and meditation, a haven in today's hectic world.

The earthworks echo the ancient landscape tradition, going back to pre-historic times and used by Maggie Keswick and Charles Jencks at their home at Portrack. Their elemental quality fit well into the majesty of the view towards the Firth of Tay.

The planting is designed to compliment and not detract from the architecture and provide all year round interest for the users, both staff and public. Around the building, simple swathes of Hedera helix 'Obvata' cover the ground plane, taking run-off water and shade from the heavy eaves. Wide beds of grasses swathe the estuary side, providing waves of movement until the spring and use only deschampsia and miscanthus varieties for simplicity. The small, contemplative garden is more intimate and provides peaceful enclosure and year-long colour with magnolias, rugosa roses, rhododendrons and azaleas, selective grasses and groundcovers. The surrounding trees, many of which are Scottish natives such as Pinus sylvestris or interesting varieties of Scottish trees such as Sorbus thibetica 'John Mitchell', provide a variety of colours and textures throughout the year.

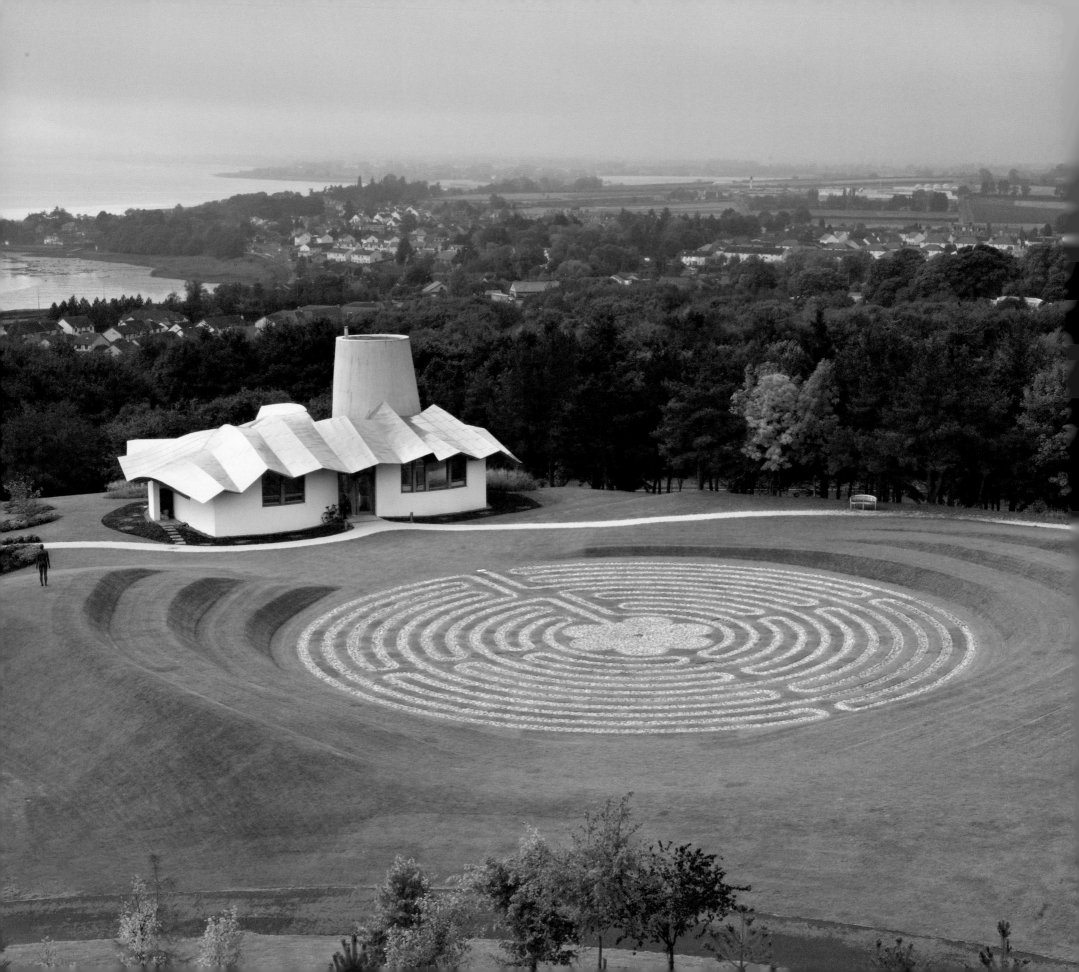

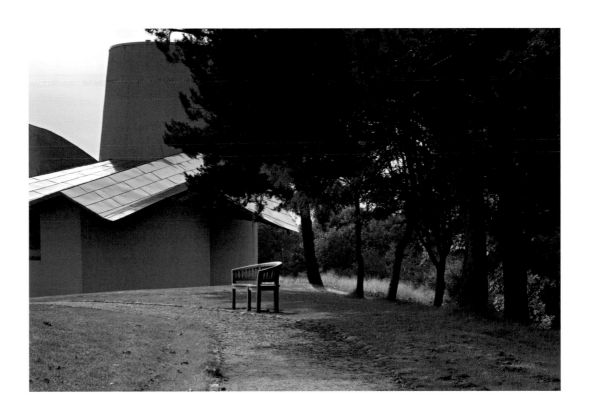

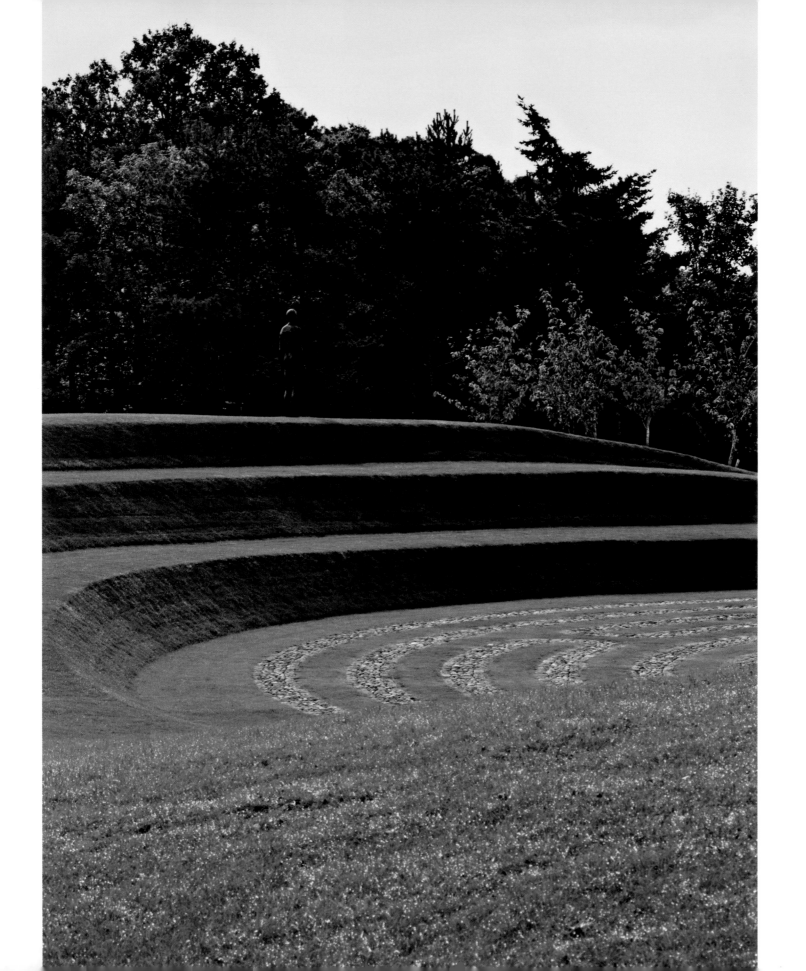

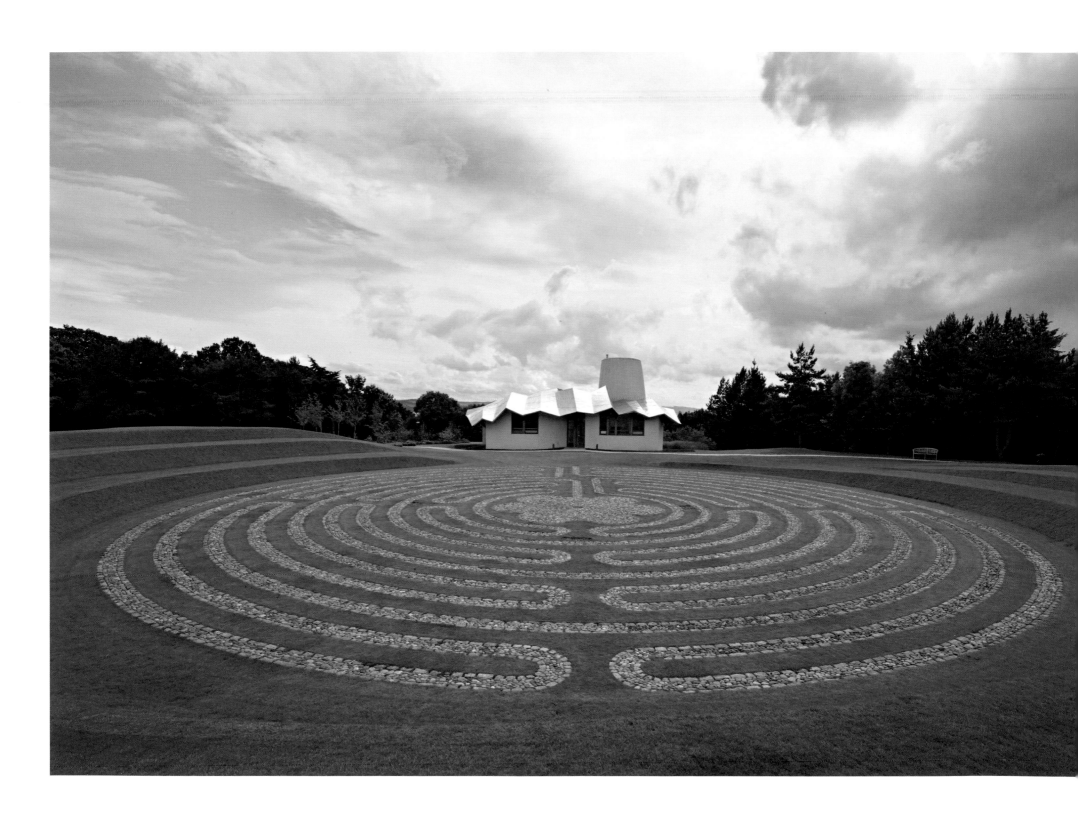

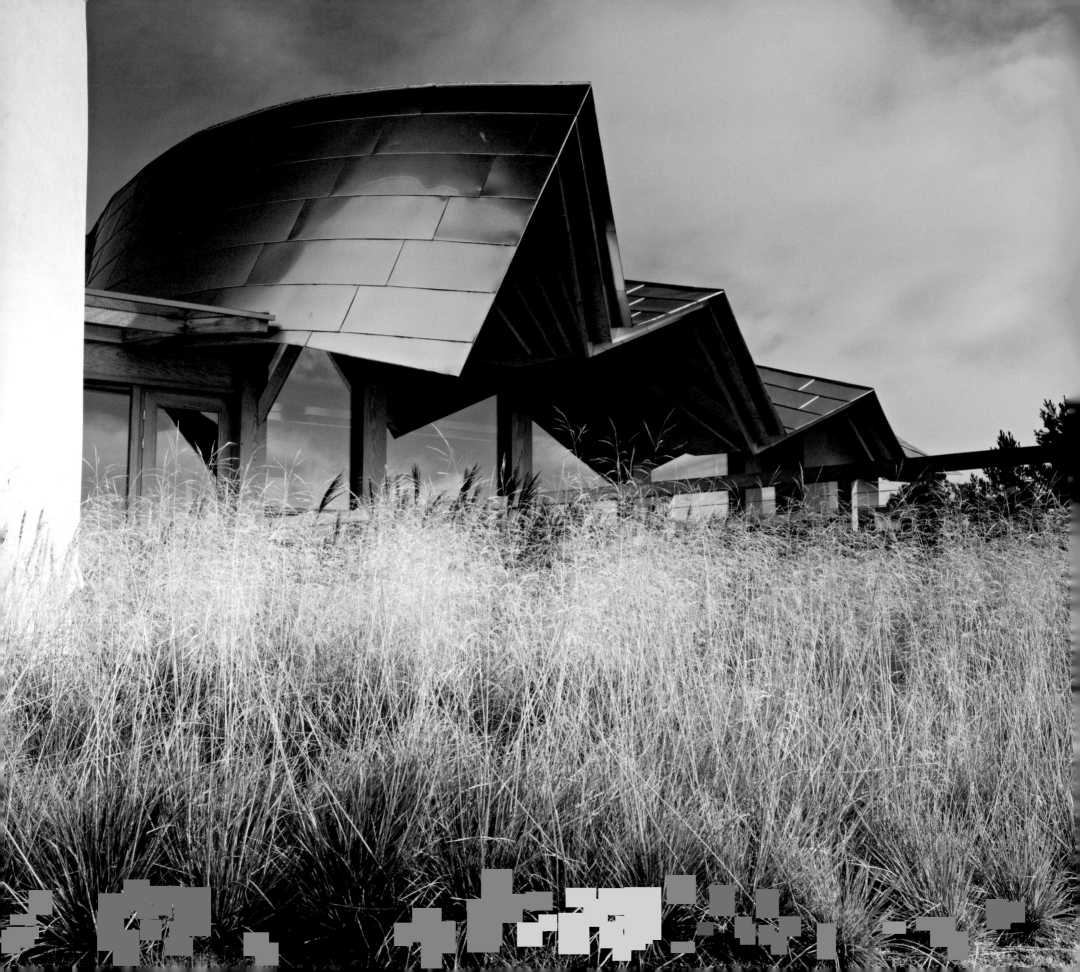

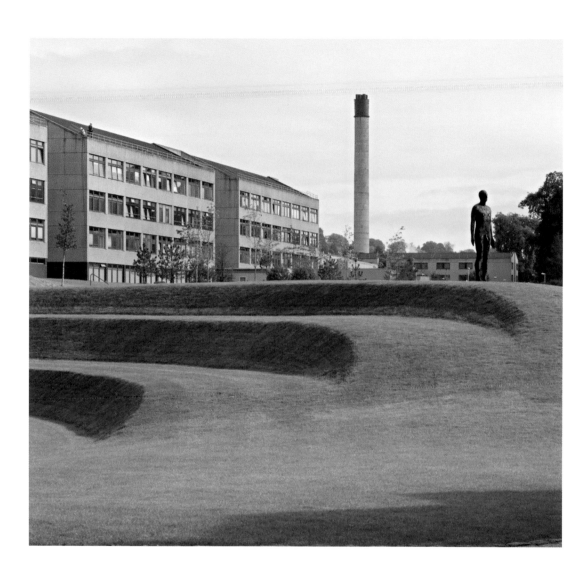

Niall Manning &
Alastair Morton

Dun Ard, Stirlingshire

We started gardening here 20 years ago in what was an open field. A plan was drawn up at the outset, responding to the site and its place in the wider landscape. We were keen to develop a garden with vivid contrasts: a feeling of enclosure and wide views out, a strong geometrical framework with exuberant planting and meadows. We were particularly keen to explore the contrast between a formal design and the views out to hills and moorland.

We appear to be in an age when the subject of garden-making and gardening 'has been reduced to the outdoor equivalent of DIY' (Tim Richardson, Arcadian Friends 2008). 'The spirit of place' is seldom considered and basic questions about individual gardens are rarely asked: What is it for? and What does it mean? A useful corrective to much writing about garden design would be the chapter headings in Douglas Swinscow's book The Mystic Garden: A Symbolic Journey, Expectation & Invitation, Surprise, Boundaries, Joy & Mystery, Perseverance, Knowledge, Finding the Way, Fulfilment, Harmony, Awakening, Serenity and Illumination.

We see our garden as a place to walk in, work in and experience in all weathers and seasons. We find many gardens overtidy and overwrought. The organic production of vegetables and fruit is a central part of what we do here. It is a loved place, a healing place and also fun.

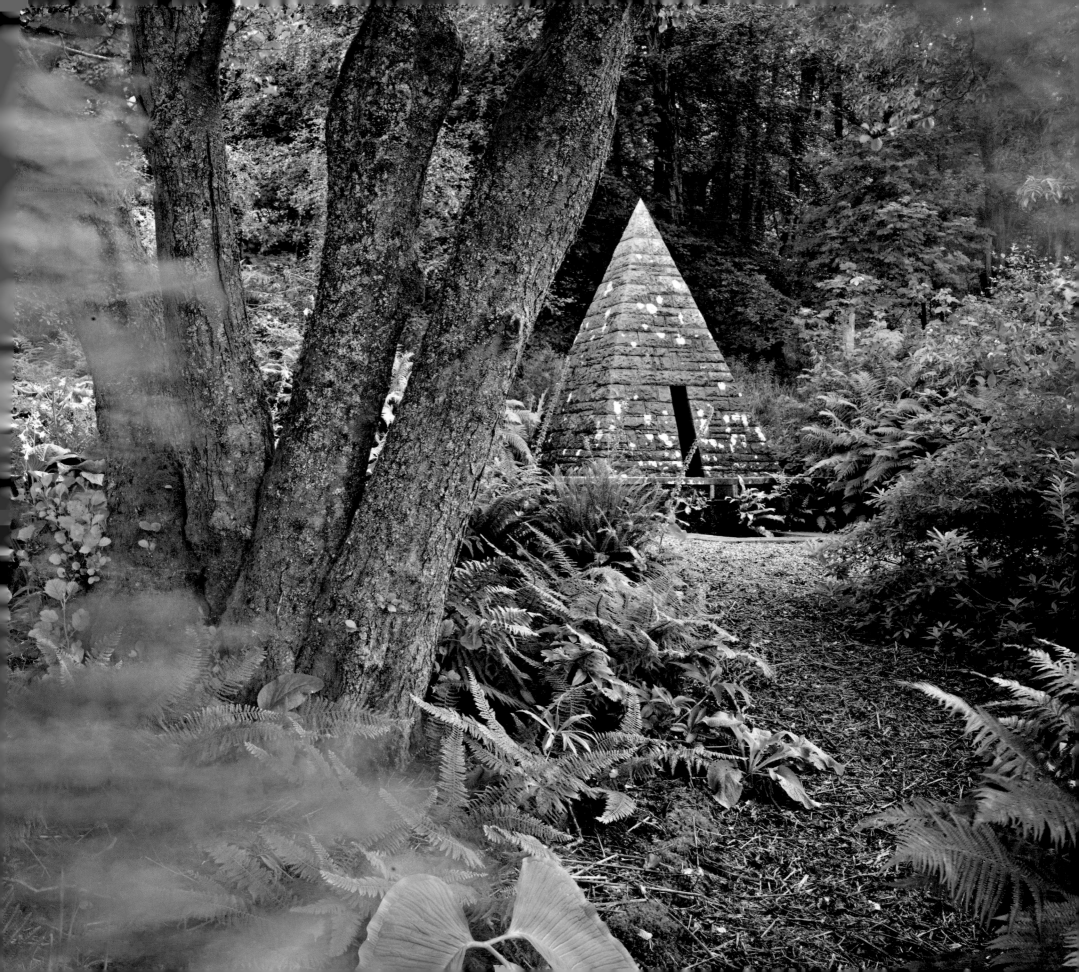

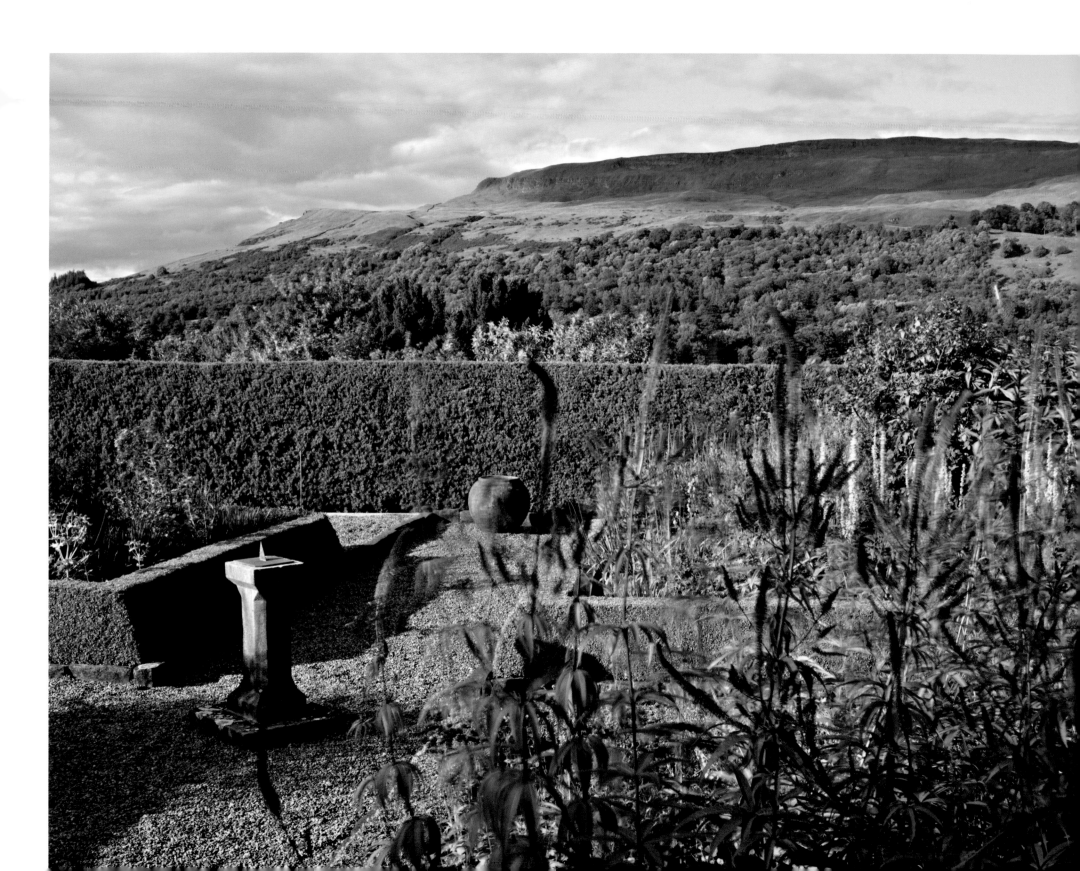

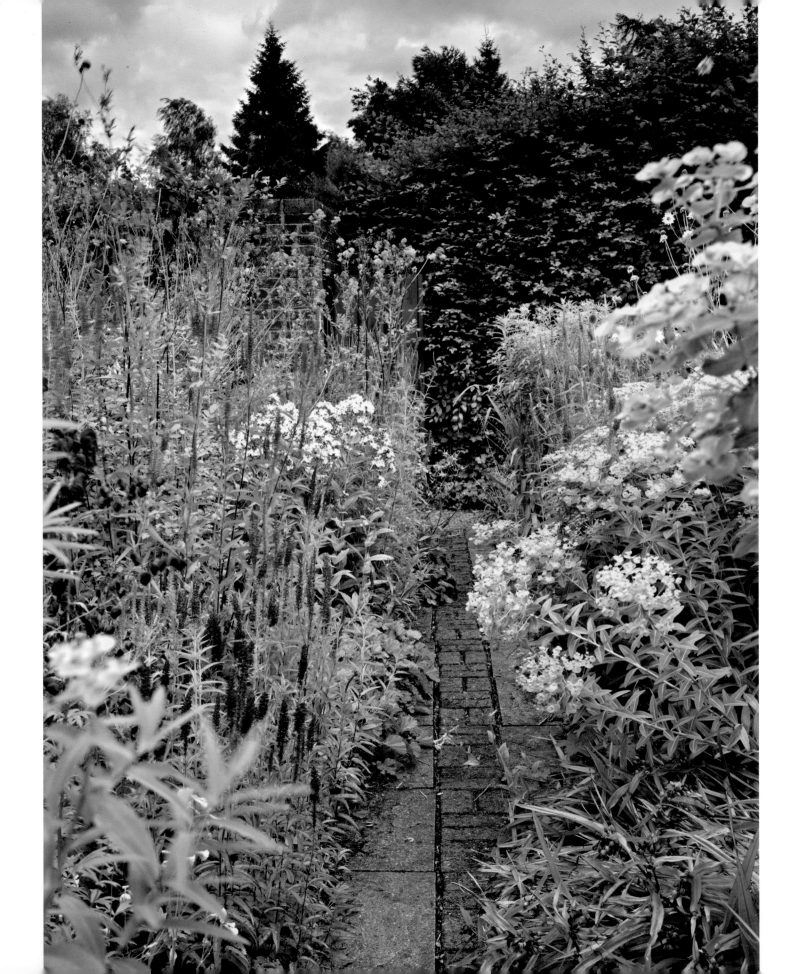

Jinny Blom

Corrour Lodge Gardens, by Fort William

The call to visit Corrour for the first time came at Halloween in the year 2000. Arriving off the sleeper train from London into a spectacular Highland landscape of bronze, rust and dun, its fiery autumn colours were breathtaking.

The invitation had been extended to transform the landscaping around the eleven miles of Loch road and also around the newly commissioned lodge, designed by the eminent architect Moshe Safdie. The new lodge was being built on the footprint of an impressive Victorian lodge that had burned to the ground in the 1940's. Thus began a long term and entirely unique project.

The estate had been in gentle decline for some time as timber prices had slumped and the nearest viable road was many miles away down forest tracks, making the sale of the plantations uneconomic. This fact informed much of the rationale behind the new landscaping. When the original Victorian lodge had been built it was the heyday of industry; wealth poured out of Glasgow. Navvies were brought from the building of the railways and vast labour forces set to work creating extravagant gardens of boulders, pools, networks of paths, cottages and taming the volatile burns to power the estate. The then owner, Sir John Stirling Maxwell, planted thousands of trees as an experiment in Highland planting and formed the Forestry Commission in its wake. An avid plant hunter, he planted an astonishing Rhododendron plantation at this improbable altitude.

This level of endeavour cannot be replicated these days and the thrust of contemporary landscaping on this scale is firmly in the direction of ecology and sustainability. It was agreed that the landscape would be designed to need minimal human management and use, as far as possible, locally indigenous species. The spread of plant disease is rife as there is so much traffic involved in the business yet the estate is clean and pure and miraculously free of it.

With such an astonishing building the gardens could not compete, instead they have become 'anti gardens'. I created a matrix of seed, grasses, trees and shrubs of local appropriateness and threaded them right up to the base of the building, lapping like waves against this alien cliff. The vestiges of the Victorian garden were restored, rather in the manner of an old Roman mosaic, and woven into the whole. The reminiscences of the Victorian gardens were threaded into the wilder plantings: Swamp lilies, Himalayan cowslips, huge Cardiocrinums and exotic ferns that would have graced the best Victorian gardens and spoken of the owner's erudition in plant hunting circles, have naturalized and pop up haphazardly through the birch copses and at the feet of Scots Pines. Trees tap at the windows of the Lodge; creepers are beginning to cover its walls; it is gradually melding with its environment.

A venture of this size is never complete and each year adjustments and additions are made, thinking develops and new information is greedily consumed. Gratifyingly, nature is returning, deer numbers are controlled so natural regeneration can take place and overgrazing is held in check. A gentle blooming is occurring in this extraordinary and evocative place.

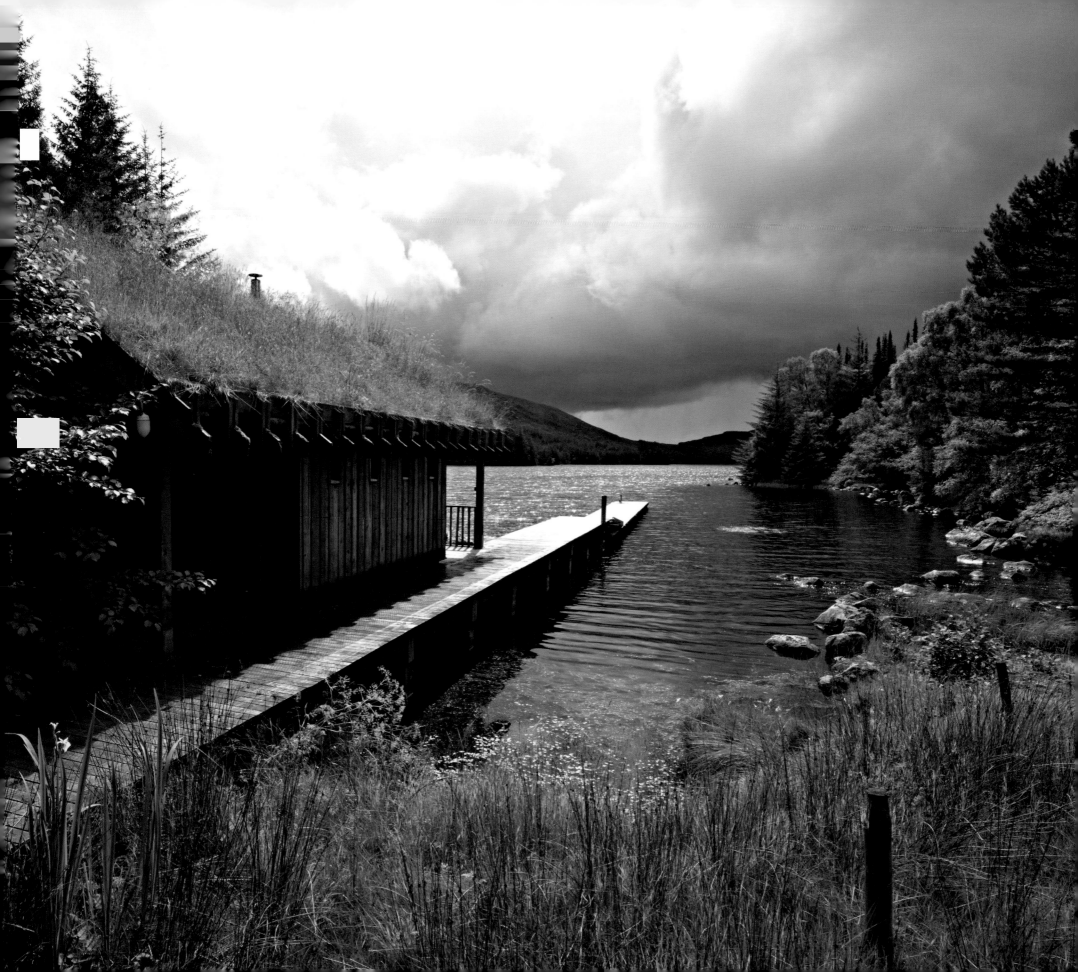

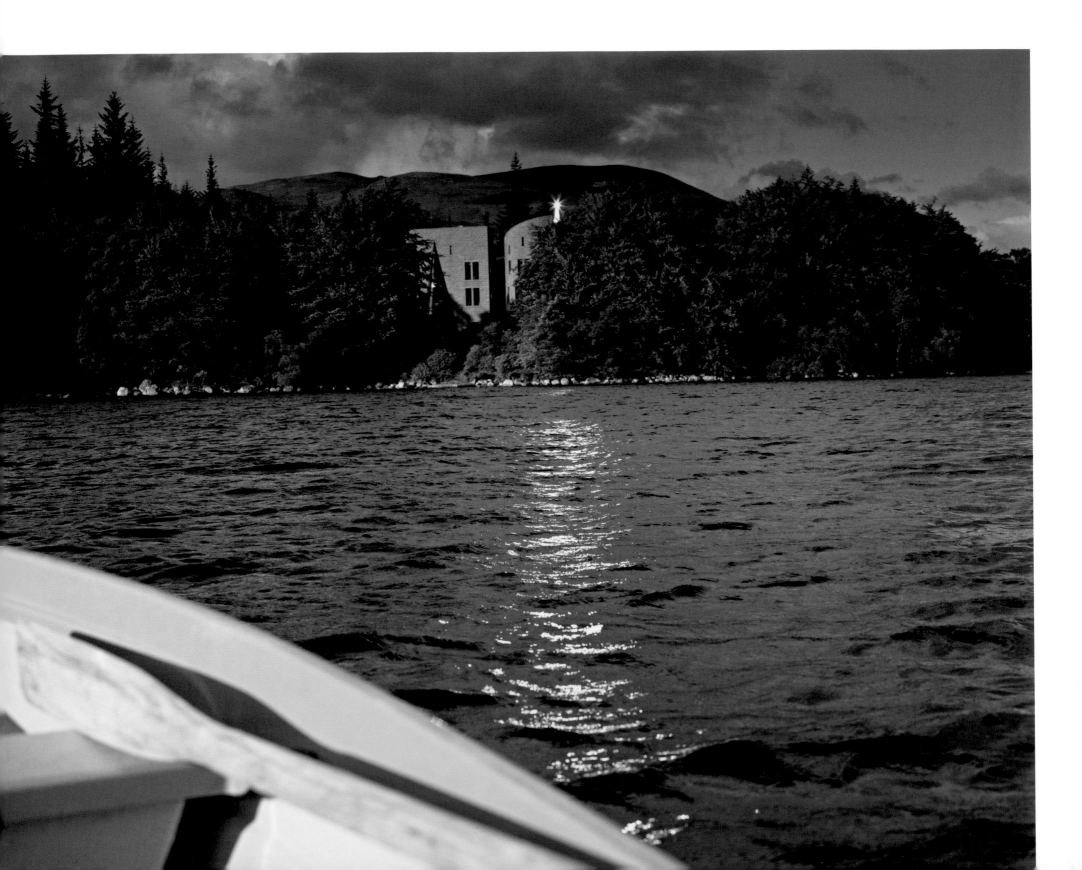

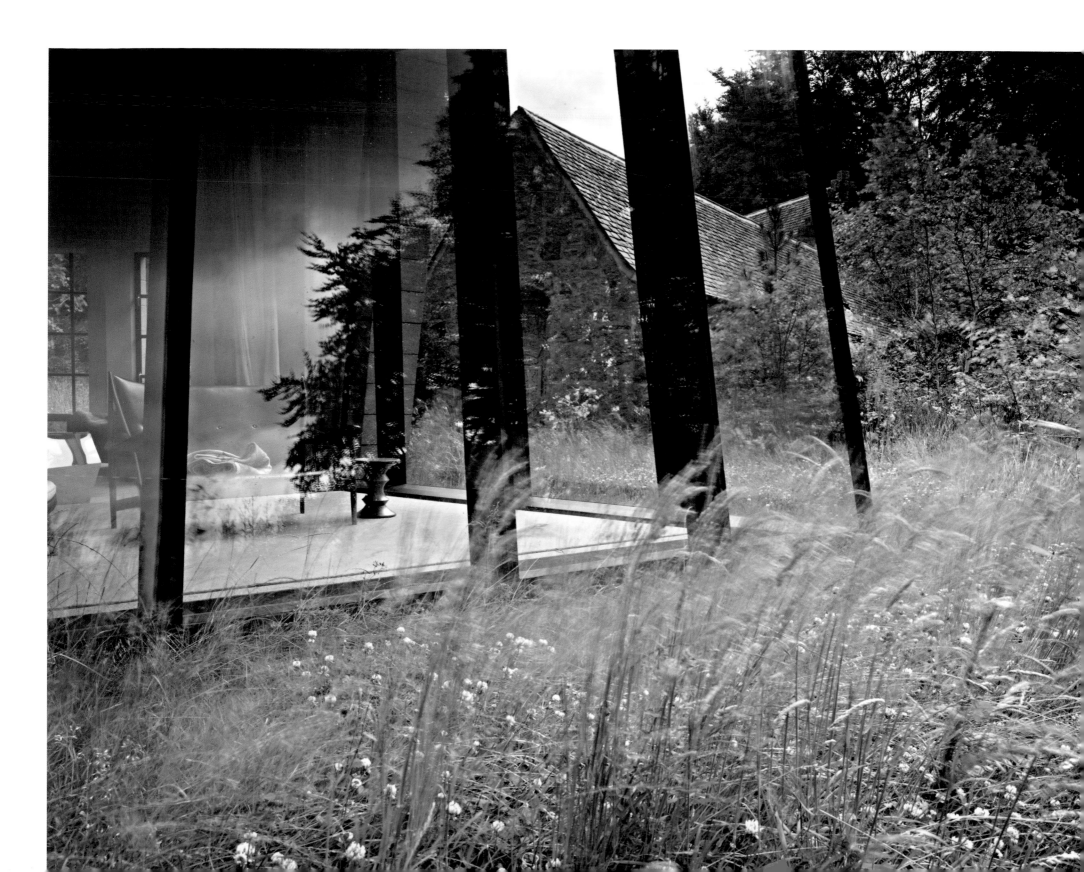

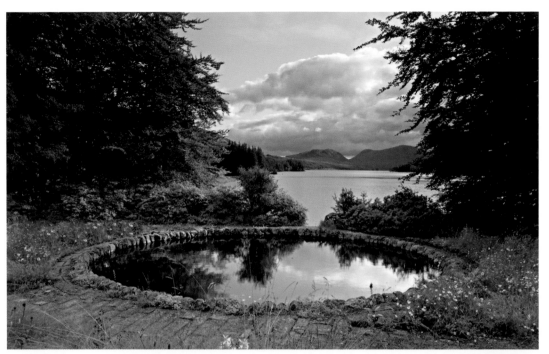
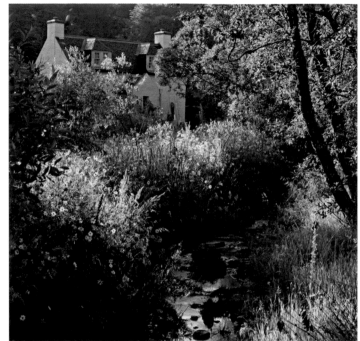
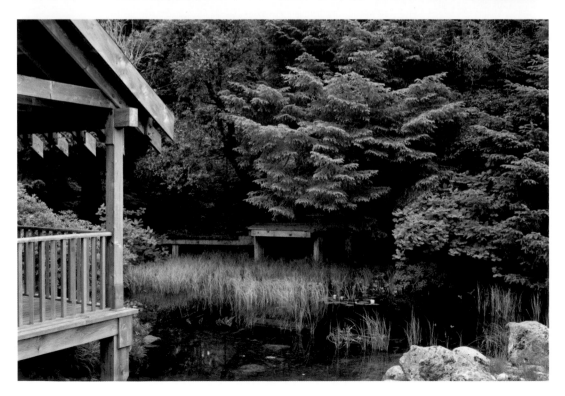

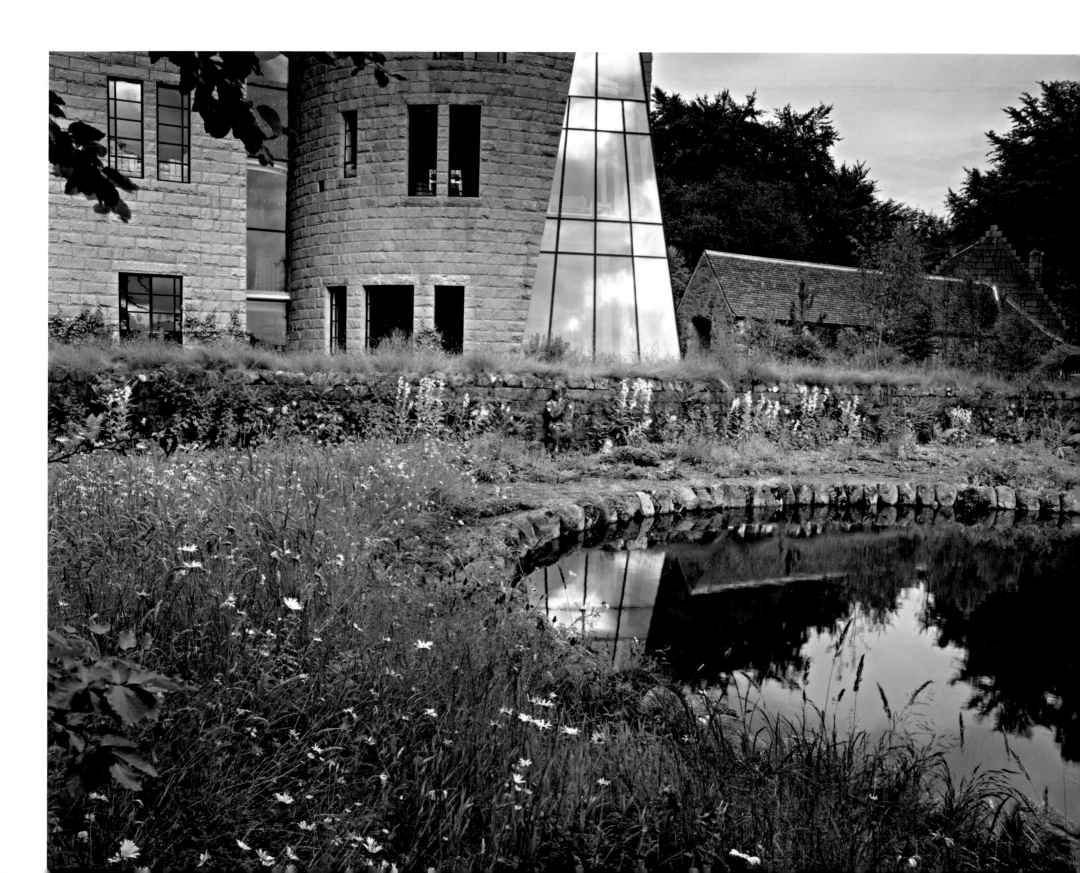

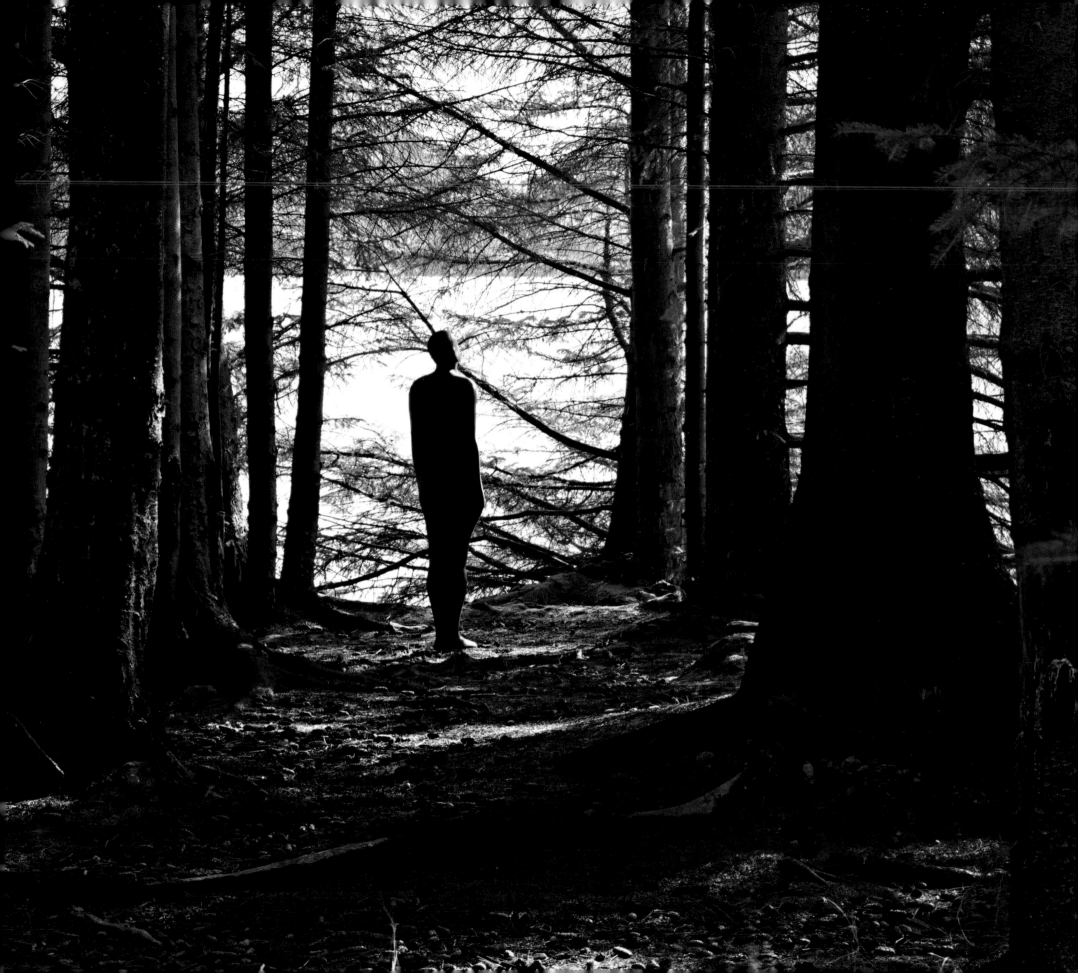

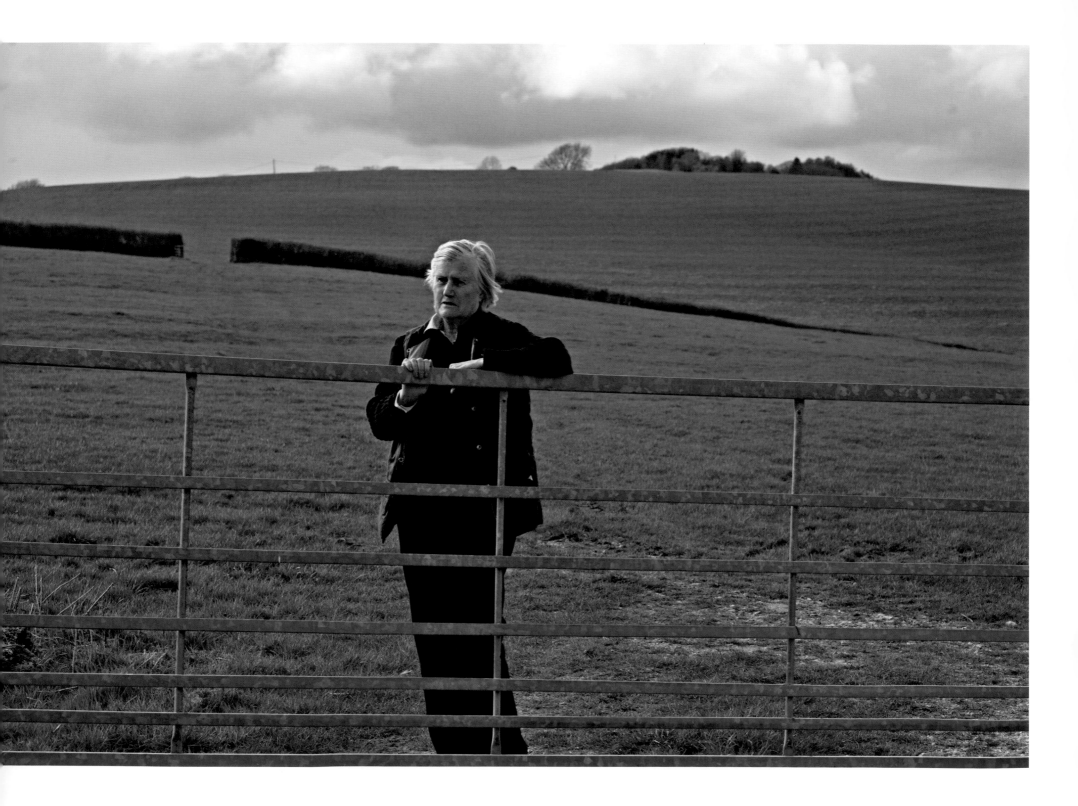

Penelope Hobhouse V.M.H.

The Monks Garden, an Island in the Inner Hebrides

This small walled garden is on a windswept island in the Inner Hebrides. It was designed for clients who live on the coast north of Boston across the Atlantic. While north-east United States has very cold winters, the island is washed by the warm Gulf Stream and has no frost, making it possible to grow a number of tender plants, especially some from New Zealand which are resistant to salt spray and storms. The principle hazard is wind which often reaches gale force and frequently changes direction, creating pockets of turbulence under the walls. There are no trees, except for a few stunted willows, growing on the island, but the garden is protected from the north by the Ben, its highest hill.

My approach was to make a network of hedges in an asymmetrical pattern to avoid wind funnels and I used privet that grows so well on the east end of Long Island. For the first few years these were wrapped up in burlap to prevent wind scorch but are now thriving. The compartments created by the hedges provide almost wind-free spaces in which shrubs, perennials, herbs and vegetables can thrive. One 'room' reflects the planting done by 14th century monks who owned the garden attached to their priory. The island was the first land visited by Saint Columba on his way from Ireland to Iona. Another garden compartment takes its theme from the plants used by Gertrude Jekyll when she laid out a garden on the Holy Island of Lindisfarne in the early 20th century. It has salt-resistant silver-leaved plants.

Elsewhere there is mixed planting of rugosa roses, peonies, New Zealand shrubs and bulbs, all of which survive the rugged conditions, and seem to enjoy the Atlantic storms. The clients look after the garden impeccably.

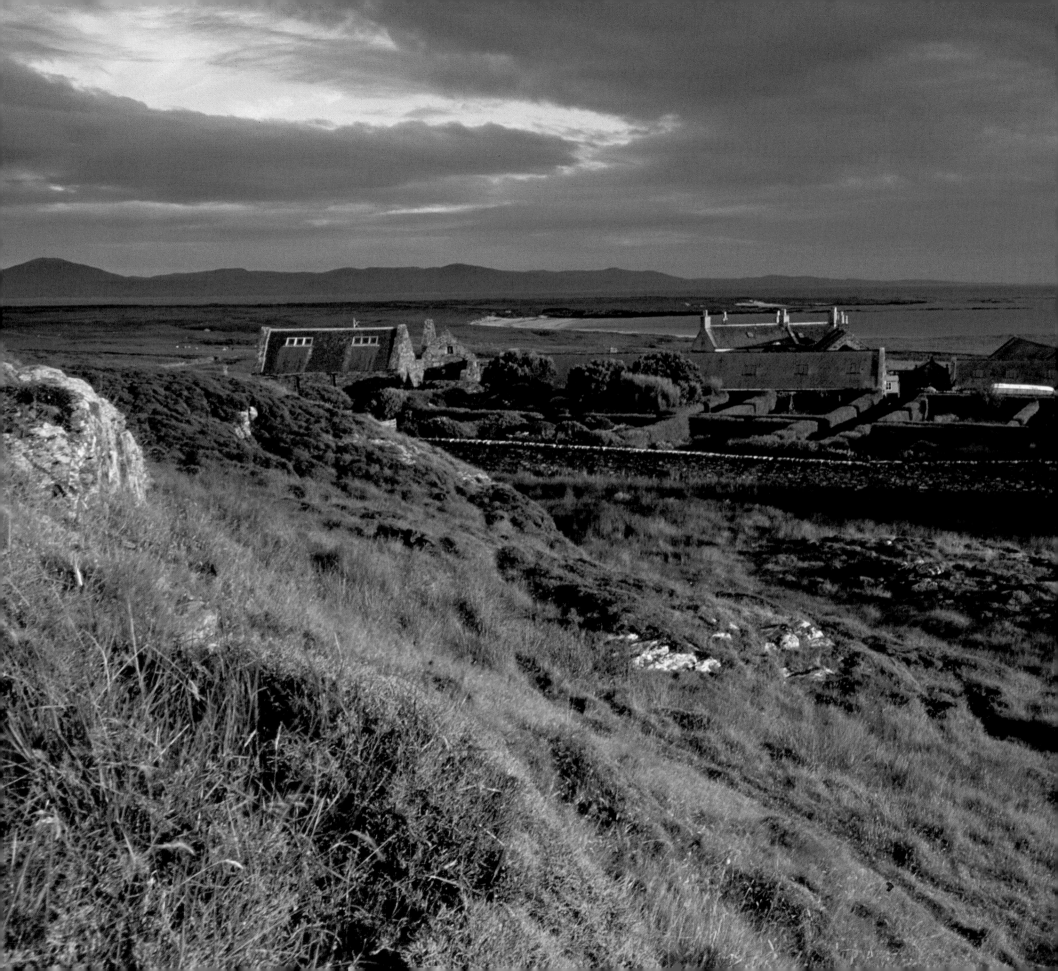

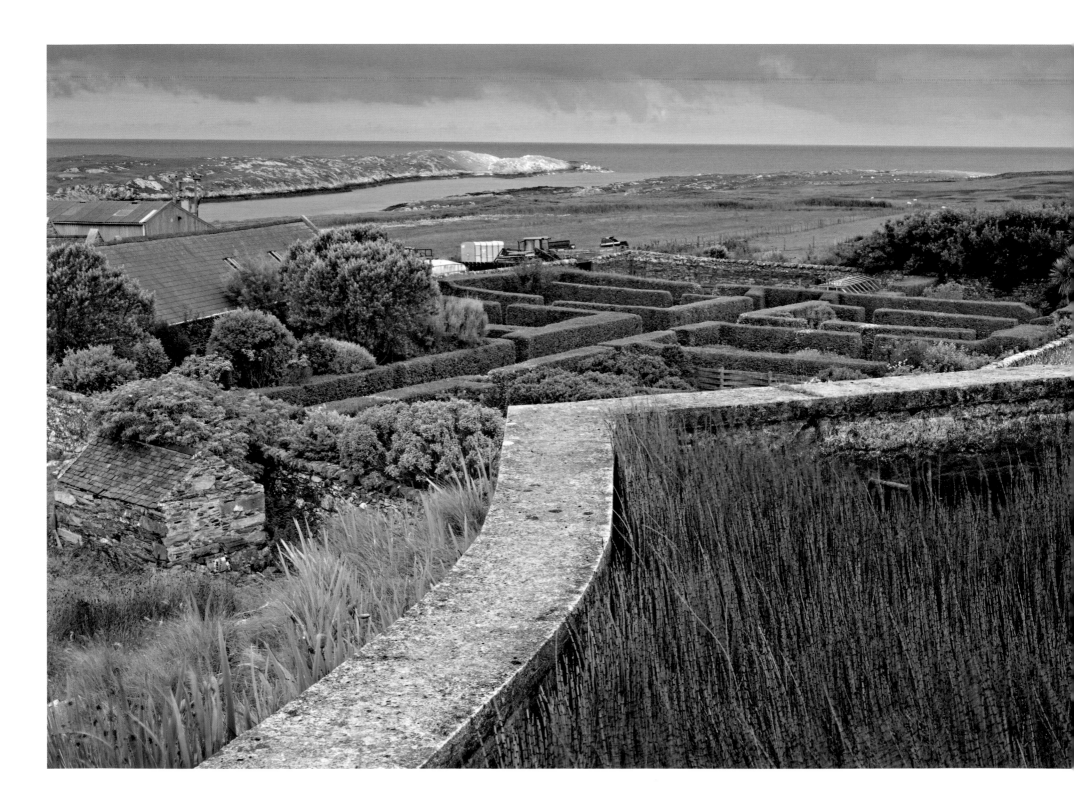

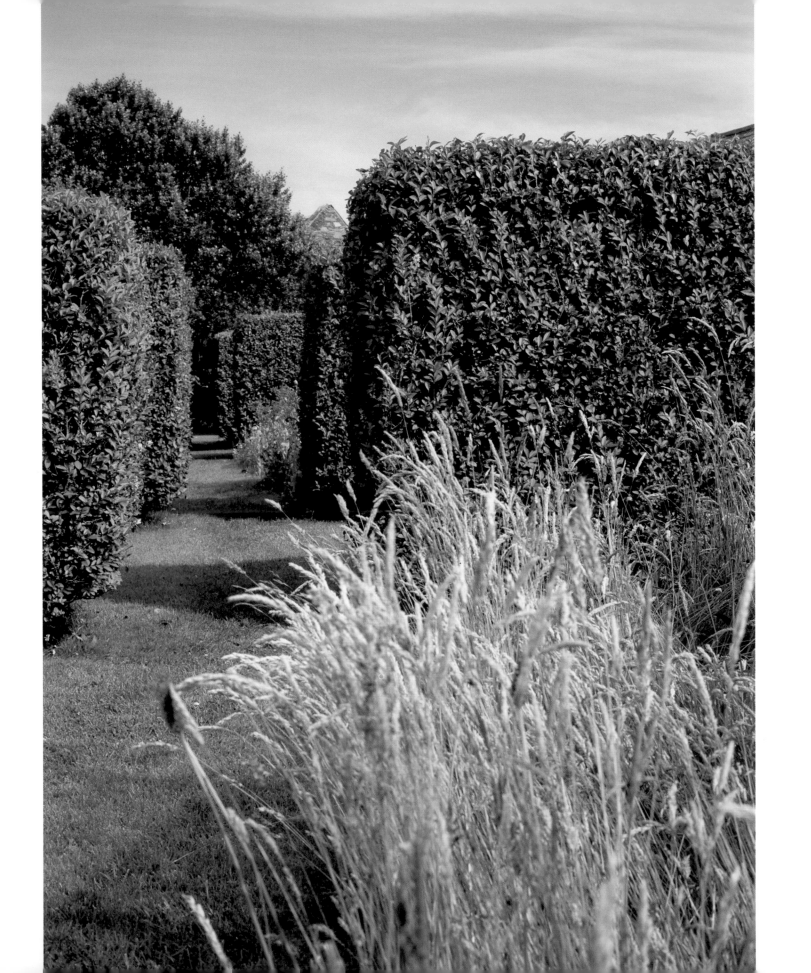

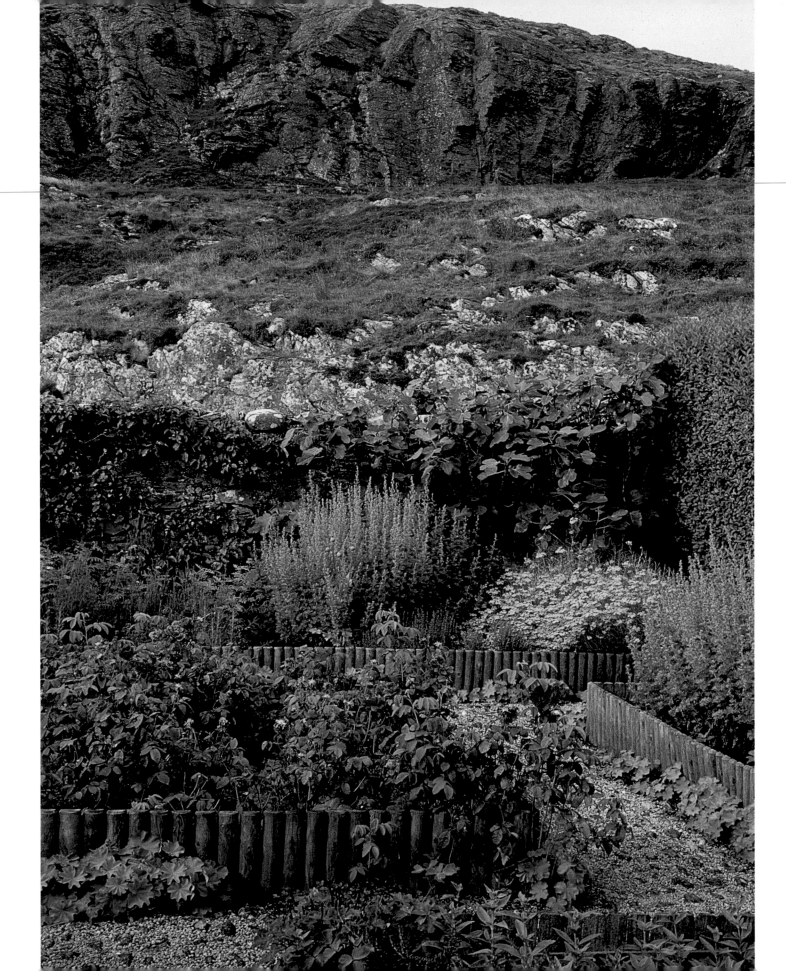

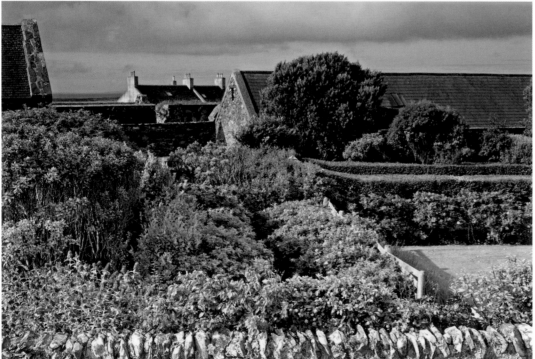

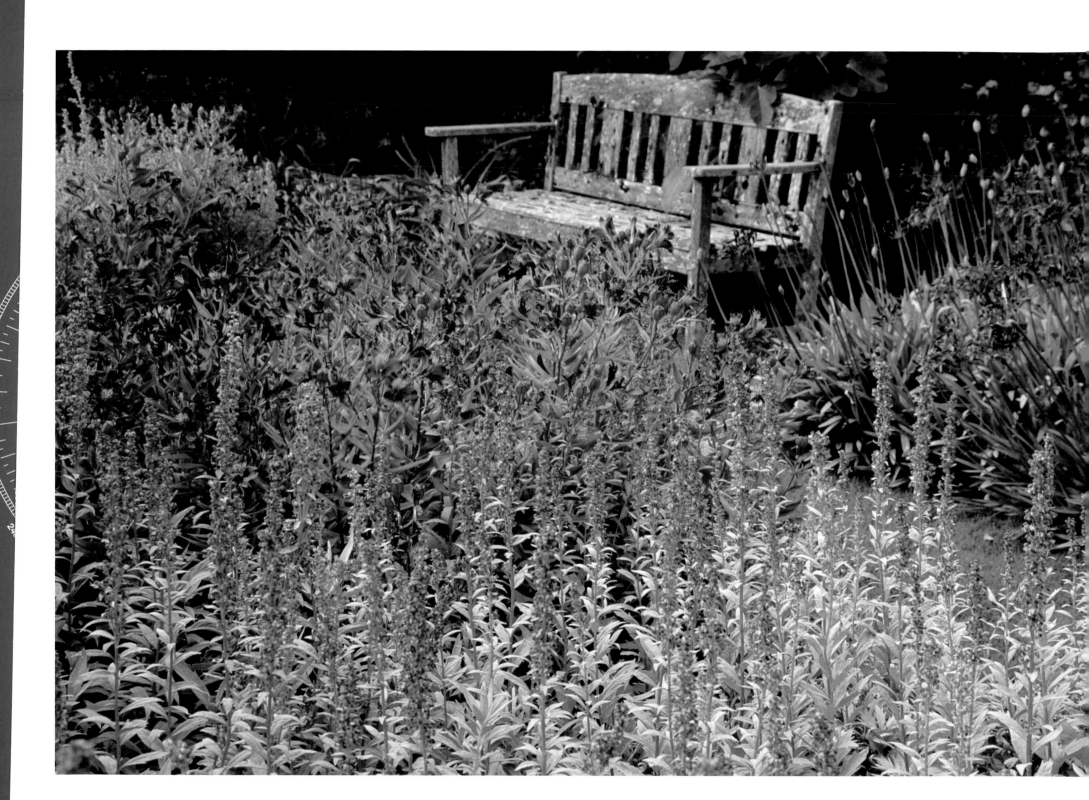

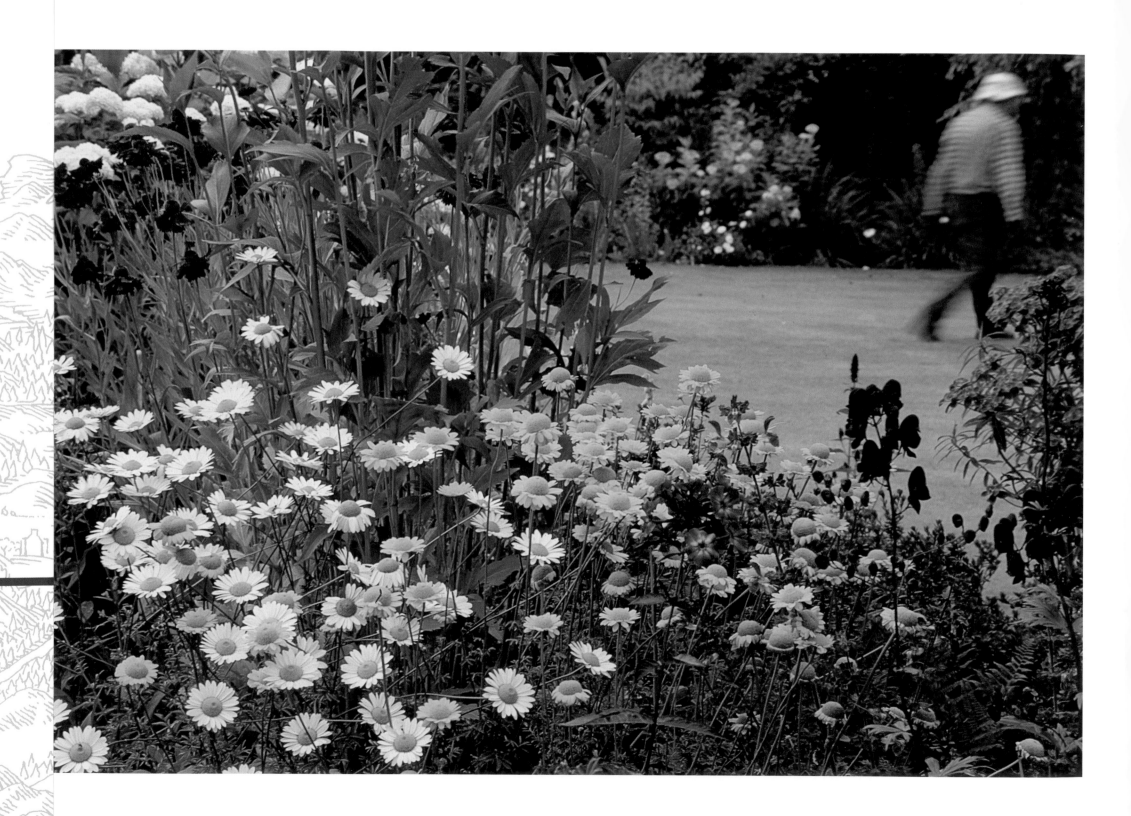

Dr Thomas Smith

Rubislaw Den North, Aberdeen

This garden has been in a constant state of reconfiguration during the last few decades. The changes continue. They result from how I change whilst living and working in North East Scotland.

The landscape has been a major influence, particularly the Scottish mountains under snow. Also, the lowlands of Perthshire and Aberdeenshire with the beautiful valleys of Dee and Don and their hinterland of rolling rich farmland and coastal fringe of rock and sand.

Equally important has been my experience of the people and culture of Aberdeen and Aberdeenshire. It has seemed to me that there was a respect for learning, which helped make a good climate for the scholarship pursued in the university. This was enhanced by the memory of illustrious predecessors such as the great Scottish philosopher Sir Thomas Reid who was born near Aberdeen and the greatest Scottish Natural Philosopher James Clark Maxwell who worked here.

Gardens are experienced holistically, but this experience is most rewarding when the whole is composed of many parts. One part will usually be a concern for the plants as living entities with their differing colours and forms. One will be an aesthetic response to colour and pattern in the different garden areas and in the garden as a whole. Another, especially for those who love the mountains, can be the response to sculptured spaces resulting from the contours of the land and from the vertical planting. It is always stimulating to look at gardens and landscapes in this way. However, an intellectual response can also be pleasurable. So the knowledgeable spectator might consider where the plants grow wild, their taxonomic and phylogeny etc. Also the garden structures and sculptures may suggest something of a garden's relation to the encompassing world. Thus, in this garden a sequence of plants illustrates their evolution, a very ancient Lewisian Gneiss rock and a ruined 'observatory' with a sky 'telescope' of narrow poplars elicits an experience of the garden as embedded in space-time. Further sculptures with quantum mechanic and relativity equations recall to the spectator other hidden aspects of the mystery in which both gardener and garden live and so the total experience is enriched.

Gardens can also feed the spirit. They can be for contemplation, for meditation, for imagination, for poetry and for philosophic reflection. These moods are nurtured by the planting, views, seats etc. In this garden they are also influenced by philosophic and spiritual inscriptions. (In the nearby garden made in 1604 in Edzell Castle, one can still see the sculptured panels in which Sir David Lindsay alludes to the learning and spirituality of his world with panels representing the Planetary Deities, the Liberal Arts and the Cardinal Virtues.)

Both the making and the viewing of the garden landscape can be an act of artistic creation in which the gardener or garden visitor explores and engages with the richness of the contemporaneous world at every level. It is an active dialogue in which the world, particularly its plants, are as important as the action of the gardener or the garden visitor.

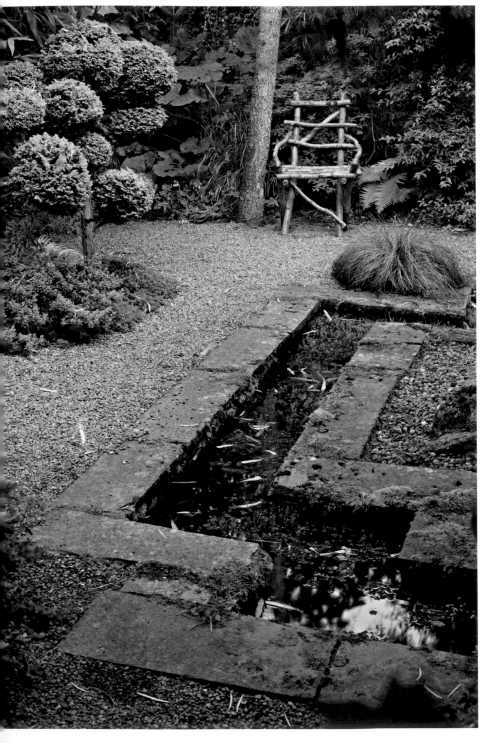
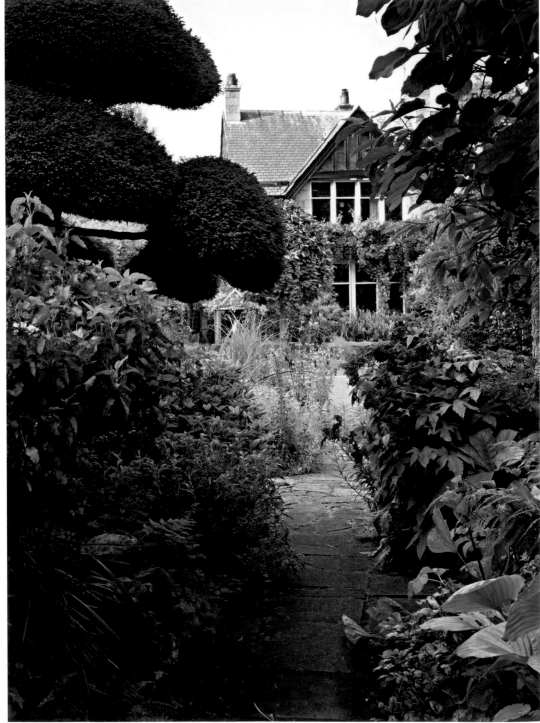

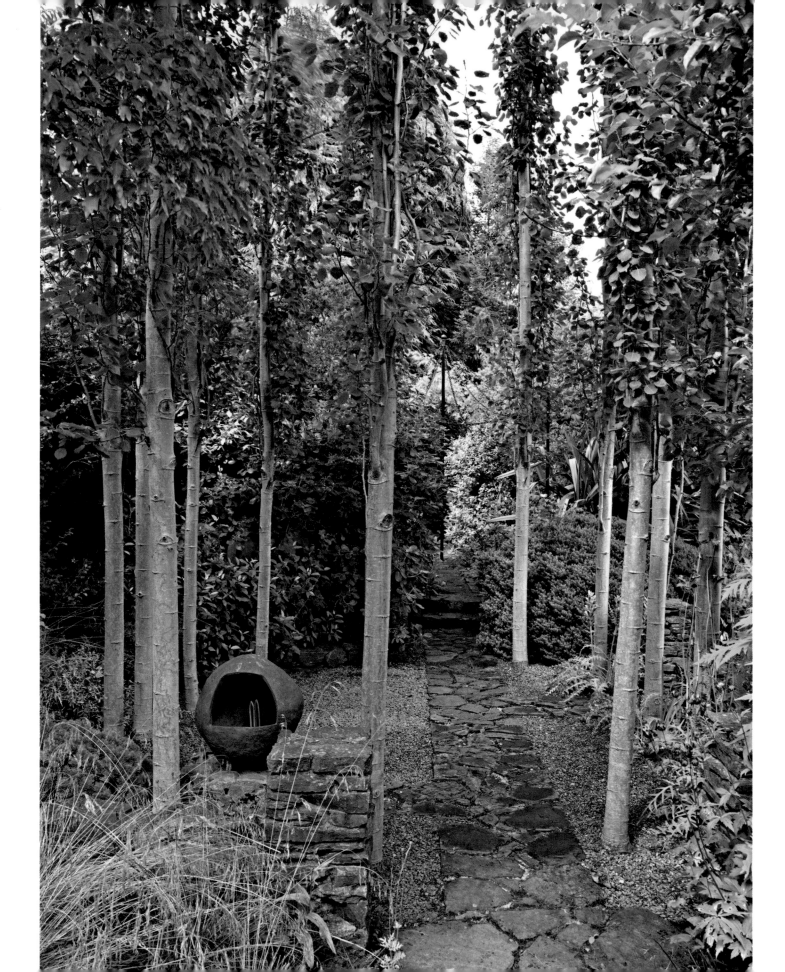

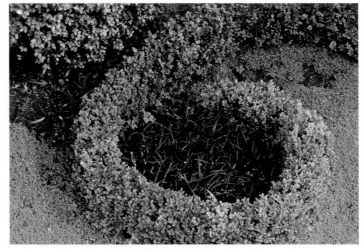

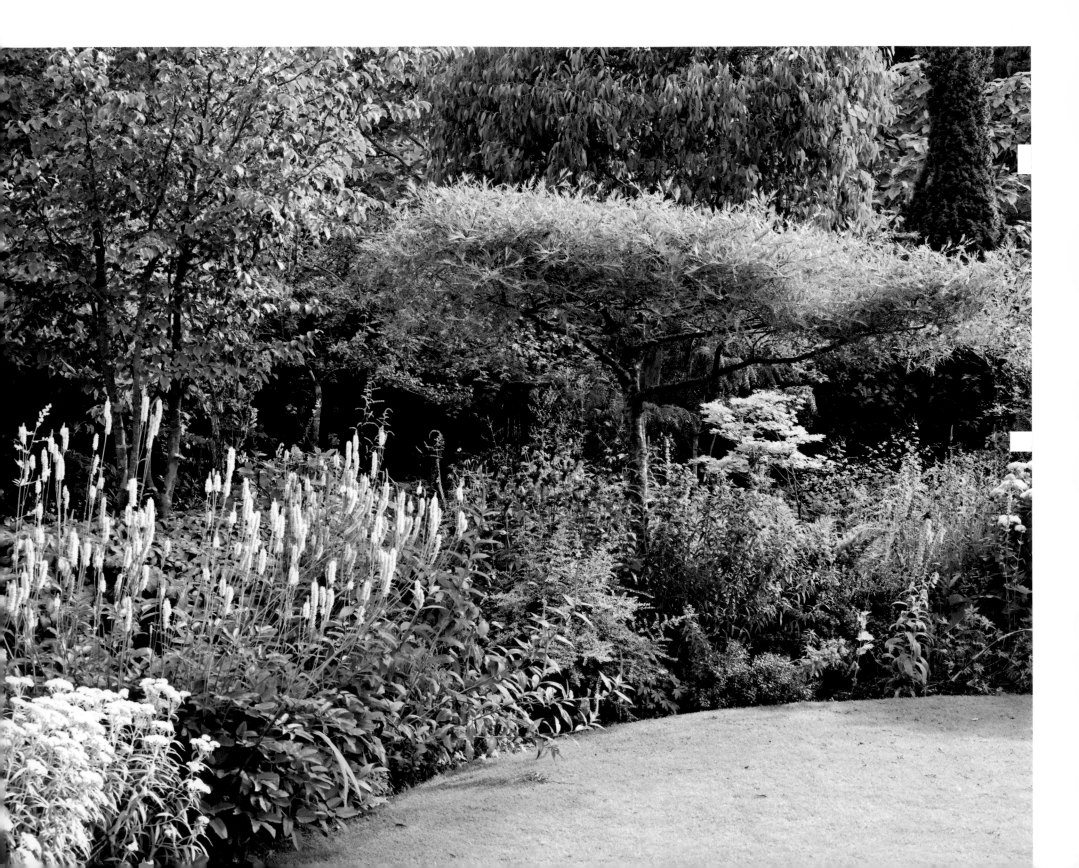

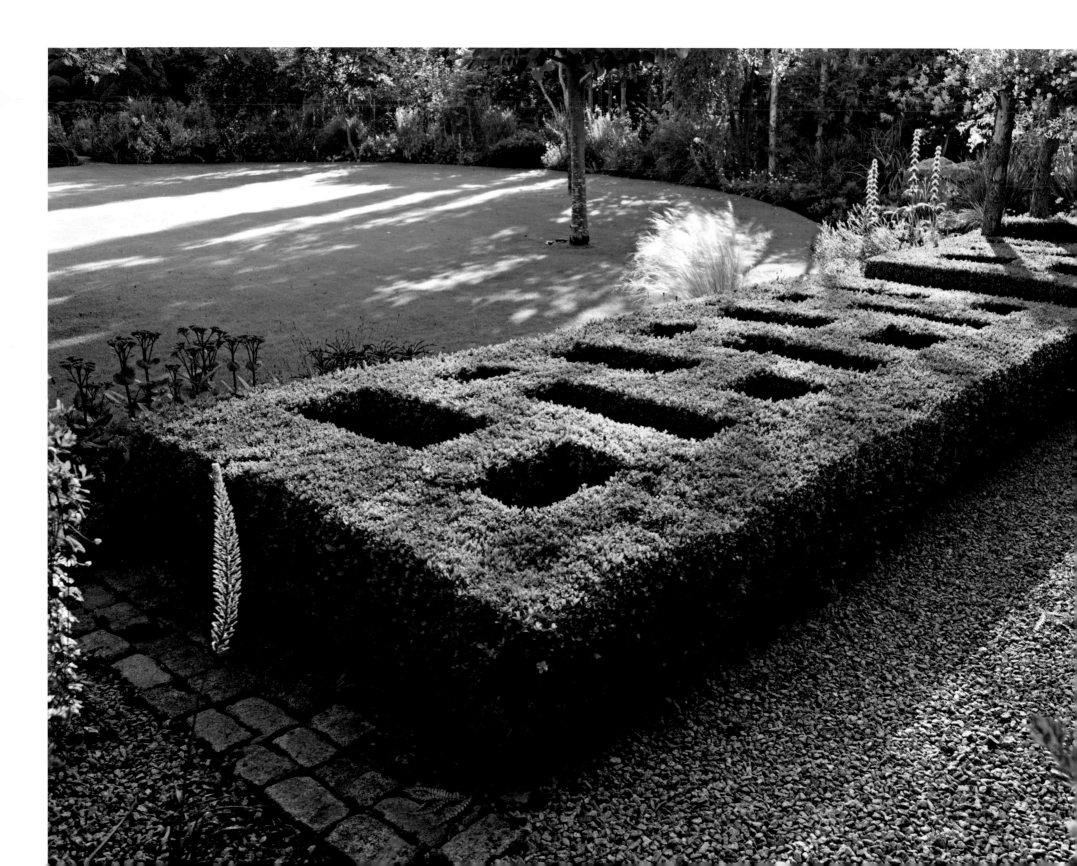

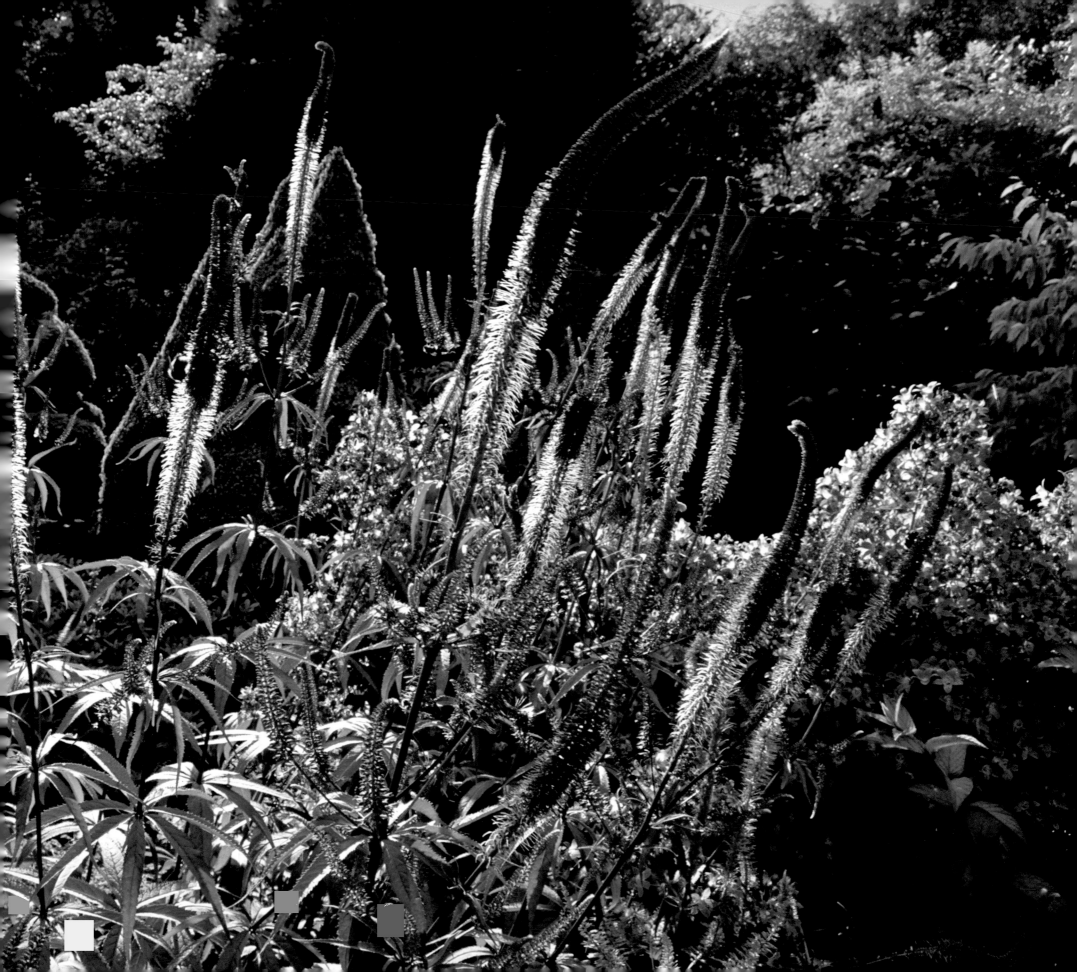

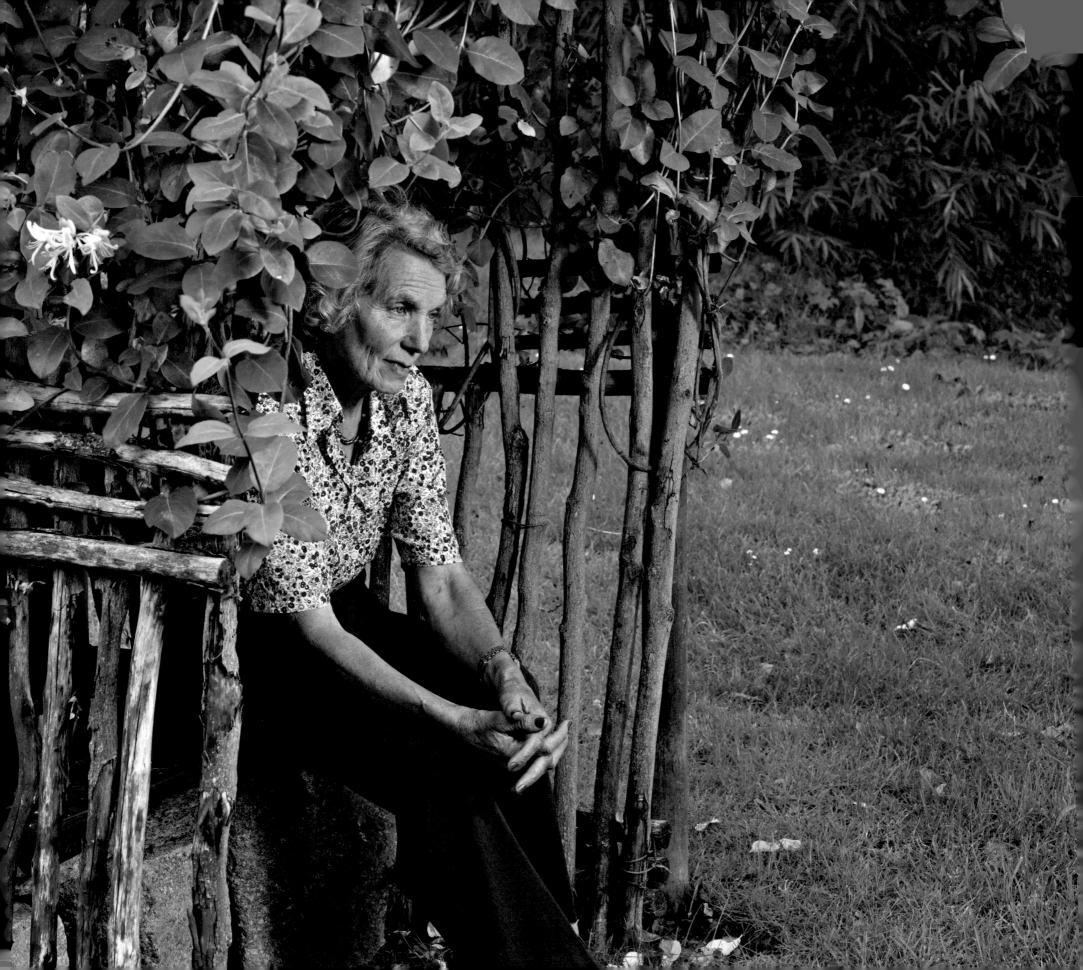

Mary Ann
Crichton Maitland

Daluaine, Aberdeenshire

Daluaine, originally a manse, was acquired nearly 40 years ago. Untended for many years, the small early 18th century walled garden is now a riot of colourful herbaceous plants. Facing south on a gentle slope, it is protected from the harsh North Eastern climate by a stand of fine old beech trees on the North side.

The glebe land below the house was added 12 years ago. From an exposed docken and nettle patch, it has become a 4 acre arboretum on a steep slope above the river Bogie. A wide variety of trees and shrubs have been planted to blend together, particularly for their leaf shape and autumn colours. Many paths have been cut into the slope to enable this area to be viewed at all angles. Sorbus, betula and acer abound.

This is a garden for all seasons. It has evolved over the years with no particular plan. I am an avid collector of plants, but seldom buy on impulse and tend to hunt for something for a particular area or idea.

Nothing is cut down until the Spring, as winters can be severe. The plants are protected by their own leaves and stalks and add interest in frosty weather and shelter for the many birds who love this garden.

Many visitors come now and it is a pleasure to share it.

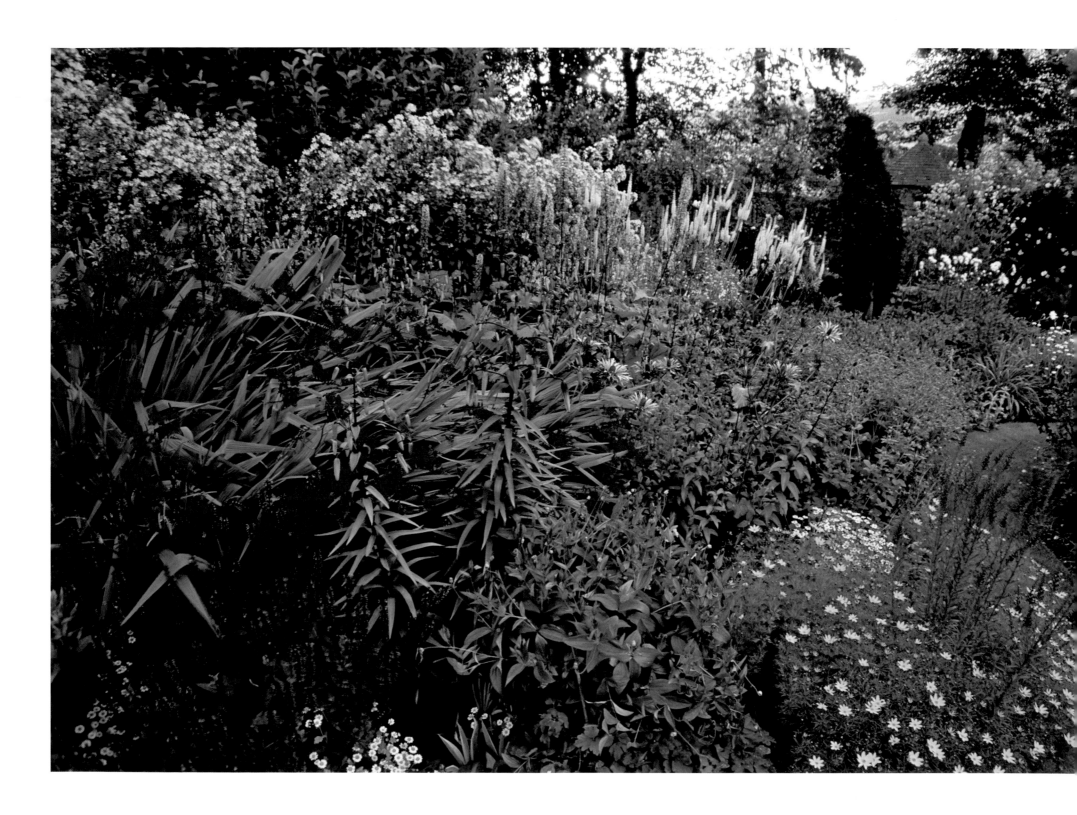

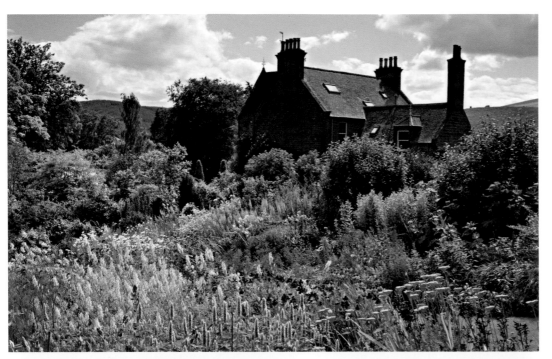
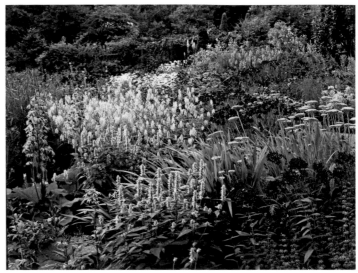
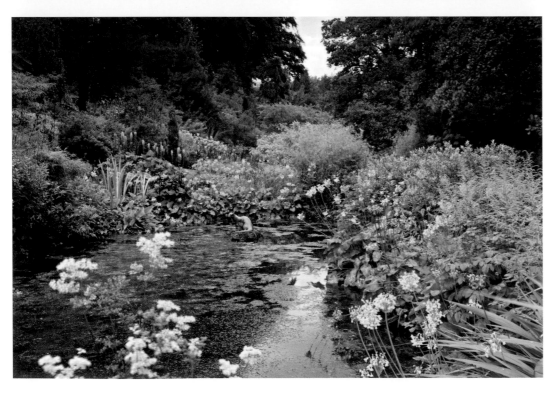

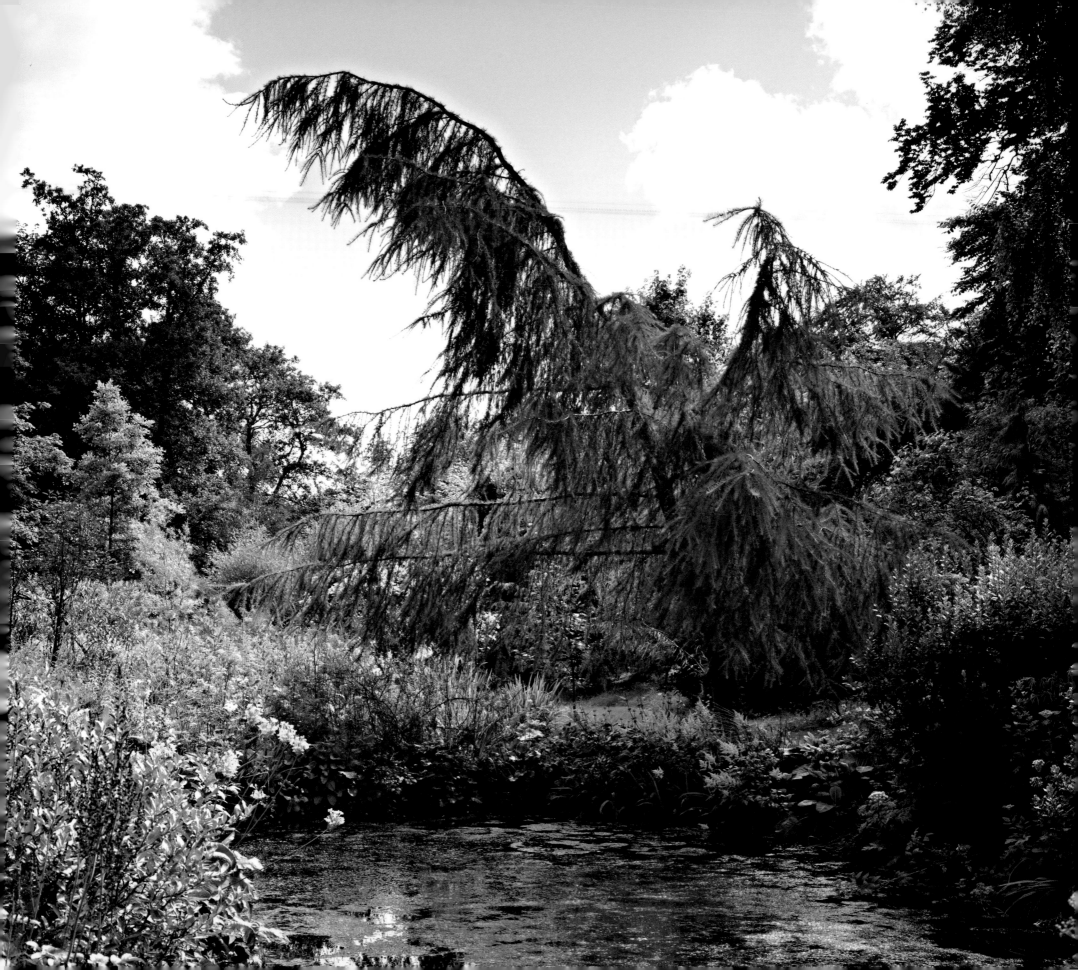

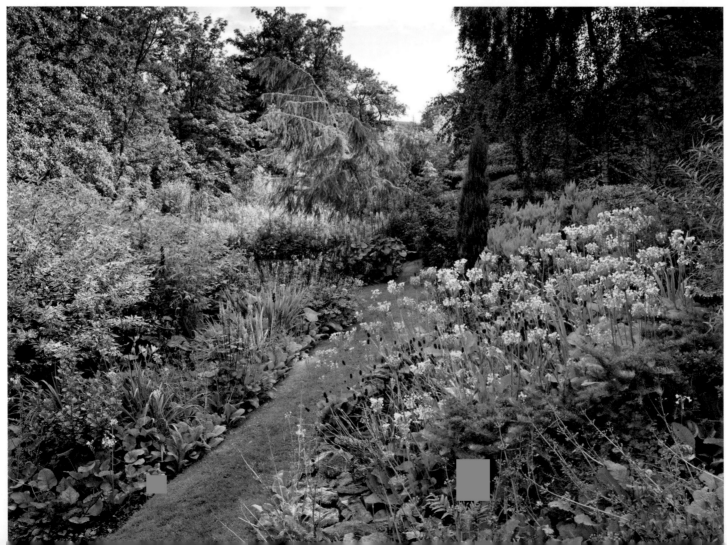

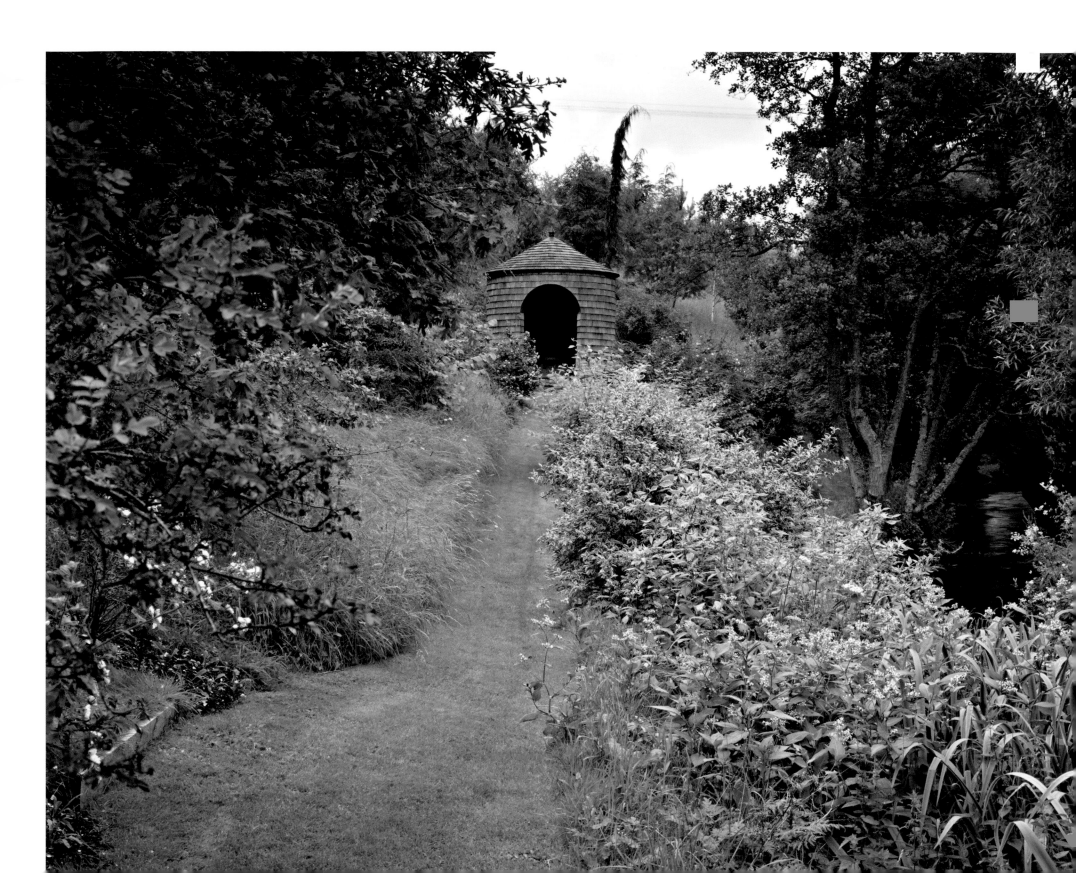

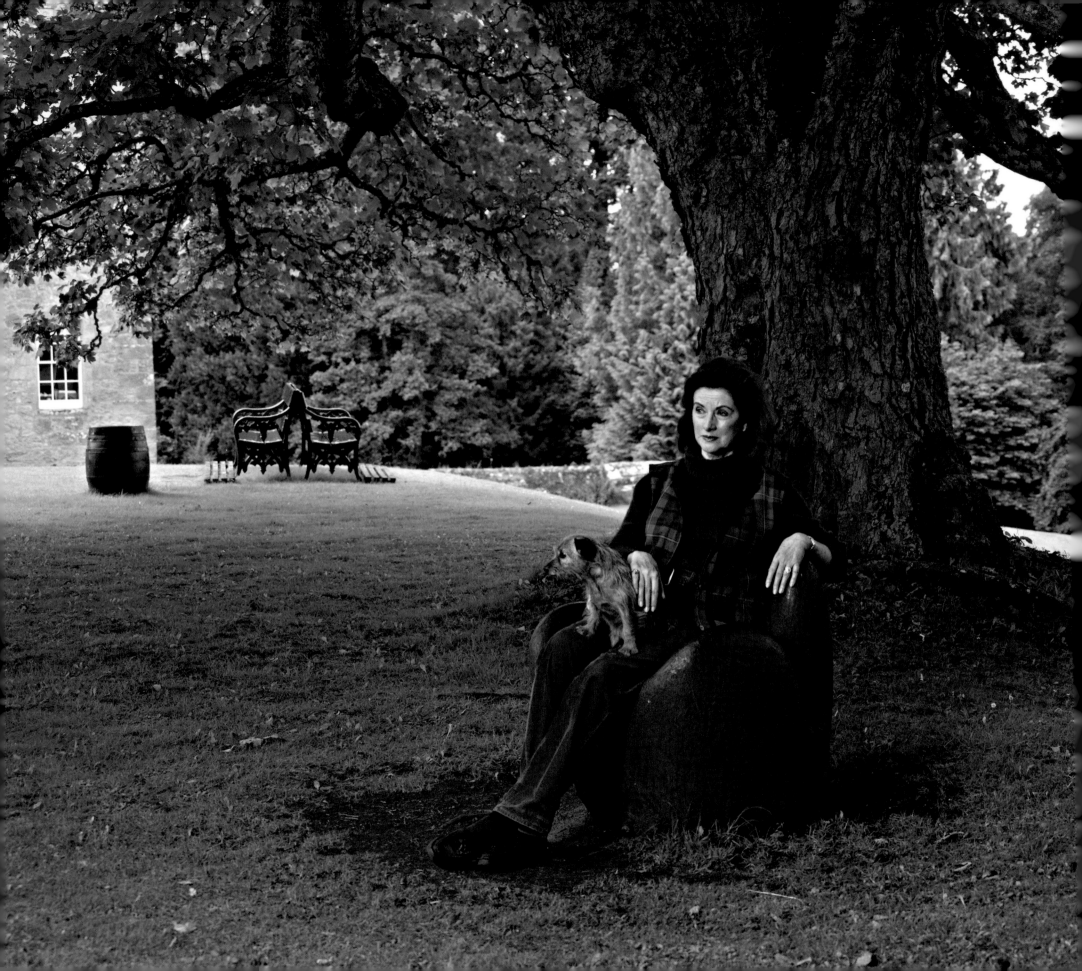

Angelika, Dowager Counctess Cawdor

Cawdor Castle Gardens, Nairn

The Castle dates form the 14th century and has been lived in by the family in a direct line ever since. The Cawdors have been keen gardeners over generations and enthusiastic plantsmen, passionate about trees. The sycamore trees on the front lawn were planted in 1710 by Sir Archibald Campbell, the Thane's brother, who was then managing the estate. The lime trees that surround the Castle were planted by him in 1717.

Cawdor is fortunate in having three gardens. The oldest garden, north east of the castle, was enclosed with walls and bastions in 1620 and was cultivated in the old fashioned manner with soft fruit, flowers, vegetables and an orchard. In the 19th century it was enlarged and became a model vegetable garden with two greenhouses, growing grapes, peaches and figs as well as a large variety of potted plants.

Hugh, the 6th Earl Cawdor, opened the Castle to the public in 1976. By 1980 the produce from this fertile patch far exceeded the needs of the family and household staff. Surplus vegetables glutted local markets and the Castle restaurant; the quantity of fruit ripe or unripe was more than visitors, conscience akimbo, felt able to devour in showery weather. Therefore, we made up our mind to renovate. In the section of the garden nearest the Castle, Hugh planted a holly maze. The pattern for this was taken from a design set in the mosaic floor of the ruined Roman villa on Conimbrigia in Portugal, and which in classical form depicts the Minotaur's labyrinth at Knossos in Crete; a conundrum devised, mythologically, by Daedelus.

In the second half of the garden I planted symbolic gardens:

Paradise – the sound of water, the smell of flowers and peace are its main ingredients. It is round, because all is one in the Universe. The entrance is difficult to find but the reward great when you get there. It is planted with shrubs and flowers that flower in shades of white to create peace, and has a bronze fountain that tells the story of my personal cosmology in the middle.

Earth is represented by a knot garden; the design of the knots was taken from a 17th century Scottish sampler in the Castle. They are planted in box and filled with plants that were used at the time either in the still room, kitchen or as medicine. In the middle is a seven-pointed star which symbolises the seven kingdoms of the planet – earth, air, fire, water, animal, vegetable and mineral.

Purgatory is filled with a large variety of thistles and roses and the Garden of Eden has a good selection of old Scottish fruit trees.

The Flower Garden to the south of the Castle was laid out in the beginning of the 18th century with large herbaceous borders and great yew hedges. In 1850 Lady Cawdor added the oval rose beds, edged with lavender, which are still there today. This garden was originally designed for enjoyment in late summer and autumn, and is a riot of colour.

The Wild Garden on the bank of the Cawdor Burn gives another contrast, with rhododendrons and spring bulbs as well as bamboos, ferns and gunnera manicata.

Cawdor Castle and Gardens are open to the public every day from 1st May until the second Sunday in October.

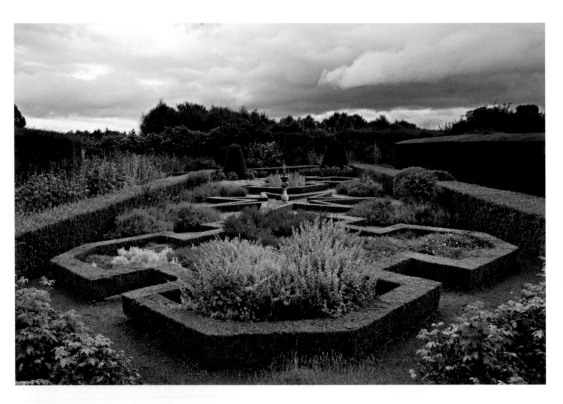

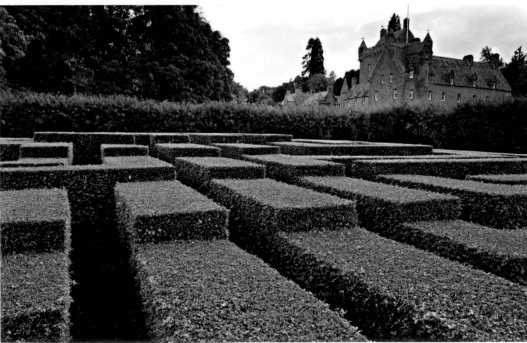

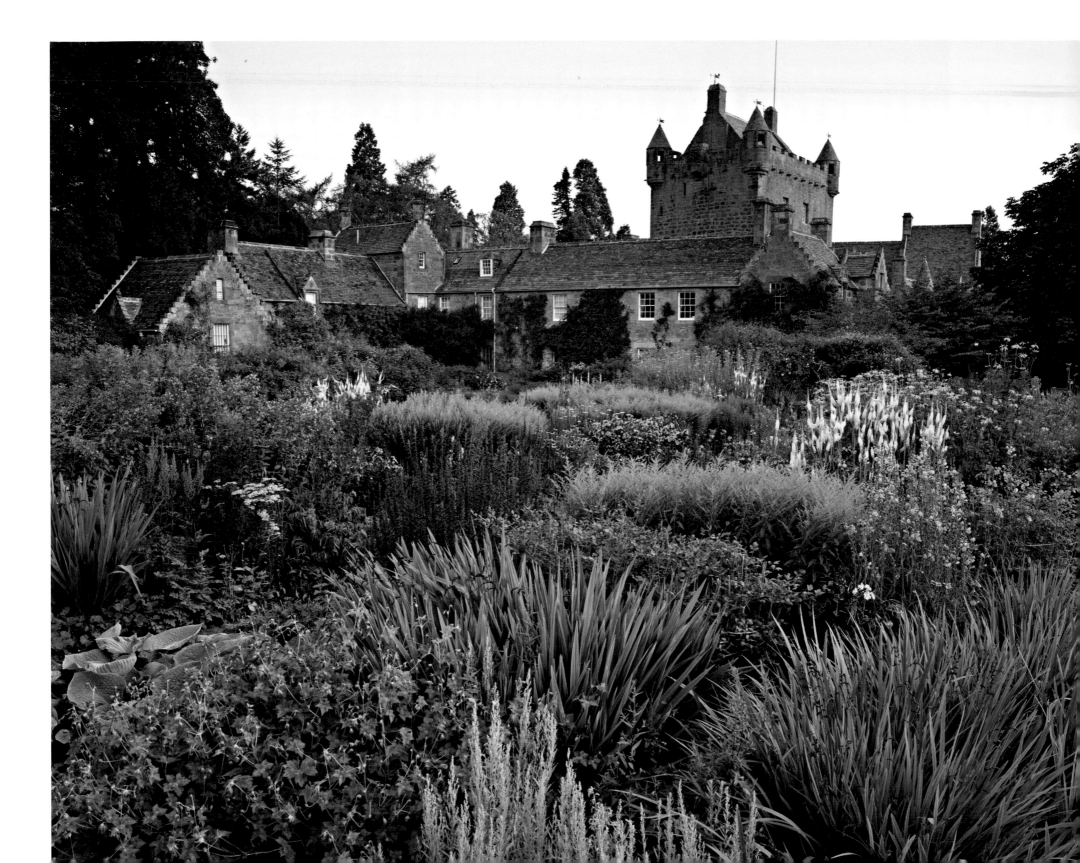

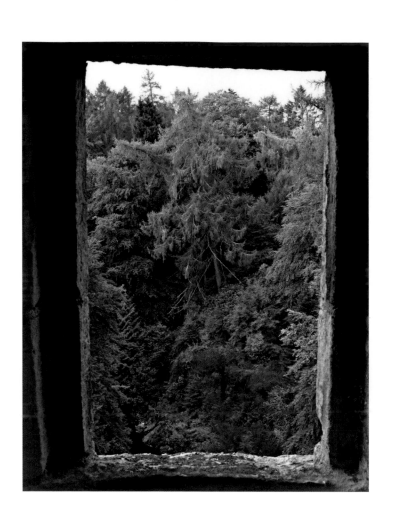

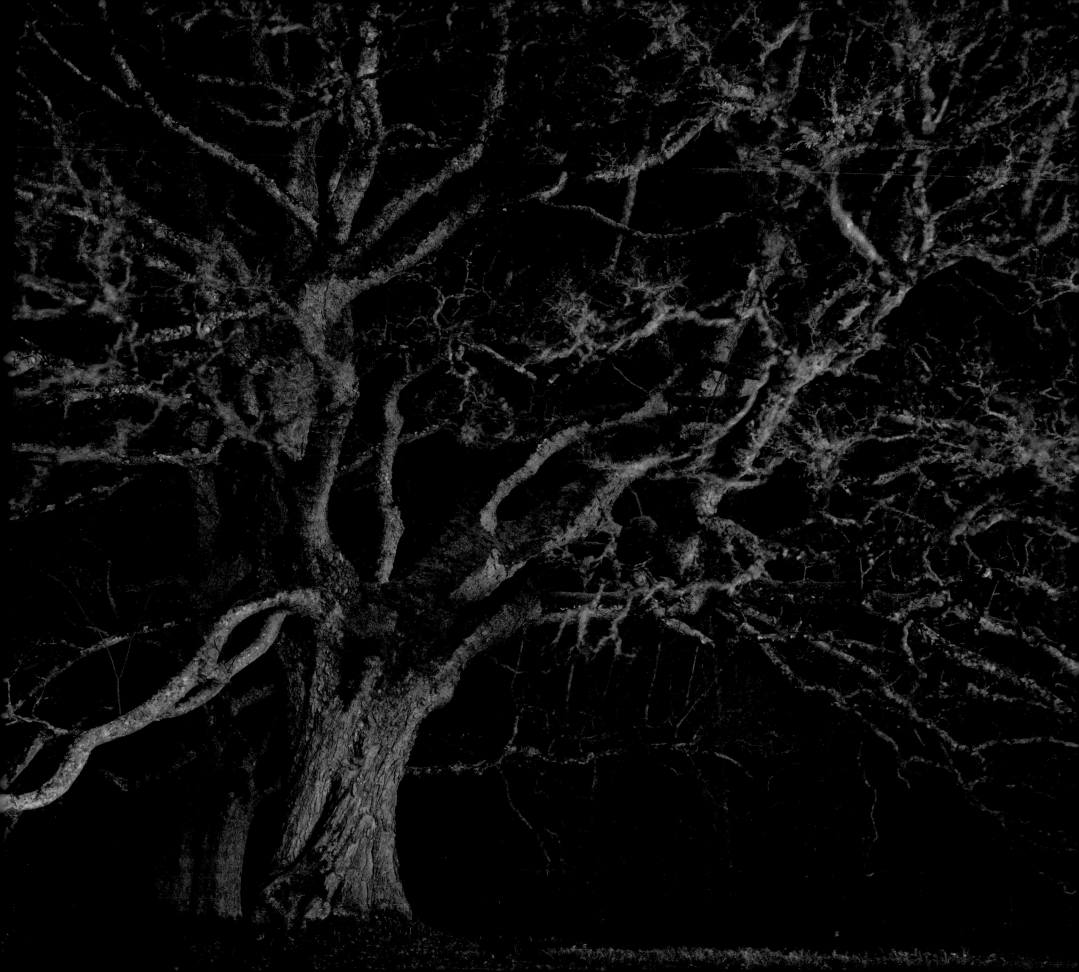

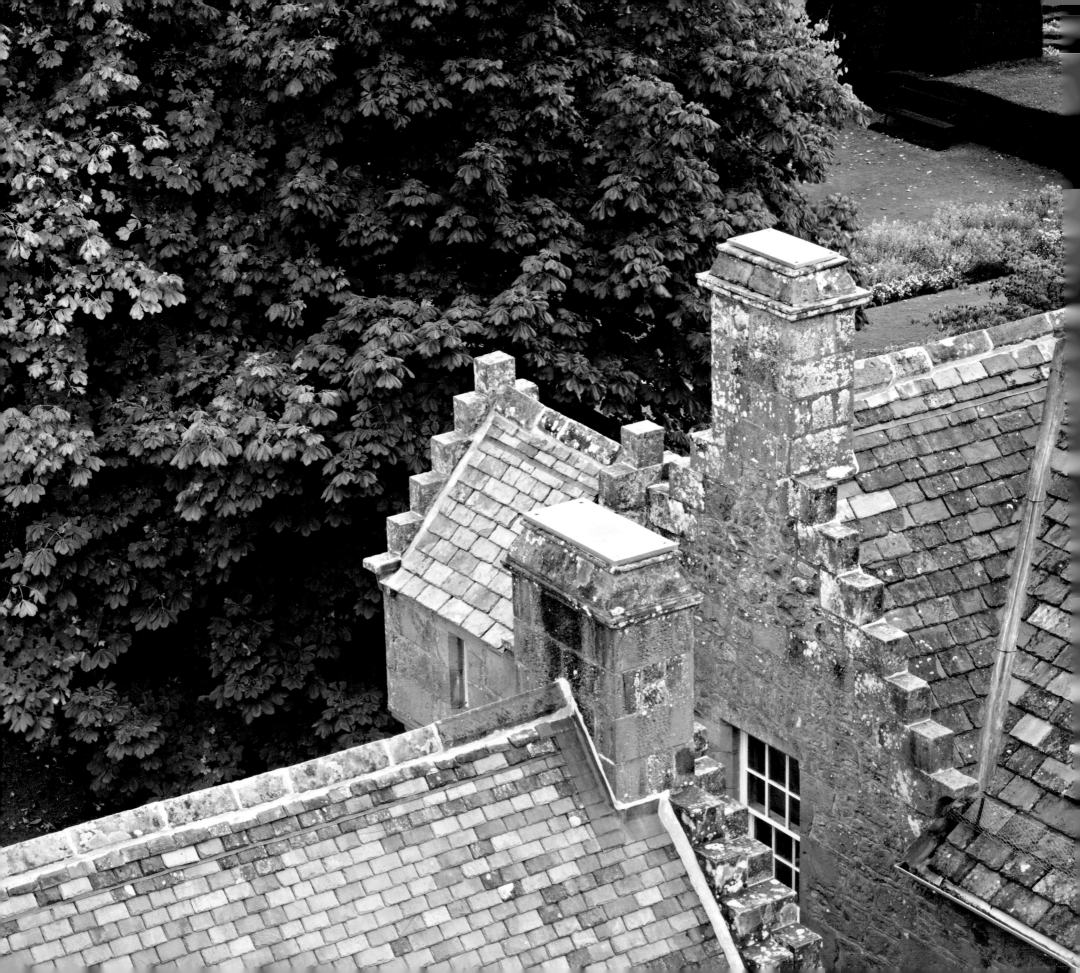

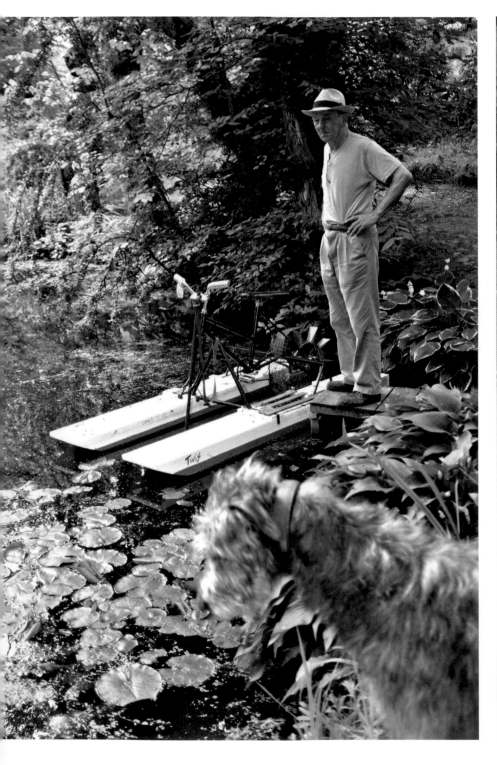

Gerald Laing

Kinkell, Ross and Cromarty

My garden is wild, sophisticated, and kept on a long lead. Gus, my gardener and friend, acts more as a referee in the continuous and ruthless Battle of the Flowers than a policeman trying to keep order. It is a more virtuous and humane role, and requires far more sensitivity. The sculpture which punctuates the text of the garden makes references that both complement and compete with the living vegetation. Some of it is in permanent residence, and some merely pausing before its journey to elsewhere begins.

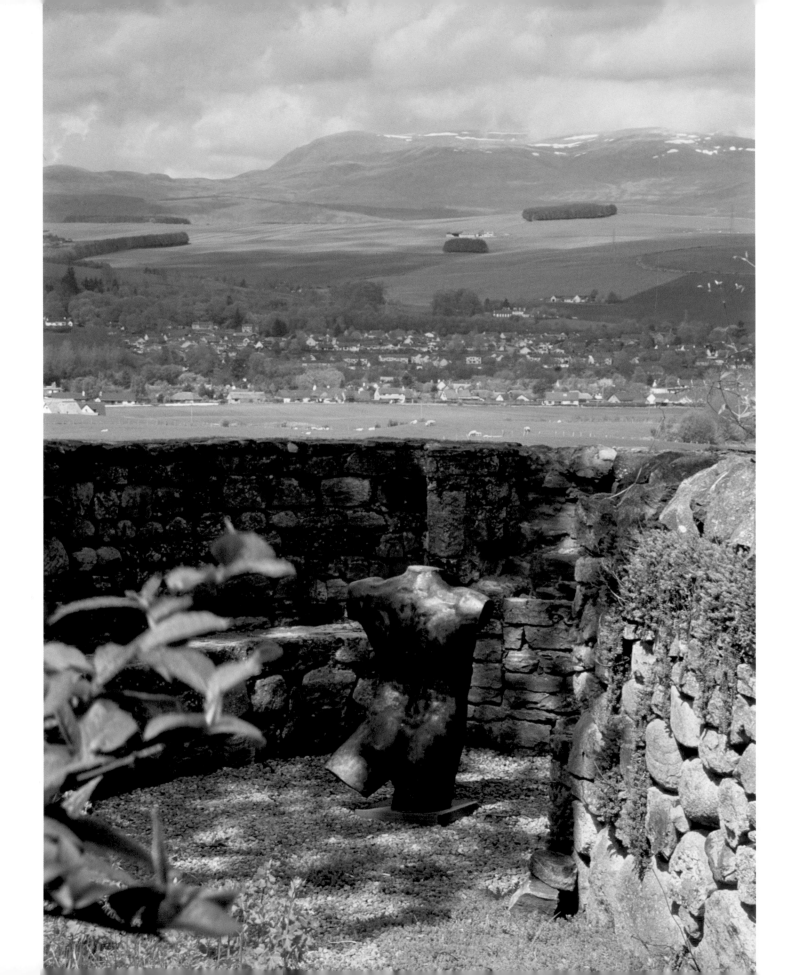

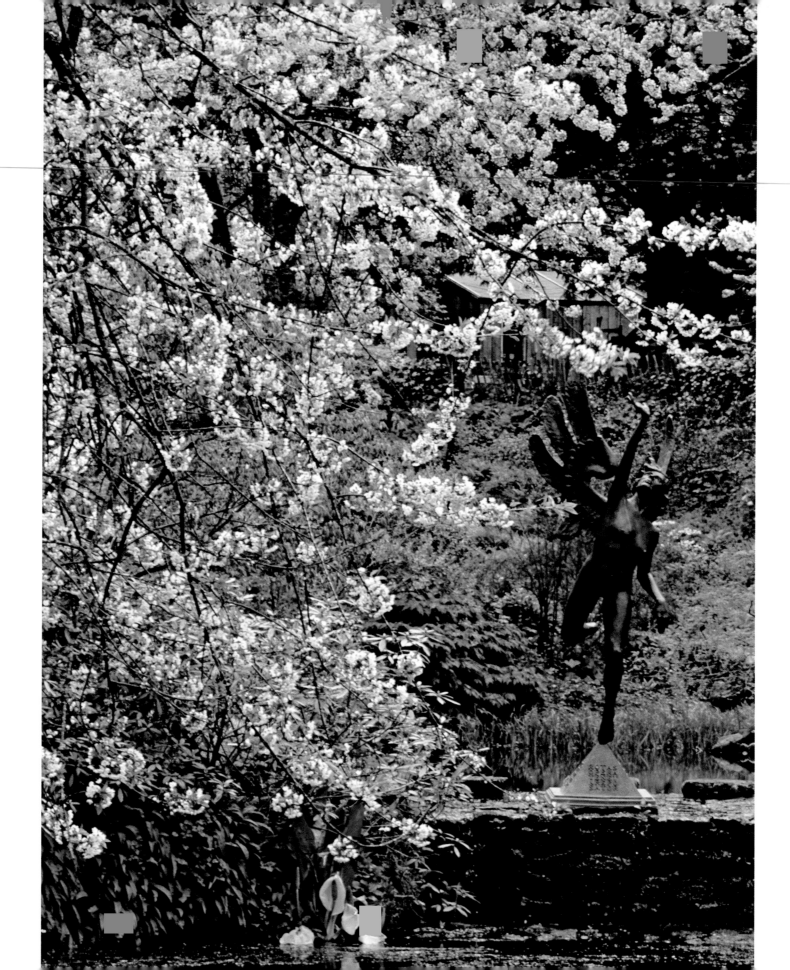

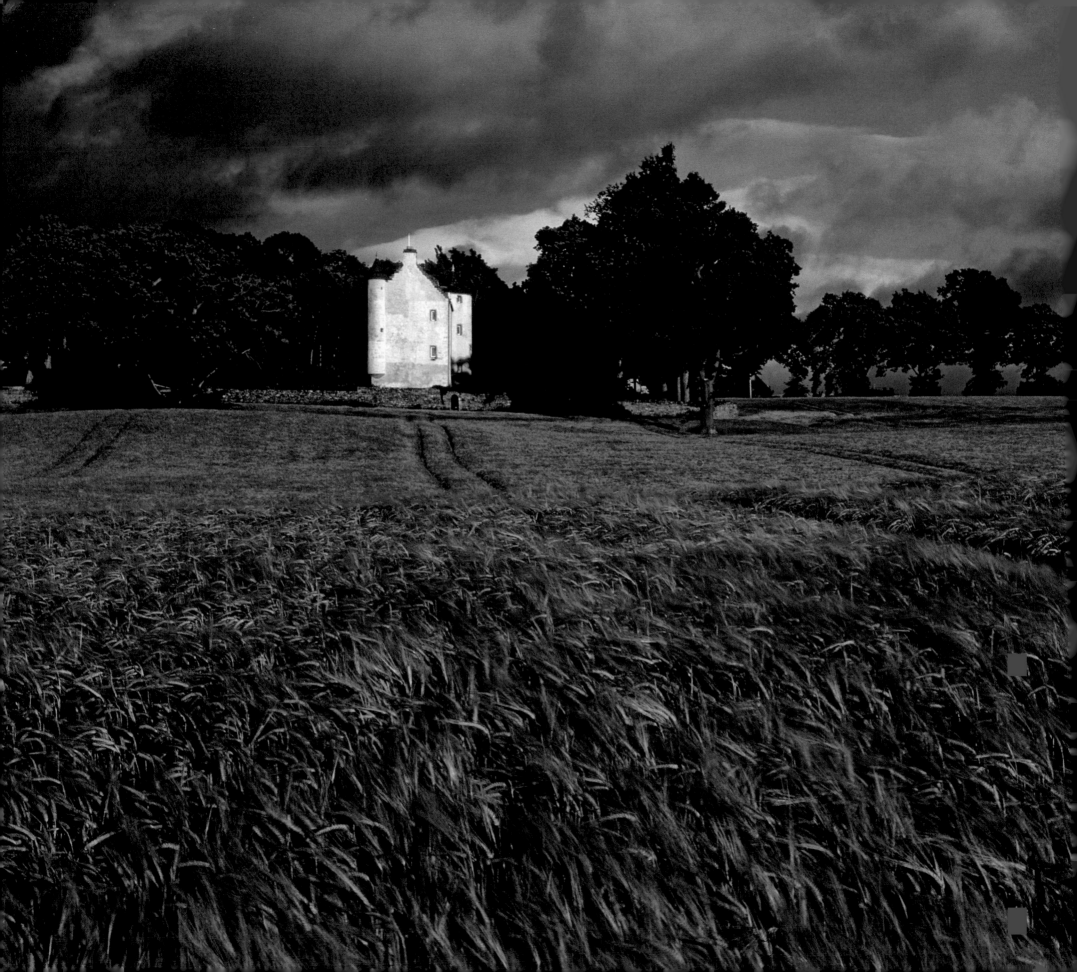

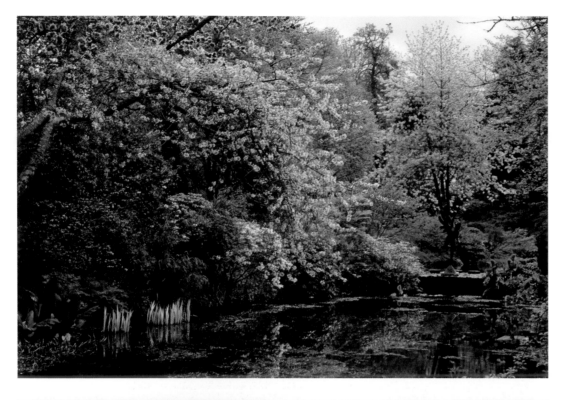

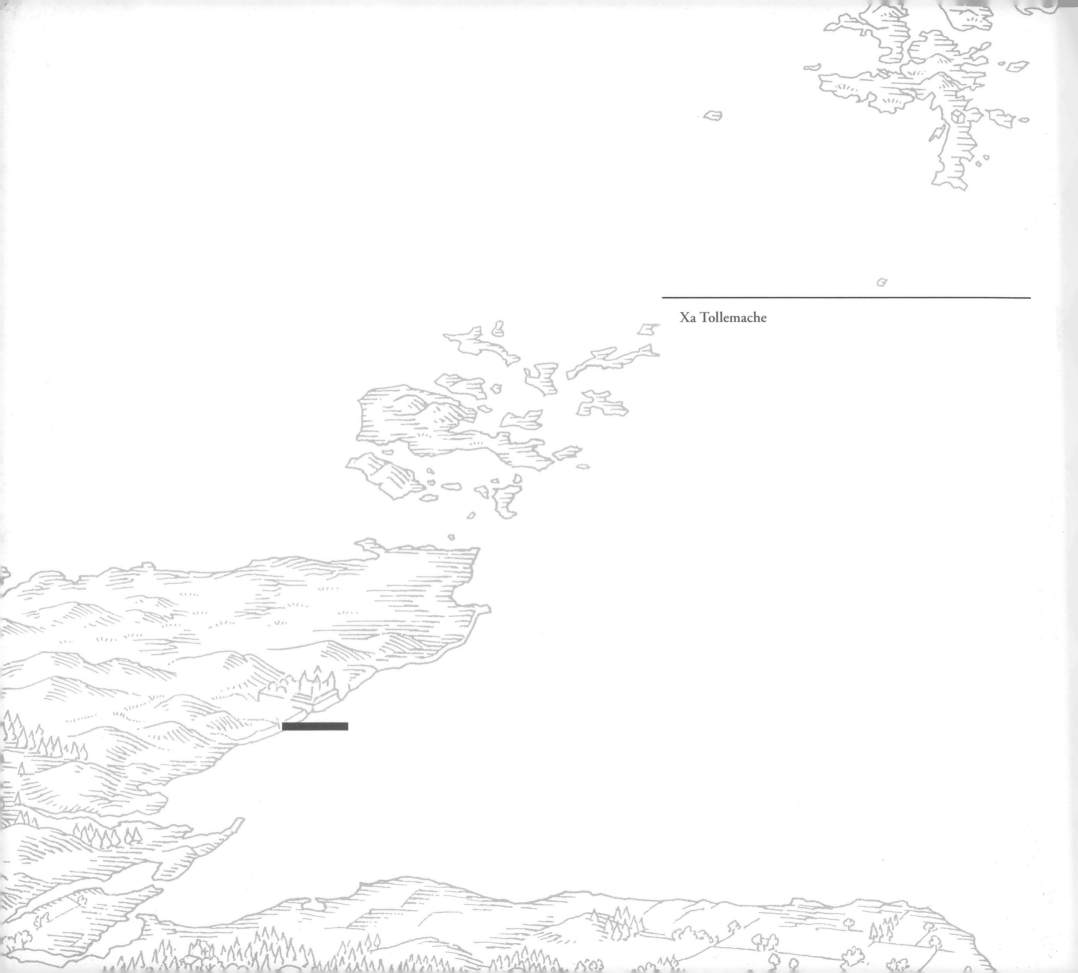

Xa Tollemache

True

Magnetic

30°

330°

60°

300°

270°

90°

120°

240°

150°

210°

180°

Xa Tollemache

Dunbeath Castle, Caithness

Spectacular Dunbeath Castle perched on a high cliff, jutting out into the sea, is 20 miles South of Wick in the far North East of Scotland.

The Earl of Caithness owned it in 1428 before it passed to the Sinclair clan in 1529. The Castle was remodelled in the 1630's.

The Marquis of Montrose took Dunbeath Castle after a siege on behalf of King Charles II in 1650 but they ran out of water and surrendered. Further modifications were made in the 1800's. In 1945 it was sold to an American, Stuart Avery, who sold it back to a Sinclair relative in 1995 when he returned to America.

In the mid 19th Century David Bryce remodelled and landscaped a driveway. As one enters past the lodge houses one glimpses the front door of the castle some ½ mile away. As one descends down the drive the Castle slowly appears encompassed by the steep staging banks and wind blown sycamores. It is an extraordinary sight.

There are two walled gardens either side of the driveway and I was brought in, in 1998 to remodel the southerly garden.

It was deeply conventional with a mixture of vegetables, fruit, shrubs and flowers growing, but lacked architectural structure to anchor it.

I introduced wrought iron decorative tunnels to divide this garden into rooms and planted a fuchsia hedge perimeter, being careful not to take away from the feeling of space. It was important to retain the working aspect of the garden and at the same time to introduce decorative planting schemes. So there is a working vegetable garden but also a decorative vegetable garden. Fruit is treated in a similar way. From the bottom door, running up the middle of the garden are two magnificent borders dividing the various 'rooms'.

A greenhouse at the top houses a fine display of hot house plants, fig and apricot trees.

Generous grass paths lead up the middle and round the entire garden behind the Fuchsia hedge.

Throughout the garden are iron obelisks and slate and stone decorative features.

Being a far northerly garden, it boasts 100mph winds from every direction, yet the variety of plants here and the magnificent showing of colour throughout the seasons make it a truly unique garden.

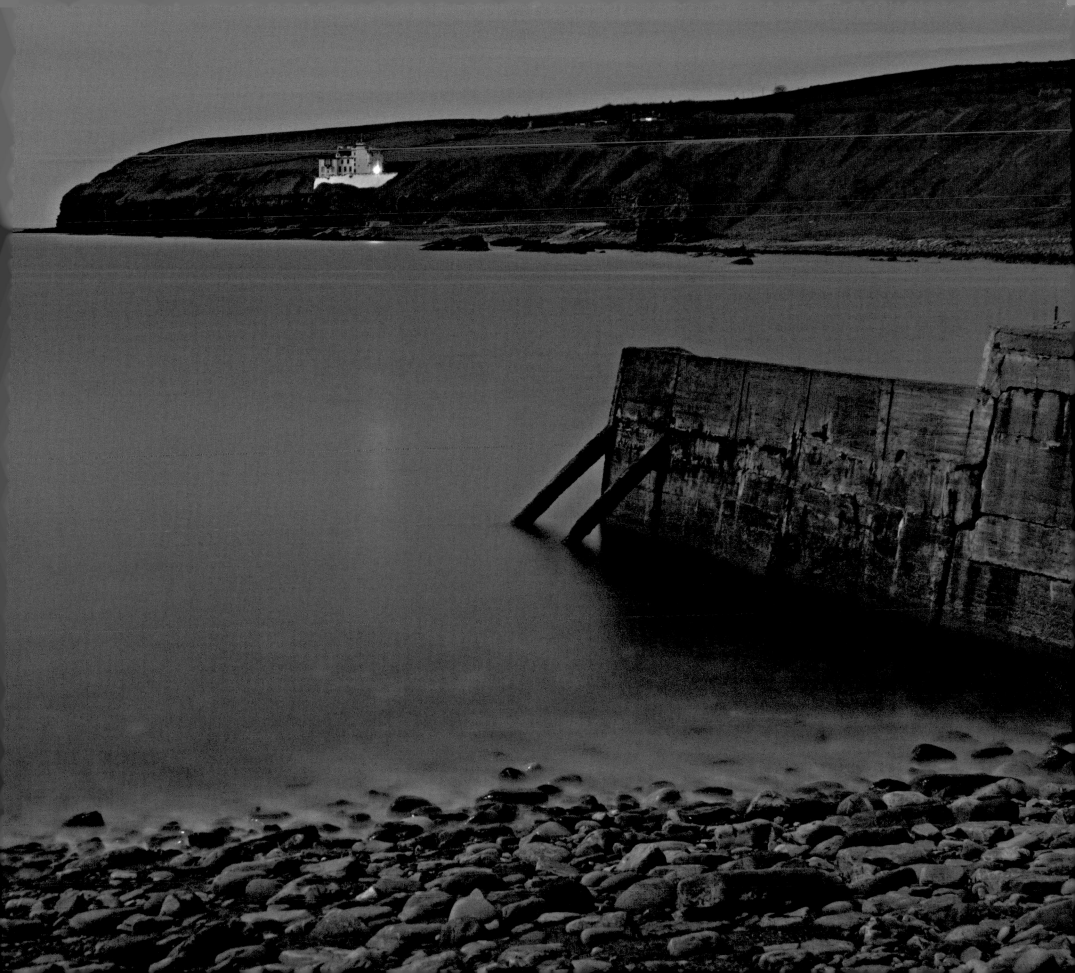

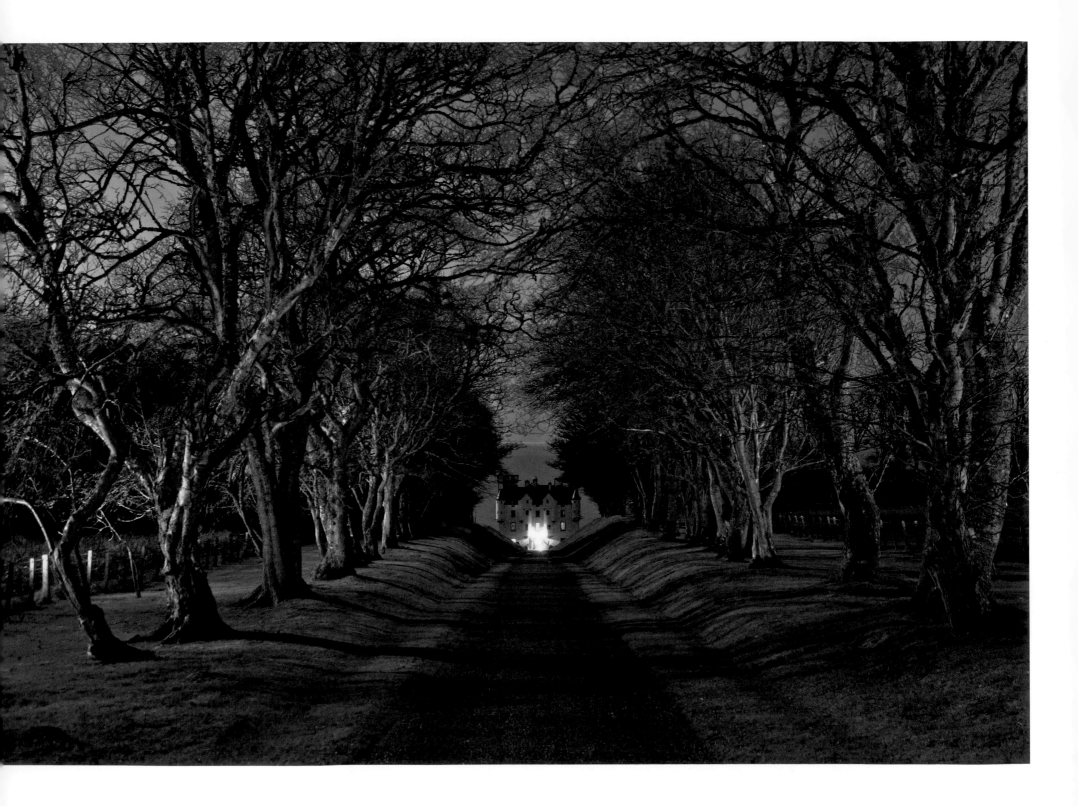

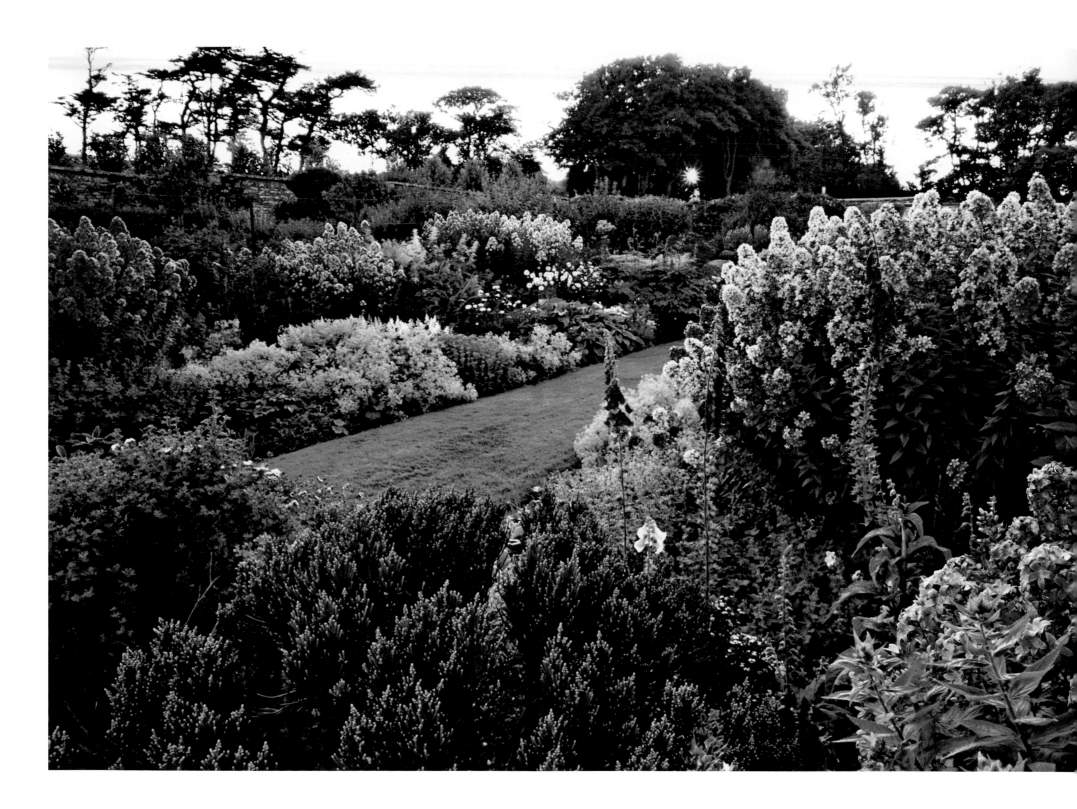

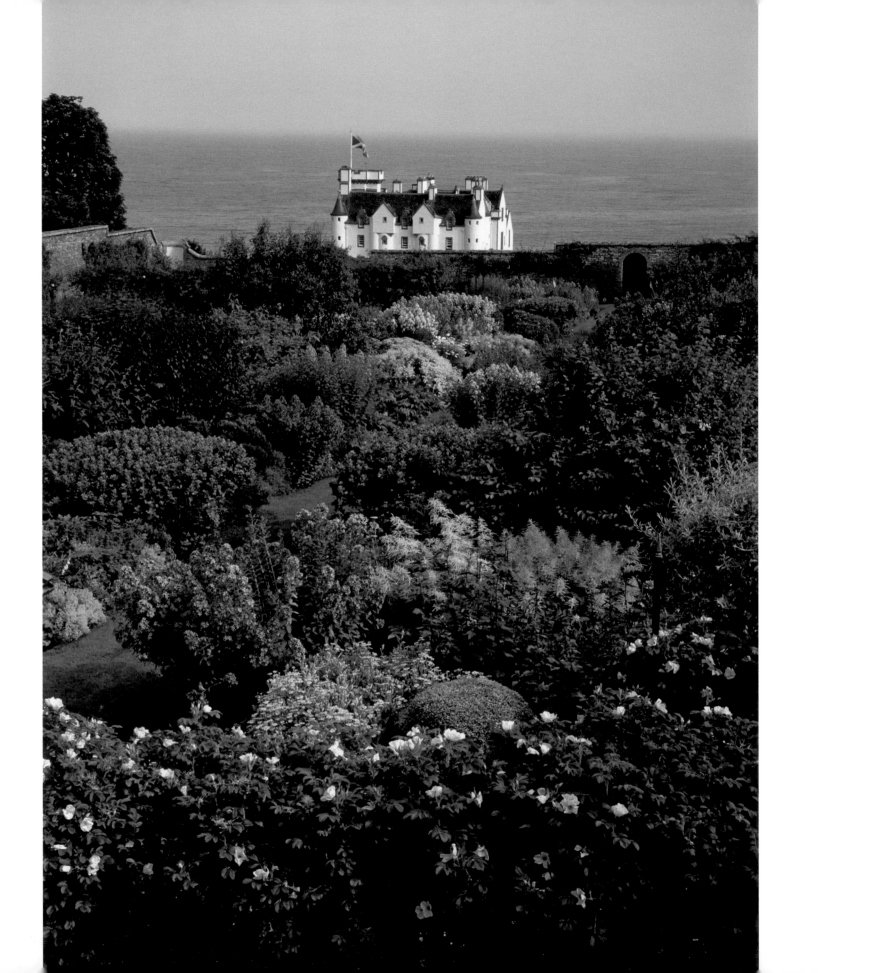

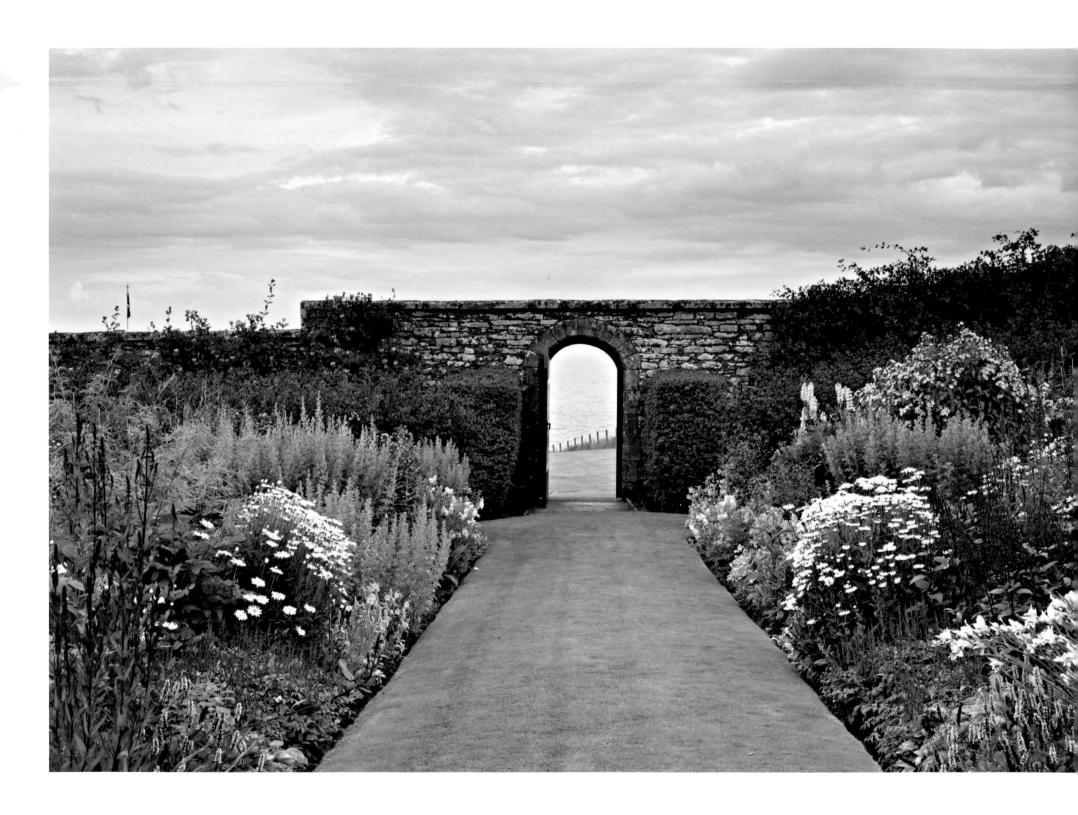

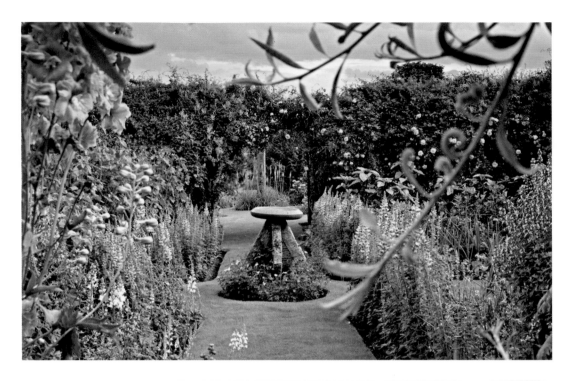

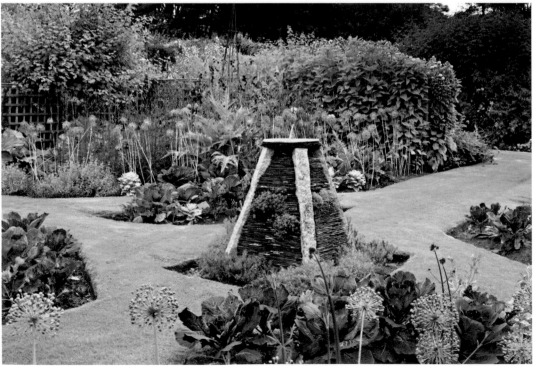

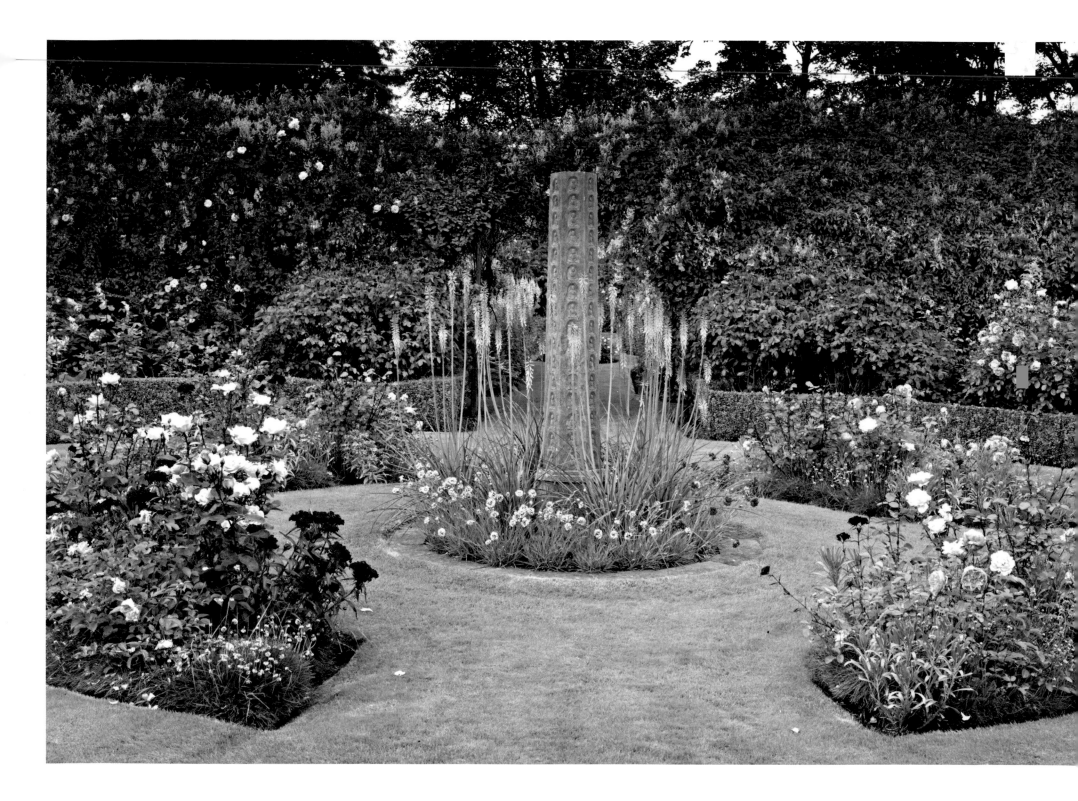

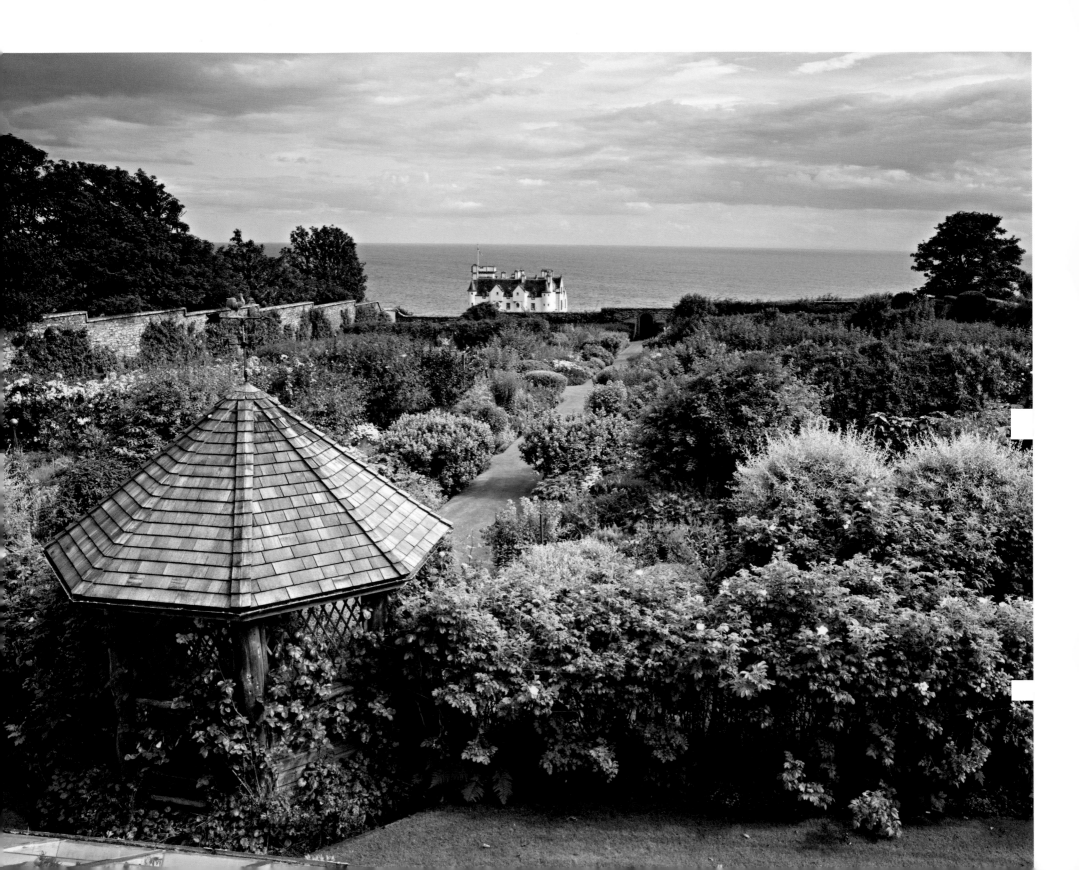

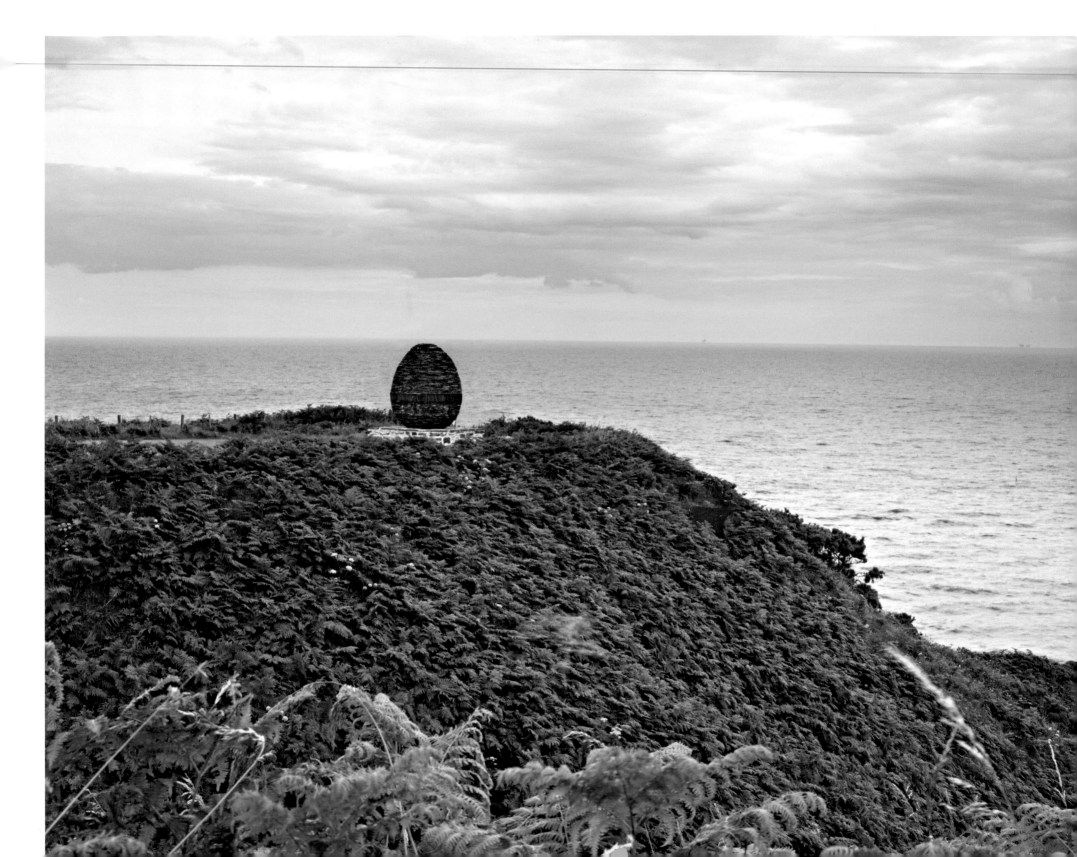

IAN HAMILTON FINLAY ABOUT TO EMBARK
WITH HIS DAUGHTER EYIE

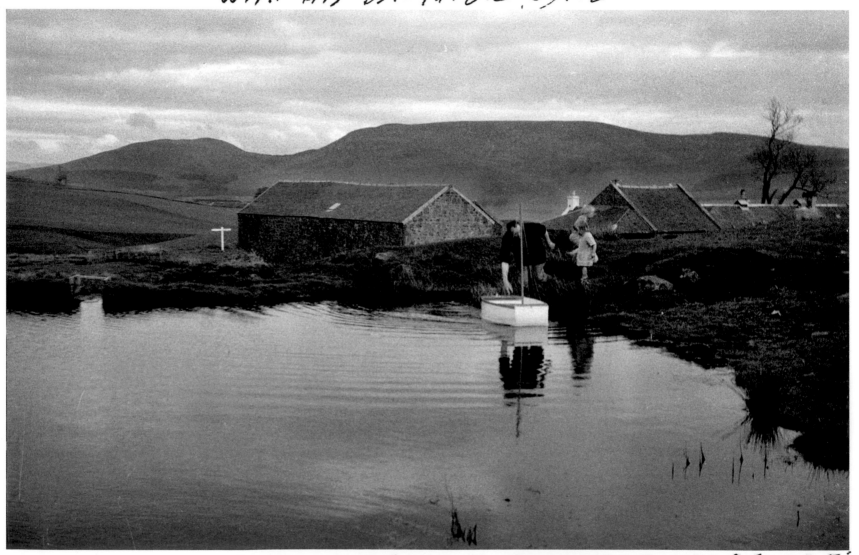

STONYPATH · 1970 — ALMOST TREELESS LANDSCAPE
AROUND LOCHAN ECK.

Allan Pollok-Morris

Field notes

Photograph by Richard Demarco

Is there an area of arts and culture so global in its connections, yet so unexplored in its locality as works by land artists and landscape designers in Scotland?

For five years I have been making journeys to Scotland to document this collection, travelling the mainland and islands to find new works and meet the people who made them. Although I very quickly became convinced there was something unique about art and gardens to be found there, I never imagined there would be such a huge breadth of work by people from very different disciplines. There are so many titles for the subject of this book: land art, garden design, landscape architecture, environmental art, land use, conservation, place making. As a photographer I am simply fascinated by the visual aspect of people's relationship with the natural world.

Gardens and views of the Scottish landscape can often be broad brushed as having romantic influences, but there are levels within this that are new, exciting and true to the make up of the natural world, rather than nostalgic, superficial and picturesque. Many people switch off when they sense any hint of romanticism because it does not fit with the prevailing climate in the art world, but it does have a relevance in contemporary landscape, if not just in recognition of a sense of place, then in a respect for the powers of nature or the environment which we do not understand. This in turn can and should have its place within the wider role of landscape design and land art in arts and culture.

Beginnings

Like many of my friends and family, I left Scotland in my early twenties to travel and find work. I never lost touch with the place and would return regularly, exploring the country through the eyes of someone who had encountered landscape design and land art internationally. I became convinced that Scotland had something special.

When a *Scotland* on *Sunday* poll in December 2004 voted Ian Hamilton Finlay's garden, Little Sparta, to be the most important work of Scottish art, it was clear that I wasn't the only one who felt that way. It was a tremendous inspiration that a country so noted for its natural beauty could give such respect to the creative works by man in the

landscape. The exhibition, *Close*, showing my collection of photographs at the Royal Botanic Garden, Edinburgh in 2008/2009 was followed, with help from the Arts Council, by an exhibition in Shetland in 2009, along with an accompanying book. I am deeply grateful to the public in both these places for the opportunity to show the collection and for the way they reacted to that first exhibition and book.

Second edition

It is very exciting to know that the exhibition will travel to North America in 2010/2011. It has meant the journey could continue in this second edition, with a chance to include new works made since the first and to update the work already in the collection. I have been able to widen the coverage in urban areas and public spaces as well as private and country gardens. I have also revisited some of the places shown in the first edition to update or expand the photography – many of the subjects now have different photographs and words from the makers of the scenes.

It is astounding how many significant new works have been made in Scotland in the last couple of years. Nicky and Robert Wilson have begun Jupiter Artland near Edinburgh, one of the most significant collections of art in the landscape. There have also been new creations on a smaller scale and this edition documents new works by Andy Goldsworthy, Charles Jencks, Ian Hamilton Finlay, Antony Gormley, Anish Kapoor, Laura Ford, Alec Finlay, Peter Liversidge, Mark Quinn, Shane Waltener, Arabella Lennox-Boyd, Andy Sturgeon, Bridget Baines, Eelco Hooftman, Nigel Sampey and Chris Rankin.

True North

Just to give it some scale, Scotland is a country not much larger than Illinois or New York State, with a total population equivalent to half of Ontario. Small it may be, but its cultural reach is far and its international familial connections strong. Many people all around the world have links with Scotland and scenes of its stunning landscapes are symbolic of this connection.

This collection is presented as a single journey moving from the south of the country to the north. A journey of the same latitude in North

America would begin half way up Newfoundland, or at the south of the Hudson Bay in Canada, and finish on a latitude between the cities of Juneau and Anchorage in Alaska.

The Northerly direction is not just one of geography, there is something deeply inspirational, almost spiritual, about travelling into the North. In the book *Ludwig Wittgenstein*: *There Where You Are Not*, Glenn Gould is quoted as saying:

'Something really happens to people when they go into the North – they become at least aware of the creative opportunity which the physical fact of the country represents and . . . come to measure their own work and life against that rather staggering creative possibility: they become in effect philosophers.'

Although it is a wonderful place to explore, Scotland is no paradise; it can be very harsh. The city of Glasgow has some of the highest crime rates, densest population and lowest life expectancy of any European city. On page 56 there is a photograph of Alec Finlay's moon-gate in Glasgow's Springburn Park. The estate manager of another property in this collection was a policeman in Glasgow and call outs to Springburn would involve three officers: two to attend the scene and one to protect the car. The park sits on a hill dotted with twenty-storey concrete housing blocks, considered to be one of the most deprived areas in Western Europe with 40% unemployment. However, without romanticising the place, many residents value the unbroken views across the city to the mountains and sea beyond and the constantly changing west coast weather sweeping through. Most Scottish cities do have this direct connection with dramatic panoramas of the wilder landscapes around.

Ways of seeing
Many of the people who have made these works are not Scottish – or have lived away for many years. Leaving somewhere and coming back, being familiar with a place and yet a stranger at the same time can make for a good language in documentary photography. In choosing which subjects to include I have been able to draw from my wider work with landscape design and land art, making decisions about which are considered most notable by people in this field, yet at the same time looking at how well these places work in the local context.

The thing that struck me first was not so much the aesthetics of the landscape, it was the scale of accomplishment by a relatively small number of people. Through trial and error over long periods of time, working with a piece of land, people have maintained their passion, developing a collaboration with nature to achieve a creative, functional or conceptual end.

The photograph on page 264 by the artist Richard Demarco is a witness to a simple, but powerful moment; the style is very open and documentary so the scene is free to be interpreted in any way. Images like this are both true to the subject captured in them and a mirror for the viewer to interpret for themself. Although it was taken before the making of Little Sparta, we can read it knowing the incredible creation in landscaping, art and poetry that took place over the following 40 years. At the same time, the picture is just of a man with his child, like any other.

In his book *The Laskett* Sir Roy Strong talks of a conversation with Ian Hamilton Finlay, 'I asked him whether it mattered that they did not understand it [Little Sparta]. No, he replied, there are many levels of understanding and none was to be despised'.

The individual in the landscape
I find it interesting how people see photographs differently. For example, some wonder why there are seldom people in these photographs, they feel the scenes are solitary or lonely.

I have tried to put the collection together from the point of view of those who created these works. The individual words from each creator were written without any overall context. The idea is to look at the macro through the micro, using local subjects to ask a global question about the importance of landscape design and land art in general arts and culture. As a result it will feel more like entries into a travel journal than a landscape, garden or art book, but a very significant aspect of these works is to see how an individual is revealed in the landscape they make.

To see the individuality of the landscape, it is important the photographs are true to the scene, capturing what is there in that moment rather than adding layers of a photographer's understanding. This is an important distinction for documentary photographers, often choosing to make photographs that look everyday, real or true rather than sensational. In the words of the garden photographer Andrew Lawson, 'the best garden makers are artists. So what is a photographer to do? He does not want to superimpose his own art on a garden, which is already a work of art in itself.'

The makers of these places were on the scene long before I arrived. But there is also a wider picture at play, the input of other people, different land uses over time and the forces of nature. Through the excitement of experiencing the place in the whole of the moment, these photographs reflect a strong respect for everything that has brought about these works and, of course, for those chance glimpses of light and other serendipitous occurrences. In this way, each photograph becomes a thank you, for everything that leads to that place when the moment for the photograph arrives.

Biographies &
image captions

JimBuchananAndyGoldsworthyCharlesJencks
ZaraMilliganAlecFinlayDouglasColtart MLI., MSGD.
IanHamiltonFinlay1925–2006NickyWilson
RobertWilsonLauraFordAnishKapoor
ShaneWaltenerPeterLiversidgeAntonyGormley
MarcQuinnBridgetBainesEelcoHooftman
NigelSampeyRolfRoscherChrisRankin
AndySturgeonJamesAlexanderSinclairPeterCool
CatherineErskineElliottForsyth
ArabellaLennox-BoydNiallManning
AlastairMortonJinnyBlomPenelopeHobhouseV.M.H.
Dr.ThomasSmithMaryAnnCrichtonMaitland
Angelika,DowagerCountessCawdor
GeraldLaingXaTollemache

Jim Buchanan

Born in Bristol in 1965, Jim Buchanan spent his formative years in Ireland, on the Donegal coast. He trained as a landscape architect at Leeds Polytechnic, but made his name as a labyrinth-maker and artist, working on ambitious installations.

Buchanan's development of large-scale labyrinths made of projected light has led him to an interest in the work of Thomas Edison, the inventor of the light bulb and the kinetoscope, an early cinematic projection device. His research is leading to a new body of work connecting the spiritual aspects of walking the labyrinth with the creative act of constructing it.

Buchanan's latest book, *Labyrinths for the Spirit*, was published by Gaia in 2007.

Andy Goldsworthy

Andy Goldsworthy is a British sculptor, photographer and environmentalist born in 1956. He was brought up in Leeds, where, as a schoolboy, he took on work as a farm labourer, and believes that the repetitive nature and rhythms of this work informed his future art. He studied fine art at Bradford College of Art and Preston Polytechnic, and has been based in Scotland for the past 25 years.

Goldsworthy travels the world creating site-specific works in natural and rural settings, using natural and found objects to produce sculpture and land art that reflects the character of its environment. He is well known for his ephemeral pieces made from materials such as ice, wood, flowers, leaves, twigs, sand and mud.

Charles Jencks

Charles Jencks is an architectural theorist, writer and landscape architect. He was born in Baltimore in 1939 and studied English literature at Harvard, before taking a PhD in architectural history at the University of London.

Jencks has lectured widely on architecture and the arts around the world and is known for his books questioning modernism and postmodernism – his *The Language of Post-Modern Architecture*, first published in 1977, popularised the use of the term in relation to the arts, and in particular architecture. Other notable books include *The Iconic Building – The Power of Enigma* (Frances Lincoln, 2005) and *Critical Modernism: Where is Post-Modernism going?* (Wiley, 2007).

Jencks's landscape work is inspired by prehistoric landforms, as well as more recent themes known to underlie nature such as strange attractors, fractal geometry and genetic organisation. His *Landform* at the Scottish National Gallery of Modern Art, Edinburgh, won the Gulbenkian Prize in 2004; other major works include his 'Black Hole' landscape in the Beijing Olympic Forest Park, his 'Time Garden' in Milan, and a DNA sculpture in Cambridge. He also expands on his design theories in his own garden in Dumfries and Galloway, which is the subject of his book *The Garden of Cosmic Speculation* (Frances Lincoln, 2003).

Jencks is based in Scotland, and divides his time between lecturing, writing and designing in the US, the UK and Europe.

Zara Milligan

'There was no catalyst for my love of gardening other than minor sibling competition and a love of plants,' says gardener Zara Milligan.

Zara Milligan and her husband, Iain, began work on their garden, Dunesslin, when their children started school. Over the past 15 years they have added drystone dykes, hedges, beds, a pond and, recently, a large rockery made of local sandstone. The garden has extensive views of the Dumfriesshire hills and is well protected by mature trees and large shrubs. 'With the help of the high rainfall and the usually mild climate, gardening here is rewarding for the impatient,' Milligan notes.

Alec Finlay

Alec Finlay is an artist, poet and publisher based in Newcastle. His artworks are often 'microtonal', using a diversity of small forms, and weaving together art and poetry with nature, ecology and sustainability.

Finlay's recent public artworks include 'Mesostic Interleaved' at the Edinburgh University library, which consists of mesostic poems distributed in the books, on shelf ends and on the pavement outside, and 'Sky-Field', in which poems are displayed using wind turbines, at Nose's Point, County Durham.

He established Morning Star in 1990, a press specialising in publications involving collaborations between artists and poets.

Douglas Coltart

Douglas Coltart is a landscape architect and garden designer with over 20 years' experience. He has lectured widely on design, both at international conferences and at home in Scotland. He has won many awards for his designs, including gold medals at the Chelsea and Hampton Court Flower Shows. He has also written for various publications and his first book, *Design and Renovation of Larger Gardens*, was published by Timber Press in 2007.

Many of Coltart's projects have appeared in books, such as *Small Town Gardens* (BBC Worldwide), and *The Book of Plans for Small Gardens* (Mitchell Beazley).

Ian Hamilton Finlay 1925–2006

Ian Hamilton Finlay was an artist, poet, philosopher, gardener and landscape designer. He was born in 1925 in the Bahamas and educated in Scotland, where he lived until his death in March 2006.

Hamilton Finlay left school at the age of 13 and had a wide variety of jobs, including fisherman, soldier and farm labourer, all of which had an influence on his later work. The intermediary stage in his development from writer to artist was his 'concrete poetry' – where the layout of the words contributes to the overall effect – much of which was published through the Wild Hawthorn Press, which he co-founded in 1961.

Poetry was at the heart of all Hamilton Finlay's work, and a further expression of this was the creation of Little Sparta, his garden near Edinburgh. The garden is on a windswept hill and blends classical sculpture with his unique use of language. At every turn, plaques, walls, statues, bridges and paving stones bear poetic and philosophical inscriptions reflecting the enduring themes of his art: the Second World War, the French Revolution and the sea.

Nicky & Robert Wilson

Nicky and Robert Wilson bought Bonnington House, a Jacobean manor house within an 80-acre estate, in 1999. Nicky Wilson had always been deeply influenced by Ian Hamilton Finlay's Little Sparta, some 30 miles from Bonnington, and had a long-held ambition to create a sculpture park. Nicky and Robert Wilson are serious collectors and know many leading contemporary artists, to whom they offered the opportunity to create new works in the grounds at Bonnington.

Jupiter Artland, the result of this collaboration, opened on May 15, 2009, when an array of challenging new works of sculptural art were revealed at night, lit by a full moon and augmented by a firework display designed by Cornelia Parker, the fall-out from which included dust from moon rock. Although the site for each work was chosen by its individual creator, the overall collection has a discernibly orchestrated cohesion.

Laura Ford

Laura Ford was born in Wales in 1961 to a family of showmen who travelled the fairground circuit. She studied at the Bath Academy of Art and Chelsea School of Art and Design, and now lives and works in London.

Ford uses soft materials, fabrics and found objects to create surreal figures from the imagination or fantasy. There is an underlying menace in most of her work. At first glance, her subjects – usually children or animals – may seem to reflect innocence or simplicity, but there is often a shocking twist that confuses these qualities.

Anish Kapoor

Anish Kapoor was born in Mumbai, India in 1954 and has lived in London since the early Seventies, when he studied at Hornsey College of Art and Chelsea School of Art and Design.

Over the past 20 years he has exhibited extensively in London and worldwide. His solo shows have been held at venues such as Tate Modern and the Hayward Gallery in London, Kunsthalle Basel in Basel, Switzerland and Haus der Kunst in Munich. Most recently, the Royal Academy in London hosted a major survey of his career to date, in 2009.

Kapoor was awarded the Premio Duemila at the Venice Biennale in 1990 and the Turner Prize in 1991. He was awarded an honorary fellowship at the London Institute in 1997 and a CBE in 2003.

94–95 Weeping Girls
The site I have picked at Jupiter has a quiet, melancholic atmosphere

101 Suck The Neck
Hole with walls plated in cast iron and opening barred by seventeen-foot high cast iron cage

Shane Waltener

Shane Waltener is a London-based artist born in 1966. His sculptures, installations and performance work draw inspiration from craft traditions, as well as art history, referencing domestic crafts such as knitting, crochet, lace-making techniques, sugarcraft and cooking.

Recent projects by the artist have become increasingly interactive, involving other artists, visitors, spectators and community groups in the making of the artworks. He aims to facilitate a process of 'group crafting', in order to allow for the free exchange of cultural and social histories relating to these crafts.

Peter Liversidge

Peter Liversidge's work spans a variety of disciplines, including drawing, film, performance, painting, photography and installation. The subjects of his work are equally diverse, ranging from the North Montana Plains to logos and luxury goods. He also aims to subvert ideas about nature with his use of stuffed birds and casts of natural objects in incongruous materials, united by an underlying streak of dark, absurdist humour.

Liversidge has exhibited widely in Britain and Europe, and his work is held in private and public collections around the world, including at the British Council, the Victoria & Albert Museum, the Tate Archive, and the Czech Museum of Fine Arts in Prague. In 2010 he will create a substantial installation at the Corcoran Gallery of Art in Washington, DC.

110 Over Here
Trapping the essence of the place and framing
an ever-changing imprint of it

111 Signpost to Jupiter
The calculation takes into account that both the Earth
and Jupiter are in elliptical orbits around the sun

Antony Gormley

Over the past 25 years, Antony Gormley has revitalised the human form in sculpture through a radical investigation of the body as a place of memory and transformation. 'I am interested in the body because it is the place where emotions are most directly registered,' he explains. 'When you feel frightened, or when you feel excited, happy, depressed, somehow the body registers it.'

Gormley has explored the relationship between the individual and the community in large-scale installations such as *Allotment* (1997), *Domain Field* (2003) *Another Place* (1997), and, most recently, *One and Other* (2009), for which members of the public, chosen by lot, each spent one hour on the fourth plinth in Trafalgar Square, London. *Angel of the North* (1998), one of his most celebrated works, is a landmark in contemporary British sculpture. *Field* (1994), an installation of hundreds or thousands of small clay figures sculpted by the local population, has been enacted in various locations throughout the world, involving local communities across four continents. 'Sculpture is an act of faith in life, in its continuity,' Gormley comments. 'We all do things like this; we have a stone that we keep in our pocket which is a guarantee of life's continuity, and it has to do with hoping that things will work out, that life will be okay.'

Gormley was born in 1950 in London, where he lives and works. He has participated in major solo and group exhibitions, including the Venice and Sydney Biennales. He was awarded the Turner Prize in 1994 and made an OBE in 1997. He is an honorary fellow of the Royal Institute of British Architects, and has been a Royal Academician since 2003.

108–9 Firmament
 Think about the endless condition of the sky and the conditioned
 space of architecture

Marc Quinn

Marc Quinn's wide-ranging oeuvre displays a preoccupation with the mutability of the body and the dualisms that define human life: spiritual and physical, surface and depth, cerebral and sexual. Using an array of materials, from ice and blood to glass, marble and lead, he develops these paradoxes into experimental, conceptual works that are mostly figurative in form.

Quinn's sculptures, paintings and drawings often deal with the distanced relationship people have with their bodies, highlighting the conflict between the 'natural' and the 'cultural'. In 1999, he began a series of marble sculptures of amputees as a way of re-reading the aspirations of Greek and Roman statuary and their depictions of an idealised whole. One such work depicted Alison Lapper – a woman born without arms – when she was heavily pregnant. He subsequently enlarged this work to make a major piece of public art for the fourth plinth of Trafalgar Square.

Other key themes in Quinn's work include genetic modification and hybridism. He has also explored the potential artistic uses of DNA – for example, *DNA Garden* (2001) is a grid of petri dishes containing strands of DNA from over 75 plant species as well as two humans. His diverse and poetic work meditates on our attempts to understand or overcome the transience of human life through scientific knowledge and artistic expression.

Quinn has exhibited in many important group and solo exhibitions internationally, including at the Victoria & Albert Museum and Tate Britain in London, the Venice Biennale, and the Fondazione Prada in Milan.

114 Love Bomb
 A modified flower at once monstrous and seductively beautiful
 demonstrating the ways in which human desires are now shaping
 the natural world

Bridget Baines
Eelco Hooftman
Nigel Sampey

GROSS.MAX was founded in 1995 by partners Bridget Baines and
Eelco Hooftman; Nigel Sampey joined as a partner in 2001.
The practice is now widely regarded as one of a few UK-based
exponents of a new generation of contemporary European landscape
architecture, and has won numerous competitions and awards for its
work in public spaces.

The practice has a strong international outlook; its first collaborative
work, in 1996, was an award-winning scheme for two parks at
Potsdamer Platz in Berlin, which was soon followed by a winning entry
for the landscape masterplan for the Hanover Expo in 2000. With
projects such as its RIBA prize-winning design for Hackney Town Hall
Square, the practice has been recognised for its modern, contextual
approach towards urban spaces.

GROSS.MAX's recent work in the UK includes the Bullring in
Birmingham and a number of public squares in London, including
St John's Square, Lyric Square and Brixton Central Square. Abroad,
it has worked with Zaha Hadid Architects on the design of the
BMW plant in Leipzig, the external landscape of a new high-speed
railway station on the outskirts of Naples and a masterplan for former
docklands along the river Nervión, Bilbao.

GROSS.MAX's strong affinity with art has resulted in a range of
collaborations with artists and the practice has won three Art for
Architecture Awards from the Royal Society of Arts, along with the
2006 European Landscape Award.

116 [left to right] Nigel Sampey, Eelco Hooftman and Bridget Baines

118 [head] Wetland at bottom of the slope
 [foot] Steps at upper terrace

119 Upper terrace with alignment of beech hedging and rock garden

120 [head] Overview Rottenrow Garden
 [centre] Grove of birch trees with ivy groundcover
 [foot] Central steps

121 Embankment of willow planting with view towards pool and steps

122 Wilderness Garden at remote corner of the site

123 View into Garden

Rolf Roscher

Rolf Roscher is a landscape architect based in Glasgow. His career has focused mainly on projects in Scotland, but he has also taught in the States and Australia. As well as the award-winning Hidden Gardens and Matrix projects in Glasgow, his previous work includes several environmental installation projects.

Roscher is currently a director of ERZ, a dynamic design practice that works across a range of scales in landscape design, urban design and strategy. The company was established at the start of 2007 and has a growing portfolio of work.

Chris Rankin

Chris Rankin is a landscape architect based in Edinburgh. He studied landscape architecture at the Edinburgh College of Art, the University of Guelph in Canada and Rhode Island School of Design, before completing postgraduate studies at the Berlage Institute in Amsterdam.

Rankin has worked in private practice in Scotland since 1993 and established his practice, Rankin Fraser, with Kenny Fraser, in 2008. He also teaches landscape architecture at Edinburgh College of Art, and is an advisor for Architecture and Design Scotland.

Rankin's work, which has won several design awards, ranges from strategic landscape planning and housing masterplans to site-specific parks, gardens and artworks in both urban and rural environments.

126 [head left] Changing herbaceous beds
[head right] Climber clad boiler house wall
[foot left & right] Community planting beds

127 Foundation Stone by Jonathan Kemp Bas-relief of lotus flower
Inscription 'peace to all living things' June 2003
Concept Angus Farquhar, Sculpted from original drawing
by Lindsay John

128 [left] A hidden garden
[right] Garden visitors' wishes

129 A section of the square route

130 Changing herbaceous beds

131 [head] Broken Circle, Julie Brook with Rolf Roscher
A continuously flowing circle of water
[foot] Wildlife sanctuary

Andy Sturgeon

With a string of Royal Horticultural Society Chelsea gold medals to his name, Andy Sturgeon has spent over twenty years carving out a reputation for sophisticated contemporary gardens at home and overseas. He prides himself on the variety of projects his practice undertakes - the thrill is not in turning out endless modern gardens in the same style but in being able to change gear between a sprawling historic landscape one week and a tiny town garden the next.

Fuelled by a passion for travel and a love of art and architecture, the work can be influenced by almost anywhere or anything.

Sturgeon began his career as a landscape gardener before studying tropical plants, working at the RHS gardens at Wisley and finally moving into garden design.

He is the author of three books, a freelance journalist and lectures internationally on garden design.

James Alexander Sinclair

James Alexander-Sinclair began his career as a landscape contractor in London in the Eighties, before moving to Northamptonshire to build a house in 1992. Since then he has designed gardens, both large and small, around the UK and abroad. He has created show gardens for the Chelsea Flower Show and the Westonbirt International Festival of the Garden, and is also an RHS judge.

Alexander-Sinclair has presented television programmes for the BBC and Channel 4, and has written articles for many publications, including *Gardens Illustrated, House & Garden, Homes and Gardens, Coast, SAGA Magazine, The Times, The Daily Telegraph* and *The Guardian*. He is currently writing a monthly series on plants for *Gardeners' World Magazine* and a regular column for *The English Garden*. His first book, *101 Bold and Beautiful Flowers*, was published by BBC Books in March 2008.

134 This family garden has it all: bbq, dining area, lounge, gym, jacuzzi, trampoline, lawn and putting green. The challenge was that it should also be uncluttered, sleek and modern.

135 A combination of built in benches, step edges and low walls create a very flexible space that can accomodate large numbers of people for entertaining.

136 [head] A veil of verbena bonariensis retains the feeling of openness in this relatively small garden
[foot] The garden was originally flat and sat much lower than the house. A series of subtle steps and raised landings makes a more comfortable connection between house and garden.

137 Outdoor seating or play area. Generous multifunctional spaces are interlinked to make a very practical yet well designed garden

138 The newly planted front garden has cubes of clipped yew to introduce a sense of formality and structure to the wide beds

139 Play for adults as well as children. The putting green is hidden behind a low wall.

142 The Visitor Centre and Thalictrum Rochebruneanum in gravel

143 Column dedicated to Augusta, Dowager Princess of Wales in 1772, Augusta founded Kew Gardens

144 Salix exigua, Matteuccia struthiopteris by the Visitor Centre

145 Thalictrum Rochebruneanum

146 [left to right, head to foot] [1] Planting in the Kitchen Garden, box hedges, broad beans, leeks, Crocosmia and fennel in background [2] Planting in the Visitor Centre Garden, Veronicastrum virginicum 'Fascination' [3] Planting in the Kitchen Garden, Calmagrostis Karl Foerster (grass in background), Helenium 'Moerheim beauty' Crocosmia 'Lucifer' & bronze fennel. [4] Planting in the Kitchen Garden, Helenium 'Moerheim beauty' Crocosmia 'Lucifer' & bronze fennel

147 Lythrum salicaria

Peter
Cool

After training at an organic horticultural college in Holland, Peter Cool began work as a gardener at Jura House in 1976, with an original brief to produce fruit and vegetables for the house and hotel.

Recognising the potential for more exotic plants in the garden due to the influence of the Gulf Stream, he began to develop the borders with a varied selection of plants that he collected on a trip to Australasia in 1990. He describes his planting style as organic, and says, 'I allow plants to do their own thing, but with a measure of control. I believe that we have to work with nature, and let it find its own balance. Often the best combinations happen by chance.'

148 Overlooking the ying yang garden from the top of the wall

150 [head] Path beside the burn that is channelled through the garden
 [foot] Hebe inspiration and Meconopsis cambrica showing
 the relaxed planting style

151 The ball garden. The rusty steel balls were reclaimed
 from the sea

152 [head] Peter planting out nursery stock
 [foot] The stone arch entrance to the ying yang garden

153 The traditional rose garden with Geranium palmatum,
 Geum Princess Juliana and Aquilegia deep purple hybrids
 in the spring

154 [head] Puya Chilensis and Erysimum bowles mauve at the top
 of the lawn
 [foot] Overlooking the middle of the garden with Meconopsis
 sheldonii in the foreground

155 The seat overlooking Jura House garden beach and Islay
 in the background

Catherine Erskine

Catherine Erskine has been interested in plants and nature since she was a child, but started gardening in earnest when she worked at an hotel near Rio de Janeiro in her early twenties. Soon after she married her husband, Peter.

Catherine and Peter Erskine have run the Cambo estate near St Andrews since 1976. 'I fell in love with the walled garden at first sight' she recalls. 'Although it was superficially tidy, it clearly longed for an eager enthusiast to love it.'

In order to cover the costs of the garden and increase the plant-buying budget, Erskine set up a mail-order snowdrop business in 1986. 'Snowdrop Tourism' took off in 2003, and the business, along with revenue generated by visitors throughout the year, largely pays for the garden.

Erskine's future plans include converting the stables and coach house to provide accommodation for student gardeners and volunteers.

Elliott Forsyth

Elliott Forsyth was brought up in Dunoon, on the west coast of Scotland. Initially, he worked as a weapons mechanic in the RAF, but in 1994 he decided to retrain as a gardener. He studied at the Scottish Agricultural College, and later trained at the Royal Horticultural Society gardens at Wisley, then at the Royal Botanic Garden in Edinburgh. Forsyth is currently head gardener at Cambo, near St Andrews, where, together with the owner, Catherine Erskine, and a small team of gardeners, he has extensively redeveloped the gardens.

His planting style is primarily Naturalistic, and he has travelled to Germany and Holland, visiting gardens and meeting practitioners, to learn about the style at its origin. Of late there has been an inward shift as Forsyth's style becomes an expression of his own experience and understanding, leading to a greater freedom in his creative work – a development that he describes as 'inexhaustible and fascinating'.

160 Naturalistic self seeding in the Cambo Burn. The Willow and Teahouse are inspired by a willow pattern plate design

161 View over the Late Season Naturalistic Borders with Foeniculum vulgare 'Bronze Form' and Veronicastrum virginicum f. roseum in the foreground

162 Diffused Naturalistic planting in the early summer area gives the impression of an enhanced meadow

163 Arching spikes of Buddleja davidii

164 Early Summer planting with Verbascum nigrum and Lythrum salicaria together with Prunus cerasifera 'Nigra'

165 Naturalistic cut flower area seamlessly blends with the rest of the garden.

166 [head] Kale 'Redbor' and Cabbage 'Aurora' combine imaginatively with annuals and perennials in the Naturalistic Potager. [foot] Leucanthemum x superbum provides a striking white foreground to view this towards the late season Naturalistic borders

167 The spherical flower heads of Echinops contrast with Helenium autumnale 'Moerhiem beauty', Stipa tenuissima lights up the scene in the background

Arabella Lennox-Boyd

Landscape designer Arabella Lennox-Boyd was born in Rome, but has been based in England for over 40 years. Her many commissions in the UK and abroad range from small town gardens to large historical country landscapes, and include the National Trust garden at Ascott House, Buckinghamshire, the gardens at Eaton Hall, Cheshire, roof gardens for commercial buildings in London and Hong Kong, and a garden and park in Dallas, Texas. She has also designed six gold medal-winning gardens for the Chelsea Flower Show, and won the Best Show Garden Award in 1998.

Lennox-Boyd has written three books: *Traditional English Gardens* (1989), *Private Gardens of London* (1993) and *Designing Gardens* (2002). She has lectured on her work in the UK, Italy and the US, and has been awarded an honorary doctorate of design by the University of Greenwich, where she is also a member of the university's assembly. In 2005, she was awarded the prestigious Premio Firenze Donna prize in Italy, for her achievements as both landscape architect and businesswoman, and in 2007 she was awarded the celebrated Torsanlorenzo International Prize, in recognition of her lifelong commitment to innovation in design and to championing green spaces.

Niall Manning & Alastair Morton

Niall Manning was born in Ireland and initially qualified in medicine in Dublin, working in hospital medicine until he took early retirement in 2001. He is a past chairman and current vice president of The Garden History Society in Scotland. Alastair Morton, who was born in Scotland, studied optometry in Glasgow and continues to work as an optometrist.

Manning and Morton met in the early Eighties and moved to Fintry in 1988, where they created Dun Ard, a garden hewn from a three-acre plot of rough hillside. The garden's hedges were planted and the terraces carved out when the foundations of the house were dug, but the garden is, in effect, the result of years of 'gestation' inspired by Manning and Morton's experience of growing plants, visiting gardens and travelling around the world.

Jinny Blom

Jinny Blom initially trained and practised as a psychologist and psychotherapist from 1985 to 1996, before launching her landscape-design practice in 2000, and devoting herself to her lifelong interest in natural landscapes and gardens.

She works on a wide range of mainly private projects in the UK, Europe and the US, and believes that good landscaping has an uplifting effect on people, architecture and the wider countryside. Her design aesthetic is one of meticulous attention to structure, so that the plants can be allowed to express their individual character.

Blom has written for and appeared in a wide range of books and publications, and contributes regularly to radio and television. She won BBC Radio Broadcaster of the Year in 2002 and was twice nominated Woman of the Year, in 2002 and 2007.

186 The monolithic sculpture by Ulrich Ruckriem is softened by my naturalised 'Victorian Plant Hunter' mix of Lilium pardalinum and Primula florindae, steadied with lupins and birch trees

187 We brought the sauna from Norway and sowed wild grass onto the roof. Even in November the children run down the long jetty and leap into the freezing waters of the loch!

188 Lodge with Sun Star. Here is the Lodge as we hoped to see it, shrouded by the Beech trees planted by Sir John Stirling Maxwell and just reaching for the last ray of evening sun

189 We felt the most beautiful way to seat the new building was by having nature, untrammelled, wash right up to its feet

190 We saved this old rock and its friend Rowan during the building of the new lodge. It feels appropriately companionable, old and new together

191 During the restoration this lovely sculpture was uncovered and reinstated.

192 [left] Pool Loch and Mountains. Man made water linking to the long view down Loch Ossian and towards Ben Nevis. Is it one of the best views in Scotland?
[right] The Doll's House. We steadied the flow of water through this little tributary and garlanded the banks with heavy doses of locally sourced wild flower seed, fruits and foxgloves so that it naturalises the setting for the Doll's House, a name given to the miniature gardener's cottage
[foot] Sauna towards Boardwalk. We made a secret route through the trees and over the water to the sauna to facilitate nocturnal bathing. Corrour is all about being out in the weather, whatever the weather

193 Lodge and Victorian Pool. The restored Victorian garden was left as simple as possible. The circular mirror of water echoing the triangulated mirror of sky in the windows of the lodge

195 Gormley in woods by Steamer Jetty. I spent ages looking for the right spot for the Antony Gormley sculpture titled Here and Here. Its is hidden in a cathedral of tall trees by an old steamer boat jetty. Suitably poignant

Penelope Hobhouse V.M.H.

Penelope Hobhouse is a garden writer, historian and garden designer with a successful international practice. Among her many books are *Plants in Garden History* (Pavilion, 1992), *A Gardener's Journal* (Frances Lincoln, 1997), *Garden Style* (Frances Lincoln, 1998) and *Gardens of Italy* (Mitchell Beazley, 1998). She is also known for her work at the Arts and Crafts garden at Tintinhull in Somerset, a National Trust property, which she and her late husband restored and revived between 1980 and 1993.

Hobhouse is now semi-retired and lives in Somerset, where she is currently working on a new garden.

Dr Thomas Smith

Dr Thomas Smith was born in Yorkshire in 1926, and has a lifelong interest in the relationship between philosophy and landscape. After the Second World War he settled in Aberdeen, where he researched and taught physics at Aberdeen University for 34 years.

Dr Smith has made a number of gardens, including a medieval garden in Yorkshire, a garden on the Moray Firth, and the garden at the Gordon Highlanders Museum in Aberdeen. The experimental evolution of his own garden is driven by his interest in how human character relates to the environment.

198 A view from the slopes of the Ben looking towards the walled Monks' Garden and the Priory. In place of medieval herbs and medicinal plants the modern layout is a series of formal hedges giving shelter to individual flower-planting schemes

199 A pathway lined with tough Rugosa roses that thrive and flower most of the summer even when exposed to seasonal gales

200 A small native plant flower-meadow has been created in a hedged enclosure

201 A view over the garden from the small reservoir on the hill

202 Privet hedges, inspired by those grown on the eastern end of Long Island, protect garden areas from the frequent cross-winds

203 A small intimate garden area reflects the idea of a medieval Hortus Conclusus

204 [head] Concrete sheep, sculpted in Holland, link the garden with the the farming landscape
[foot] A pathway lined with tough Rugosa roses that thrive and flower most of the summer even when exposed to seasonal gales

205 Silver-leaved artemisias, orange-flowered alstroemerias and azure agapanthus flower in late summer

208 Anthemis tinctoria 'Kelwayi', Achillea grandifolia and T.S.

210 [left] Chamaecyparis obtusa 'Tetragona Aurea'
[right] Chamaecyparis 'Boulevard' with Filipendula rubra

211 Populus tremula 'Erecta' in 'sky telescope'

212 [left to right, head to foot] [1] Chamaecyparis 'Boulevard', Picea glauca var.albertina 'Conica' and Hydrangea arborescence 'Annabelle' with Thalictrum 'Elin', Filipendula rubra and Artemisia Ludoviciana 'Valerie Finnis' [2] Hedera helix [3] Serpentine Buxus sempervirens with Dicksonia antarctica and Rodgersia podophylla 'Rotlaub' [4] Serpentine Buxus sempervirens emerging from a pool of Ophiopogon planiscapus 'Nigrescens' with Soleirolia soleirolii [5] Lewisian Gneiss stone with Trachycarpus fortunei, Astelia cathamica, Puya apina, P. chilensis, Ricinus 'New Zealand Black' and R. 'Dominican Republic'

213 View from the house

214 Alnus glutinosa 'Imperialis' with Sanguisorba canadensis, S. hakusanensis, Anaphalis margaritacea, Monarda 'Gardenview Scarlet' and Acer Shirasawanum 'Aureum'

215 Buxus sempervirens with Eremurus 'Emmy Ro', Stipa tenuifolia and Morina longifolia

216 Summer House Reflections

217 Veronocastrum 'Fascination'

Mary Ann Crichton Maitland

Mary Ann Crichton Maitland's passion for gardening was inspired by her grandmother and mother, both keen gardeners. 'It is difficult to explain to non-gardeners the intense pleasure I derive from the long hours I spend in my garden, in all seasons and often engaged in endless repetitive work,' she says of Daluaine, her garden in Aberdeenshire. 'Yet the older I become, the more time I want to spend there. It's not just about digging and delving; it is the joy of finding the first snowdrop after the long winter. All is magical and worth every ache in the old bones at the end of the day.'

Angelika, Dowager Countess Cawdor

Angelika Countess Cawdor was born in the Czech Republic and grew up in Africa, before moving to Paris, where she lived for 17 years and founded a communications agency, collaborating with some of the greatest names in the fashion and film industries. She fell in love with the Highlands when she married Hugh, 6th Earl and 24th Thane of Cawdor, in 1979, and since then she has dedicated herself to bringing new life to Cawdor Castle, while preserving its historic heritage. The castle is the focus of a new book, *Highland Living*, which is published by Flammarion.

228 The bronze fountain in the Paradise Garden was designed by Spanish sculptor Xavier Corbero and depicts my personal cosmology

229 A venerable sycamore on the lawn in front of the Castle, planted by Sir Archibald Campbell, brother of the Thane of Cawdor who was factoring the Estate in the 1720's

230 [left] The Earth Garden with at its centre the seven-pointed star and Adam and Eve leaving paradise. The knots, taken from an old Scottish sampler, are planted with plants that are used either in the kitchen, in the still room or for medicinal purposes
[right] Over the roof of Cawdor Castle flies a Tibetan prayer flag. It represents Bodhisattva Samantabhadra's deep aspiration to attain enlightenment to benefit all living beings. The message of this revered text, taught by the Buddha and recited for thousands of years will be borne onto the wind wherever the flag is flown
[foot] The Maze was planted in Holly by Hugh, the 6th Earl Cawdor in 1980

231 The castle seen from the Flower Garden which was laid out in the 18th Century

232 [left] Lavender 'Lavendula angustifolia Munstead'. The oval lavender beds filled with roses were added by Lady Elizabeth Cawdor in 1850 [right] The outline of the Cawdor Maze comes from the first known image of the Knossos Labyrinth which is in a mosaic floor in a Roman villa, Conimbrigia in Northern Portugal. The design of the Maze is attributed to Daedelus
[foot] The large herbaceous borders are at their best in mid summer. They were added to the garden in Victorian times

233 Irish Yews 'Taxus fastigiata' (green) and 'Taxus fastigiata aureomarginata' (golden), stand guardian to the entrance of the Slate Garden

234 Seen from the turret of the castle, the Cawdor Big Wood, 850 acres of primeval Caledonian Oak wood

235 In the winter the night shrouds the venerable 18th century Sycamores in front of the Castle

236 The venerable Horse Chestnut. The Cawdors have been passionate about trees for generations. The horse chestnut, to the left of the drawbridge, was planted in 1722 by Sir Archibald Campbell, brother of the Thane of Cawdor, who was factoring the estate

237 Tobacco plant 'Nicotiana affinis'

Gerald Laing

As one of the original wave of pop artists, Gerald Laing produced some of the most significant works of the movement. In London, during the early Sixties, he pioneered the painting of enormous canvases based on newspaper photographs of models, astronauts and film stars – his 1962 portrait of Brigitte Bardot is one of the most iconic works of the period.

He returned to the Highlands from New York in 1969 to concentrate on sculptural work. Initially exploring abstraction and sculpture in the landscape, he moved on to figurative sculpture, creating high-profile public commissions such as the bronze bas-relief twin dragons at the exits of the Bank tube station in London.

Laing has recently returned to painting, and to contemporary media images similar to those that inspired his early work, with new paintings depicting Amy Winehouse, Kate Moss and Victoria Beckham.

Xa Tollemache

Xa Tollemache's landscape projects and garden designs span the globe. Her understanding of garden history and experience with scale and proportion, combined with a passion for plants, has made her sought after for both town and country gardens all over Britain.

Tollemache's passion for gardens began in 1972 at Framsden Hall, a house on her husband's family estate. Later, at the main house, Helmingham Hall, she worked with head gardener Roy Balaam and became a 'hands-on' gardener, restoring and replanting the nineteenth-century parterre and rose garden.

In 1995, Tollemache began to take outside garden design commissions, and was asked to do a planting scheme at Ginge Manor in Oxfordshire. Other notable commissions include an internal courtyard garden at Wilton House, a walled kitchen garden at Arundel Castle, the Millennium Garden at Castle Hill in Devon, and private projects in France and the States. She won a gold medal at the 1997 Chelsea Flower Show and silver-gilt medals in 2001 and 2003.

Tollemache continues to work extensively on her own garden at Helmingham Hall, as well as on commissions worldwide, including a new design for double herbaceous borders at Cholmondeley Castle. Her garden-design work has been featured in many publications, including *House & Garden*, *Telegraph Magazine* and *The Sunday Telegraph*.

For Jim and Pat Pollok-Morris

This project has brought together the very generous help and support of the people whose work is shown here and I am very grateful for their contribution. Many others have helped maintain the places in this collection and made it possible for them to appear in the exhibition & book and I am very thankful for all their work.

I wish to thank Sir Roy Strong, Tim Richardson, Gary Hincks, Richard Demarco & The Demarco Archive Trust, Benedict Wordsworth, Elle Moss, Damon De Ionno, Pia Simig, Eric Ladd, Geoff Barlow, Lou Fagan, Harriet Resnick, David Hanke, Tessa MacIntyre, Jessica Doyle, Anne Gatti, Jackie Bennett, Hege Kvam, Brian Tinsen, Clifford Burt, John Meletiou, Simon Duffy, Justine Watt, Nicky & Robert Wilson, Janet Hardy, Eric J Sawden, Bob MacPherson, Richard Riley, Angus Farquhar and Christina Hemmett.

I am very grateful to Lydia Berrington for all her help with the film accompanying the exhibition and to Alan Boyd, Susie Honeyman and Scott Skinner of the band 'Little Sparta' for their musical contribution.

Thank you also to House & Garden UK, BBC Gardens Illustrated, the Garden Design Journal, The Financial Times, The Times Magazine, Country Life, The Daily Telegraph, The Sunday Times, Homes & Gardens, Garden Design USA and The Royal Horticultural Society journal 'The Garden' for commissions which contributed directly to this project.

Allan Pollok-Morris

First published by Northfield Print 2008, www.northfieldprint.co.uk

Second edition published by Northfield Editions 2010, www.northfieldeditions.com

Printed in China.
ISBN 978-0-9560338-1-9